Praise for Titus Burckhardt

"No one since the legendary A.K. Coomaraswamy has been able to demonstrate how entire civilizations define themselves through their art with the precision of Titus Burckhardt."
 —**Huston Smith**, author of *The World's Religions* and *Why Religion Matters*

"He devoted all his life to the study and exposition of the different aspects of Wisdon the age of modern science and technocracy, Titus Burckhardt was one of the most nents of universal truth."
 —**William Stoddart**, author of *Remembering in a World of Forgetting*

"Titus Burckhardt looks at … Christianity with the eyes of a scholar who combines deep spiritual insight with the love of eternal Truth. Burckhardt's writings reveal that this Truth is as fresh today as it was millennia ago, and that it will last as long as humans long to see the Divine light."
 —**Annemarie Schimmel**, Harvard University, author of *Mystical Dimensions of Islam*

"Not only did Burckhardt reveal the metaphysical truth of various traditional civilizations as expressed through the language of sacred art, but he also composed a number of illuminating works on Christian art, both in relation to the total vision of Christianity and to the traditional science which made the production of Christian sacred art possible."
 —**Seyyed Hossein Nasr**, The George Washington University, author of *The Heart of Islam*

"As a writer and thinker on a wide range of topics integral to the sacred traditions, Titus Burckhardt has an unerring ability to reach to the essential truths and to speak persuasively of their relevance and importance to the contemporary mind."
 —**Brian Keeble**, author of *Art: For Whom and For What?*

"One of the leading authorities of the Perennialist School, Titus Burckhardt brought a unique combination of gifts to the exposition of the world's great wisdom traditions. Burckhardt was at home in a variety of religious worlds and able to speak with authority on many wide-ranging subjects. His eloquently written and beautifully crafted books are enduring treasures."
 —**James S. Cutsinger**, University of South Carolina, editor of *Paths to the Heart: Sufism and the Christian East*

"Titus Burckhardt was one of the most authoritative exponents of the perennialist school. His work was centrally concerned with the principles informing traditional arts and sciences, and with the nexus between intellectuality and spirituality."
 —**Harry Oldmeadow**, La Trobe University, Bendigo, author of *Traditionalism: Religion in the Light of the Perennial Philosophy*

"Burckhardt was one of the most remarkable of the exponents of universal truth, in the realm of metaphysics as well as in the realm of cosmology and of traditional art. He was a major voice of the *philosophia perennis*, that 'wisdom uncreate' that is expressed in Platonism, Vedanta, Sufism, Taoism, and other authentic esoteric teachings. In literary and philosophic terms, he was an eminent member of the 'traditionalist school' of 20th century authors."
 —*Banyen Books and Sound*

"For anyone who has dreamt that art and architecture is more than a fancy play of aesthetics, Burckhardt's essays set the stage for the *fiat lux* of the soul before the miracle of revelational art. To read him is to see form transfigured into sacred intelligence."
 —**Mark Perry**, author of *On Awakening & Remembering*

Praise for The Essential Titus Burckhardt
Edited by William Stoddart

"An exceptional and powerful 'discernment of spirits' is the hallmark of all Titus Burckhardt's writings. In this anthology of essays, judiciously selected and edited by William Stoddart, the harmonious 'architecture' of the author's thought will stimulate readers to awaken and deepen their own discernment."
 —**Jean-Pierre Lafouge**, Marquette University, editor of *For God's Greater Glory: Gems of Jesuit Spirituality*

"Dr. Stoddart has provided us with far more than an anthology. This book is a spiritual and intellectual journey that requires repeated reading. It brings together the wisdom of the major religious traditions, and demonstrates how the metaphysical principles involved play out in the various fields of human endeavor, in science, art, government, and individual spiritual lives. Anyone wishing to understand and or heal the wounds of the modern world would be well advised to study in depth this wonderful book."
 —**Rama P. Coomaraswamy**, M.D., F.A.C.S., author of *The Destruction of the Christian Tradition*

"Titus Burckhardt has always been a primary inspiration to me. I had the privilege of meeting him in London in the 1970s, with S. H. Nasr. His bearing, modesty, and natural reticence hid his great stature as an artist, scholar, and man of wisdom. I recommend this book to all today."
 —**Keith Critchlow,** author of *Islamic Patterns: An Analytical and Cosmological Approach*

"Two words spring to mind on reading *The Essential Titus Burckhardt*: awe and gratitude. Awe because of the extraordinary perception and beauty of his writing—from his masterly analysis of Christian art and his profound and penetrating understanding of the Renaissance.…And gratitude, such tremendous gratitude that we now have at our disposal writings of such caliber to guide us through not just sacred and traditional art but through so much else besides (for example, evolution and modern psychology). With the sharp sword of Truth he sees through the illusions of modern art as few other writers have done. As a teacher of the principles of traditional art this book will be my primary sourcebook! It is a treasure and should be on the shelves of every teacher of art and every art student today."
 —**Emma Clark**, author of *Underneath Which Rivers Flow: The Symbolism of the Islamic Garden*

"The reader will find in this book unequivocal refutations of many of the false notions intrinsic to modernity. William Stoddart, the anthologist, has made excellent choices from the extensive Burckhardt oeuvre, and the book is highly recommended for anyone who does or would like to take seriously the human vocation to transcend oneself."
 —**Alvin Moore, Jr.**, editor of *Selected Letters of Ananda Coomaraswamy*

"Burckhardt's approach to the philosophical, cultural, artistic, scientific, and religious phenomena of diverse civilizations and historical periods is as original as it is comprehensible; his style is clear, dispassionate, and remarkably beautiful. *The Essential Titus Burckhardt* amply demonstrates that Burckhardt is one of the few truly 'essential' writers of our time."
 —**Mateus Soares de Azevedo**, editor *Ye Shall Know the Truth: Christianity and the Perennial Philosophy*

"This volume is filled with methodological insights for the comparative study of cultures through the arts, religion, and science.…A necessary book for university and seminary libraries, [it] will prove useful for those interested in the interdisciplinary study of religion, art, cultural history, and science, and in the comparative study of religion."
 —***Islam and Christian-Muslim Relations***

"One finds new insights on every page, and what is more, finds that these become more profound with each reading."
 —**Arthur Versluis**, University of Michigan, author of *Theosophia: Hidden Dimensions of Christianity*

World Wisdom

The Library of Perennial Philosophy

The Library of Perennial Philosophy is dedicated to the exposition of the timeless Truth underlying the diverse religions. This Truth, often referred to as the *Sophia Perennis*—or Perennial Wisdom—finds its expression in the revealed Scriptures as well as the writings of the great sages and the artistic creations of the traditional worlds.

Siena, City of the Virgin: Illustrated appears as one of our selections in the Sacred Art in Tradition series.

Sacred Art in Tradition Series

The aim of this series is to underscore the essential role of beauty and its artistic expressions in the Perennial Philosophy. Each volume contains full-color reproductions of masterpieces of traditional art—including painting, sculpture, architecture, and vestimentary art—combined with writings by authorities on each subject. Individual titles focus either on one spiritual tradition or on a central theme that touches upon diverse traditions.

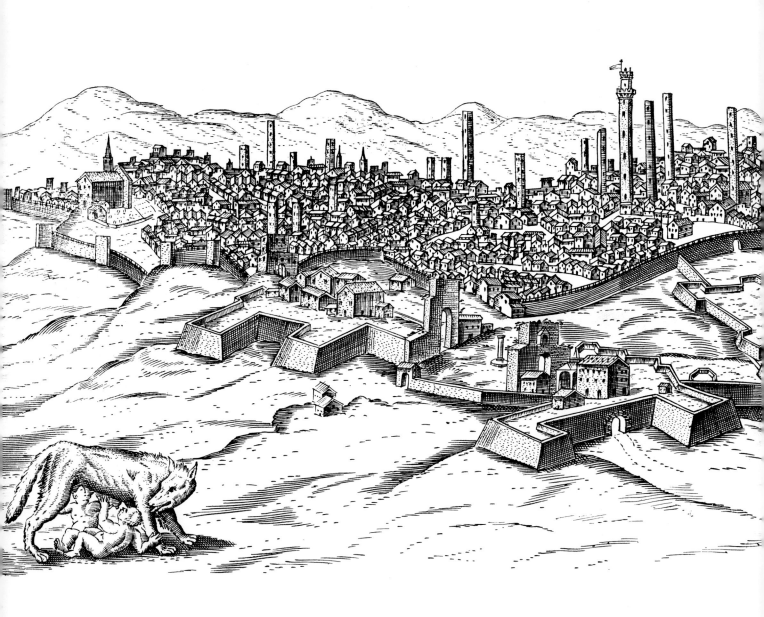

SIENA

CITY OF THE VIRGIN

Illustrated

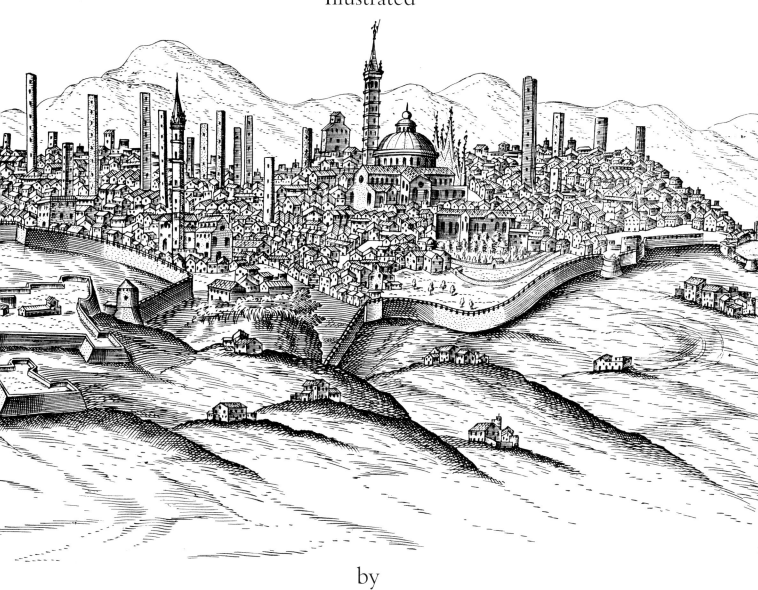

by

Titus Burckhardt

Foreword by William Stoddart

World Wisdom

Siena, City of the Virgin: Illustrated
© 2008 World Wisdom, Inc

Translated into English by Margaret McDonough Brown

Cover reference:
Giuseppe Zocchi, *Siena, view of the Piazza del Campo*, 1739
Simone Martini, *Maestà*, 1320

Library of Congress Cataloging in Publication Data

Burckhardt, Titus.
 [Siena, Stadt der Jungfrau. English]
 Siena, city of the Virgin / illustrated by Titus Burckhardt ; foreword by William Stoddart.
 p. cm. -- (Sacred art in tradition series)
 Translated by Margaret McDonough Brown.
 Includes bibliographical references (p.) and index.
 ISBN 978-1-933316-59-8 (pbk. : alk. paper) 1. Siena (Italy)--Description and travel. 2. Art--Italy--Siena. I. Title.
 DG975.S5B813 2008
 945'.581--dc22
 2008004985

Printed on acid-free paper in China.

For information address World Wisdom, Inc.
P.O. Box 2682, Bloomington, Indiana 47402-2682
www.worldwisdom.com

CONTENTS

Titus Burckhardt, 1950

FOREWORD

Titus Burckhardt, a German Swiss, was born in Florence in 1908 and died in Lausanne in 1984. He devoted all his life to the study and exposition of the different aspects of Wisdom and Tradition.

He was the lifelong friend and associate of Frithjof Schuon, and is the main continuator of the current of intellectuality and spirituality of which René Guénon and Frithjof Schuon were the originators. It was on this basis that, in this age of scientism and technocracy, Titus Burckhardt was one of the most resolute exponents of universal truth in the realms of both philosophy and traditional art. In a world of existentialism, psychoanalysis, and sociology, he was a major voice of the *philosophia perennis*, namely, that 'wisdom uncreate' of which Saint Augustine spoke. In literary and philosophical terms, he was an eminent member of the 'Traditionalist' or 'Perennialist' school of twentieth century authors.

Most of Burckhardt's works were on sacred art. He had a particular love for the Christian Middle Ages, as his books on Chartres and Siena—not to mention his pioneer publication of a facsimile copy of the entire Book of Kells—bear witness. In these matters, Burckhardt was not merely a scholar; the full nature of his vocation emerges from what he himself has written:

"In order to understand a culture, it is necessary to love it, and one can only do this on the basis of the universal and timeless values that it carries within itself. These values . . . meet not only the physical, but also the spiritual needs of man; without them his life has no meaning.

"Nothing brings us into such immediate contact with a given culture as a work of art which, within that culture, represents, as it were a 'center'. This may be a sacred image, a temple, a cathedral. . . . Such works invariably express an essential quality, which neither a historical account, nor an analysis of social and economic conditions, can capture. A work of art . . . can, without any mental effort on our part, convey to us immediately and 'existentially' an intellectual truth or a spiritual attitude, and thereby grant us all manner of insights into the nature of the culture concerned."

Burckhardt was imbued with the Platonic doctrine that 'beauty is the splendor of the true', and it was in this spirit that the present volume on Siena was written. It is an enlightening account of the rise and fall of a Christian city which, architecturally speaking, remains to this day something of a Gothic jewel. Most important of all, however, is the story of its saints, whose fascinating lives and writings may have been hitherto unfamiliar to many readers. Burckhardt devotes many of his pages to Saint Catherine of Siena (who, in the troubled times in which she lived, did not hesitate to cajole and exhort the Pope of the day whenever she felt he had fallen short of his duty) and to Saint Bernardino of Siena (a preacher and spiritual guide who was perhaps the greatest of the Catholic practitioners and teachers of the saving power of the Holy Name).

The art historian Emma Clark has spoken of the extraordinary perceptiveness and beauty of Burckhardt's writings, and of his masterly capacity to analyze and appreciate Christian art. May these gifts, which are amply exhibited in *Siena, City of the Virgin: Illustrated*, bring pleasure and profit to a large cohort of new readers.

William Stoddart
December 2007

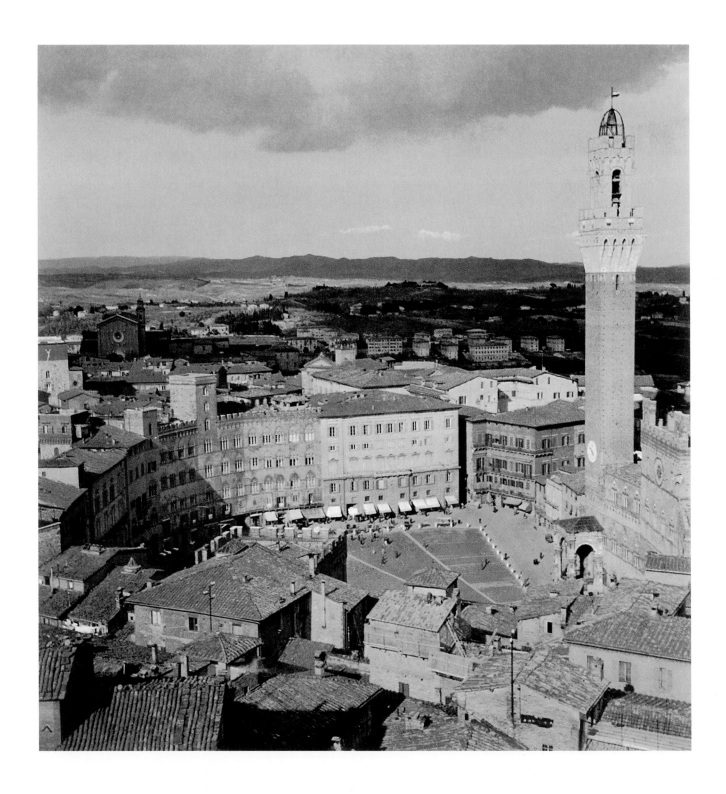

Siena: The Campo from the Cathedral tower.

VIII

PREFACE

This book is an attempt to depict the destiny of a town in which the spiritual development of the Christian Western world from the Middle Ages up to the present day is exemplified, by drawing on the evidence of the most direct contemporary witnesses. These include not only written reports, chronicles, letters, documents, and sermons, but also works of art in so far as these reflect the spirit of a given period or throw into relief the character of particular persons or events, or else tell the story of a great communal achievement, such as the building of the Cathedral, and thereby illustrate a particular side of civic history. In order to connect the statements of all these contemporary witnesses a general commentary was needed, ranging local events alongside the great march of European history: at least an attempt has been made to indicate that these local events—above and beyond their own special momentary effects—were demonstrations of a great spitirual destiny.

For the title of the book we have used the words 'The City of the Virgin', corresponding to the name given to their city by its inhabitants at the moment of its greatest flowering: the story of the town's adherence to the Holy Virgin in fact runs like a thread throughout the years of Siena's history. It is possible that to many readers the continual references to Mary almost as if she were a divine Person may seem strange: if so, we would ask them to consider the unfathomable truth which radiates from the person of the Mother of God—quite apart from Her personal actuality, which we in no wise wish to 'explain away'—and to remember that She represents a never-failing, indestructible source of maternal power to be found at one and the same time in the depths of the human soul and in the whole of the world itself.

<div align="center">★</div>

The author acknowledges with grateful thanks the advice and co-operation of the following persons: Professor G. Cecchini, former director of the State Archives of Siena; Professor G. Garosi, director of the City Library of Siena; Signor Dario Neri, Professor R. Bianchi-Bandinelli, and Professor Enzo Carli, director of the Picture Gallery of Siena.

Acknowledgements are also due for valuable information drawn from the following works: Langton Douglas, Storia politica e sociale della Repubblica di Siena, *Siena 1926; Wolfgang Braunfels,* Mittelalterliche Stadtbaukunst in der Toskana, *Berlin 1953; Vittorio Lusini,* Il Duomo di Siena, *Siena 1911; L. Zdekauer,* Il Costituto del Comune di Siena dell'anno 1262, *Milan 1897; Enzo Carli,* La Peinture Siennoise, *Paris 1955.*

Works from which special documents have been translated are mentioned at the end of this book as also, with appropriate abbreviation, in the margin of the text. Wherever abridgements have been made, this has been indicated by the use of points (...).

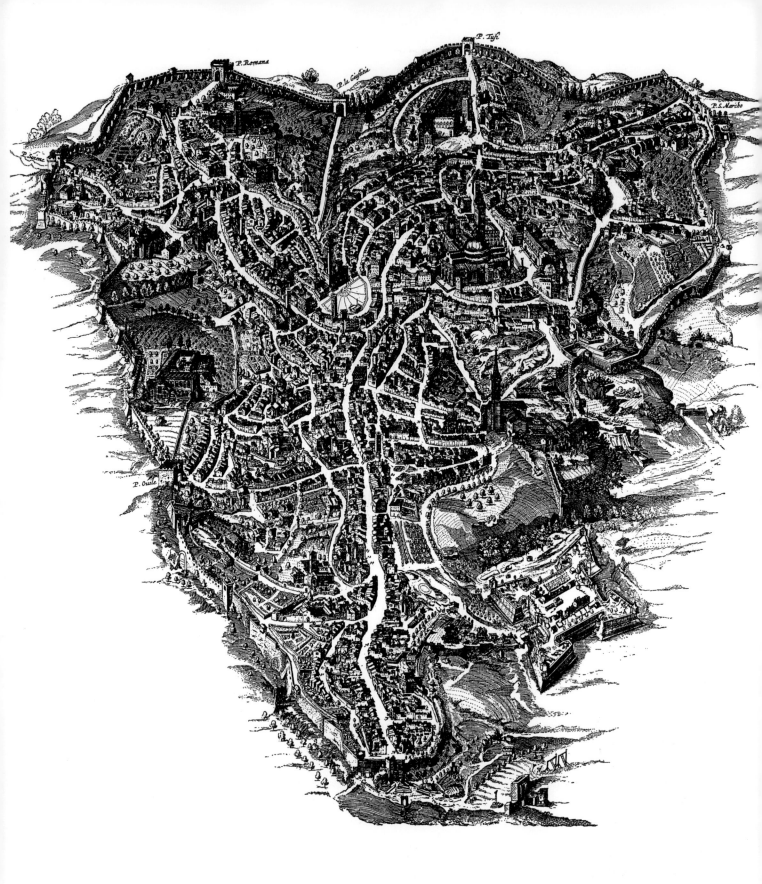

Bird's-eye view of Siena. Engraving after a painting by Rutilio Manetti, beginning of 18th century. Printed by Pierre Mortier, Amsterdam. At the bottom, the Porta Camollia.

X

SENA VETUS CIVITAS VIRGINIS

The rapid development of our modern towns, due to industrial techniques, makes us almost forget the true meaning of a *civitas*, a city, that derives its measure not from the machine age but from man, and its order from the spiritual outlook of a human community. These qualities of order have been preserved throughout the years in the city of Siena. When one stands on the Campo, that spacious shell-shaped centre of the town ringed around with high Gothic buildings, one realizes that here men were still men; no nameless mass existed, for each free man's word carried its weight in the communal affairs, yet all were bound by a universal scale of values.

It is not the rational order of many Baroque towns that we find in Siena; its little universe is many-sided, for it represents the very body, soul, and spirit of Man. The town is built along the curves of three ranges of hills spread out like the veins in a leaf. One can look across from each height to another part of the town, separated by a valley yet still remaining one and the same city, with its earthen-red towers and houses. On the highest crest—the Castelvecchio—stands the Cathedral. At the point where the three parts of the city divide, the Campo, formerly the market-place, slopes downwards to the *Palazzo Pubblico*, the Town Hall, from which the slender minaret-shaped tower, called by the Sienese 'il Mangia', rises to the height of the Cathedral. Between the ridges on which the city rests, both in the dips and on the slopes, nestle countless gardens protected and enclosed by the all-embracing arms of the city walls.

Visible from a great distance, the Cathedral and the Town Hall tower appear as symbols of the two powers, the religious and the temporal. Suspended high in the air the Cathedral looks down in peaceful isolation, clad in alternating bands of light and dark coloured marble which lend to it a severity and coolness amounting almost to a transparency, in contrast to the earthen-red of the surrounding buildings. And opposite to the Cathedral, from the valley of the Campo, rises boldly the Town Hall tower, a banner of strength and confidence above all other roofs.

The beauty of Siena is not merely the result of an unconscious or 'natural' growth; it has been consciously built up by its citizens, as a work of art, with a keen sense of unity but also with that deep respect for the inherited rights of the castes, the professions, and the clans, which is the special mark of the Middle Ages. It has been truly said that whilst in France and in Germany the northern Gothic period produced the cathedral as its masterpiece, Italy in the Middle Ages reached the height of communal achievement in the building of the Gothic town.

Gothic architecture has been more perfectly preserved in Siena than in any other city of Italy. No other town possesses such a central place as the Campo with its inimitable proportions, a perfect stage built by the people of Siena whereon to play their proud history. No other city has retained in equal measure the harmony and severe purity of the architecture of those times. That it has survived unspoilt for so long is due to the fact that, following on Siena's rise to fame in the twelfth, thirteenth, and four-teenth centuries, the city suffered a decline during the Renaissance and, subsequently, a long period of obscurity. To the general aspect of the city the Renaissance added little, so that the beginning of the nineteenth century found the town almost exactly as the Gothic architects had planned it.

The fate of Siena follows an almost symbolic pattern: first her rise to fame through religious faith, followed soon by the misuse of power inducing inner disruption, and ending in downfall and humil-iation, despite repeated warnings received through saints and heavenly signs. At one time during the thirteenth century Siena achieved the proportions and importance of the Paris or London of those

days; but, though the pride of its citizens remained unbroken, the sixteenth century found Siena destitute of power.

In the Middle Ages the development of Tuscany depended on the choice of either Florence, Siena, or Pisa as the chief commercial centre. Each of these three towns struggled for the honour of being on the most direct trade-routes across Tuscany between France and Rome. At first the victory fell to Siena, later however to give way to the claims of Florence. And thus began the ascent of Florence to fame, culminating in the glory which was hers during the Renaissance. The different characteristics of these three cities, which became strongly marked during their struggle for supremacy, are still clearly visible today: Florence standing on both banks of the river and showing its Roman origin in the squared planning of the city centre, some parts of the town being of a rude medieval permanence, others becoming dominating and magnificent with the Renaissance, which spread the fertile land with splendid villas. Pisa, on the other hand, was formerly the most important harbour of Tuscany until it was abandoned by the sea. Its majestic Cathedral and Baptistery stand like a new temple of Jerusalem, strangely isolated, on what was formerly the site of the harbour, recalling bygone days when ships from Constantinople, Sicily, and Spain came here to anchor, bringing austere and richly coloured Byzantine paintings destined for Siena or Florence. Siena, however, does not resemble in any way either of the other towns: far from the sea and without the unifying thread of a river, built on sun-baked hills amidst a country which, despite its richness in corn and wine, could not compare with the fruitful valley of the Arno, its prosperity depended entirely on retaining control of the trade-routes which passed near its doors.

To judge by its general layout Siena is probably of Etruscan, even perhaps, as John of Salisbury states, of Gallic origin. The town certainly existed in Roman times, and throughout the Middle Ages its citizens considered themselves to be Romans. It is believed that on the hill of the Castelvecchio, the present site of the Cathedral, stood a temple dedicated to Minerva. This would lend a double significance to the name Siena bears, the *vetus civitas Virginis*, for Minerva was the virgin Goddess of Wisdom.

The cathedral marks Siena as the see of a bishop. Until towards the end of the twelfth century the bishop was also the supreme secular authority; he ruled with the help of consuls chosen for the most part in direct election by the people. This led to a gradual diminution of the bishop's power in secular affairs, the government passing eventually into the hands of the municipality; and in the period which concerns us here, the years when Siena began to take that form in which we still find it, the city was ruled by a council consisting partly of nobles and partly of elected representatives of the people or, more exactly, of members of patrician families.

POPE AND EMPEROR At the outset of the events which led to the city becoming an independent municipality, it became involved, as happened to many another town in Italy, in the struggle between Pope and Emperor. Pope Alexander III, who contended with and defeated the Emperor Frederick Barbarossa, leader of the cities of Lombardy, was himself a native of Siena of the Bandinelli-Paparoni family. A tradition preserved in the local liturgy represents him as having consecrated the Cathedral in the year 1174. It is however certain that even before that time the Cathedral was used for divine service, so it is possible that the consecration was only that of a side-altar. The same Pope Alexander III had proclaimed, by means of a papal bull, the abolition of serfdom. A greater benefactor of Siena, however, was undoubtedly his opponent Frederick Barbarossa who in the year 1186 granted the citizen body of Siena the right to elect its own consuls, coin its own money and administer justice in town and country. From that moment Siena adhered to the Emperor and belonged to the imperial Ghibelline party, in contrast to Florence where in general the papal party of the Guelphs remained in power.

2

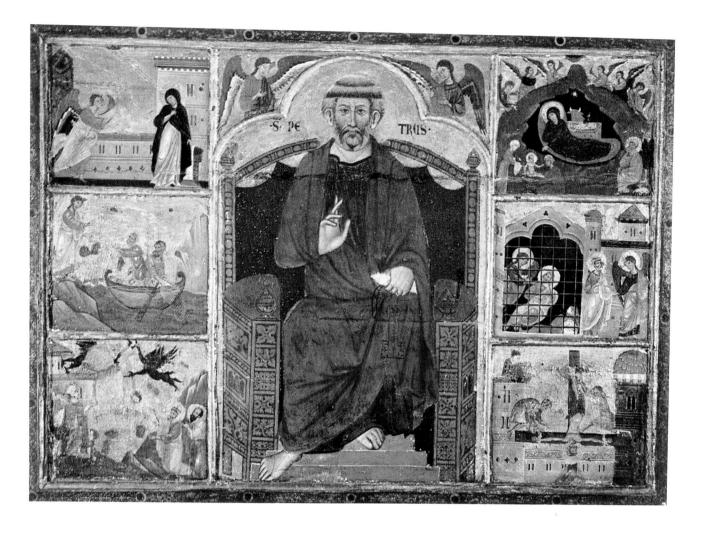

Altar-piece in the style of a Byzantine icon, showing the Apostle Peter preaching in the Church, together with six scenes from the life of the Holy Virgin and of the Apostles. Probably of the school of Guido da Siena, second half of the 13th century. *Picture Gallery, Siena.*

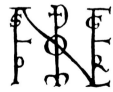

Imperial Monogram *(Fredericus Imperator Romanorum)* on a Charter of 1186 in which Frederick I granted freedom to the city of Siena.

The fight for supremacy between the Guelphs and Ghibellines is one of those historical contrasts perpetuated by the fact that each party was in the right on the very plane where the other was in the wrong, and conversely: the Guelphs held that the Pope was not only head of the Church but also ruler over all Christendom, the Emperor being charged by the Pope with the administration of secular matters; the Pope being like the sun, and the Emperor like the moon, merely reflecting thes un's light. In the opinion of the Guelphs the unity of Christendom depended on the Pope's supremacy in all matters whether religious or secular. On the other hand the Ghibellines claimed that the Emperor, as the administrator of justice, and the Pope, as supreme priest, both held their positions immediately from God: for had not Christ Himself said, 'My Kingdom is not of this world', thereby setting apart his priestly successor from secular dominion? And with his words 'Render unto Caesar the things that are Caesar's' did he not acknowledge the Roman Emperors for all time to be the legitimate administrators of social order and justice? As great a man as Dante strongly defended this latter conception. In point of fact the two opinions are not so irreconcilable as they at first appear. Neither of the two parties denied that the spiritual order stood above the temporal order or that on the latter plane the Emperor was the trustee of justice, but, as so often happens when theoretical justice goes hand in hand with what appears to be factual injustice, the points in dispute became hopelessly entangled. The Emperor, when appointing or dismissing priests of princely rank, could after all claim that they were princes and as such were subservient to him, their secular ruler, but nonetheless in such cases he encroached upon the territory of the Church. On the other hand the Pope, in entering into political questions, appeared not so much as the Father of all Christendom but rather as a prince among princes. This he might seek to justify as a necessary defence against attack on his priestly power, but in so doing he brought himself down to the level of merely secular rivalry. That the Pope held princely rank was very strongly censured by Dante who considered it to be a betrayal of the apostolic example of poverty.

The free towns were now faced with the choice between these two differing conceptions of religious and secular government and they leaned naturally towards whichever side happened to suit their own interests and was inimical to the interests of their rivals. Dissension between the highest religious and political authorities not only contributed to the eventual independence of the towns but was also the cause of the struggles between cities developing the violence of a holy war. The *Civitas Dei*, 'City of God', described by St. Augustine, was no longer to be equated with the whole of Christendom; that being impossible, it had become the ambition of each separate community to realize that ideal of its own. Now each free city became an independent individuality; being alone, it was all to itself. If it happened to its natural rival to be in the wrong, if he broke a contract or offended against accepted custom, this sufficed for him to be treated as an enemy and as a danger to Christian society, and his territory could be burned and plundered with a good conscience.

THE WAR
WITH FLORENCE

The chief cause of enmity between Florence and Siena was the incessant struggle for control of the main trade-route connecting France with Italy through Genoa, Lucca, and Colle di Val d'Elsa, passing close by Siena to Acquapendente, Viterbo, and then on to Rome. Throughout the twelfth century the portion of this route lying in Tuscany, together with its branch to the harbour of Pisa, had been under the control of Siena. Florence was at a disadvantage, since it lay off this route, while to the south of the city wide impassable tracts of boggy land on the banks of Lake Trasimene prevented all forms of traffic. But Florence lay on the river Arno and in the long run stood to win the day.

Riches accrued to Siena thanks to a strange relationship between the nobles and the merchant classes. Patrician families who had taken up their abode in Siena, whether voluntarily or because they had been

compelled to do so by the city Council after being forced to abandon their castles, employed their inborn spirit of adventure in developing business connexions on a large scale. As *milites et mercatores Senenses*—the 'Knights and Merchants of Siena'—they formed commercial companies like the *Grande Tavola*—the 'Great Table'—carrying spices from the Orient and cloth from Flanders and trading between Rome, Paris, and London, but more especially handling money, exchanging florins, *provins*, and sterling, and lending it out at interest. The Sienese are still famous for their banking, and were in those days as much beloved by those who were in need of money as they were hated as creditors. Although loyal to the Emperor, which bound them to the Ghibellines, they had for many generations been charged by the Pope with the task of levying Peter's Pence in several countries and were thus protected by papal letters of safe-conduct. They were ready if necessary to use weapons to defend their caravans laden with valuable goods. In fact they strangely resemble the Kuraish, those noblemen of pre-Islamic Mecca whose caravans plied between Syria and the Indian Ocean.

Florence, though the larger of the two towns, was at a continual disadvantage owing to Siena's flourishing trade, and trade jealousy was further encouraged by the existing enmity between the Guelphs and the Ghibellines. Thus the causes of strife increased daily, though merchants of both towns bartered goods, artists were exchanged between the one city and the other, pilgrims from both sides set out on pilgrimages, and monks united in brotherly prayer.

A page from the Tolomei trading-company's account-book, between 1272 and 1280, the oldest surviving book of its kind.
State Archives, Siena.

In July 1260 the noble Sienese merchant Vincenti di Aldobrandino Vincenti wrote as follows to his representative at the fair in Provins, Champagne:

Bandinelli

"In nomine Domini, amen. Reply to the letters from France brought by the first messenger from the fair at Provins in May of the year twelve hundred and sixty. Giacomo Guidi Cacciaconti, Giacomo and Giovanni and the other companions greet you. We have received the letters by the hand of the merchants' messenger from the above-named fair in Provins in May of said year. From these letters we have taken note of your wishes. The business entrusted to us we shall transact and we beg you, in like manner, only to lend against good security whatever monies you have in hand or those you will receive, so that whenever necessary we can recall the loans. We pray for the help of the Lord our God in the aforesaid transactions and that He give you grace so to act to your own honour and to the prosperity of the Company, Amen.

"...We reiterate what we already wrote you: you need feel no surprise at our selling *provins* and that we propose to continue doing so, for you must know, Giacomo, that our expenditure is great and our business increased since the war we wage against Florence. And you must also know that we need much money to carry on such a war. In our opinion therefore there is no better way of gaining money than in selling *provins*. Should you argue it were better to borrow money here, pray be convinced that it would not suit our particular purposes: for know you, we are owed by dealers the sum of 10 *denarii* and 6 pounds and by others who are not merchants 10 *denarii* and 12, according to the exchange. And everyone here is in the same position so you can see that there is no money to be borrowed. Take therefore no exception to our selling *provins*, as we prefer to owe money in France rather than to have debts here, or to sell sterling, which is of much more value to us, for we receive *provins* at the same rate of exchange as you yourself. It would be unwise to sell sterling or to borrow money here for we shall benefit from England more than from France. Were we to take a loan here the cost would be higher than any profit we could make in France. Therefore regard our transaction with favour and without criticism...

"... and know you, the war will weigh heavily on our purse. But we shall harry the town of Florence so severely that she will never trouble us again, if the Lord God keep King Manfred and preserve him from evil, Amen..."

Manfred, the natural son of Frederick II, had been crowned king of Sicily. He was a handsome, valiant knight and talented as a poet. In him the Ghibellines saw their future emperor. Although the Pope had excommunicated him the Sienese entered into an alliance with him, taking the oath of fidelity on one condition, namely that he should never require the city to offend in any way against the rights or property of the Holy Church. This alliance, however, was in direct contradiction to the peace treaty of 1255 with Florence which Siena had signed shortly before with the Guelphs. This peace treaty provided that no political exile from the one city should find shelter in the other. In the year 1258 the party-leaders of the Florentine Ghibellines were expelled from that city. Siena took them in, whereupon Florence seized the opportunity to declare war. Siena turned to King Manfred for help, who sent his captain, Count Jordan, with a troop of German horsemen to the assistance of the confederate townsmen. In the above-quoted letter the following passages also occur:—

"Be it known that in Siena eight hundred horsemen have been assembled to bring death and destruction to Florence. Florence, however, goes in such fear of our horsemen that they always avoid collision with our cavalry and never remain to make a stand, so that when we destroyed Colle they withdrew their troops and horsemen beyond Barberino...

"Since this letter was written news has reached the writer that Montepulciano has fallen and has sworn allegiance to our lord the king—to King Manfred and the City of Siena. They will take the field as our allies, our friends are their friends, our enemies their enemies. After this achievement Count Jordan and the whole army which he commanded at Montepulciano betook themselves to Arezzo, where we are confident he will hold his ground. This then is the position at present, which, God willing, will not only be maintained but will be further strengthened.

"Despatched on Monday, the fifth day of July.

"To Giacomo Guidi Cacciaconti, to others *non detur*."

Two pages from the Memorandum *(Memoriale)* listing the wrongs done to the city of Siena in the year 1224. Right, a simplified outline of the Cathedral and city towers. *State Archives, Siena.*

The battle of Montaperto which ended the war between Siena and Florence is described in an anonymous chronicle of which several copies, made during the fifteenth century, have survived. The original, obviously written soon after the events described, must have appeared at least as early as the thirteenth century. Everything about it bears the mark of a first-hand account and tallies with much that can be found in contemporary letters and documents written at the time of that famous battle. The following is an excerpt from a manuscript preserved in the City Library of Siena:—

Muratori

"... The Florentine envoys left their troops near Pieve Asciata, reaching Siena on that same day. Entering the town, they demanded a hearing. The town of Siena was governed at that time by a magistracy of twenty-four citizens who were assembled in the Church of San Cristoforo in the Piazza Tolomei, the Council's usual meeting-place. The Florentine envoys, immediately on arrival, were requested by the Sienese Council to deliver their message on that same day, namely 2 September 1260. Accordingly, with great boldness and no signs of respect, the envoys from Florence appeared in the Council Chamber and made known their demands. Without either greeting or preamble they said: 'In the name of the great and mighty City of Florence we demand that this town be at once divested of its walls throughout the whole of Siena, leaving us complete freedom of passage. Over each third of the town a governor will be set of our own choosing. Added to this we shall erect a great fortress at Camporegi with troops and equipment to be at the disposal of our mighty city. All this will be taken in hand at once. Give answer and accede to our demands without delay! If you refuse, the army of the great City of Florence will lay siege to your town and you can expect no mercy. We await your decision.'

"Having listened to the unjust demands of the Florentine envoys, the Sienese, through the medium of one of the twenty-four Councillors, answered in the following words: 'Gentlemen, we have taken note of the message brought to us in the name of the city of Florence. This is our answer: we will consider your demands and a verbal reply will be sent to the military chiefs and deputies of the Florentine army.' Whereupon the envoys left Siena that same day to rejoin their units, which had meanwhile been withdrawn from Pieve Asciata to re-encamp on the plain near Cortina, between the two small rivers of Malena and Biena, where they had awaited the return of their messengers.

"On that same day the chief councillor of Siena called a meeting of the Magistracy in the Church of San Cristoforo. Here the demands of the Florentines were made public, followed by a discussion. The first to offer advice was Signor Bandinello de'Bandinelli, a nobleman of Siena, who spoke as follows: 'Citizens and councillors of Siena! In order to avoid worse disaster, it would appear advisable to satisfy in part the demands of the Florentines. My suggestion is that on one side of the town a breach be made in the city wall, otherwise we shall suffer terrible carnage.' To this suggestion Signor Buonaguida Boccacci expressed his agreement, together with some other members of the Council, but the next speaker, Signor Provenzano Salvani, rose and said: 'Honourable councillors, as you all know, King Manfred of Apulia is our liege lord, and his deputy, Count Jordan, lives in our city. Were it not wise and seemly to lay all these questions before him personally? You know also that he and his troops are at our disposal. My opinion is that we should send for him at once and lay before him the message brought by the Florentine envoys.' This advice satisfying the majority of those present, a messenger was sent to request the presence of Count Jordan. He appeared soon after, bringing with him his Seneschal and a bodyguard of sixteen state officers of high rank. An interpreter accompanied them, for they understood no Italian. Entering the Council Room they bared their heads as a sign of respect and their interpreter opened the proceedings with the question: 'What are the commands of your excellencies?' The spokesman for the Magistracy replied as follows: 'Count Jordan, and you, honoured and brave Knights, hear what has been demanded of us by the Floren-

tines...', and there followed, in ordered sequence, all that had gone before, the interpreter translating the while into German for the Count and his knights. As soon as the report was ended the Germans went aside to discuss the subject in their own language, making no disguise of their pleasure at the prospect of hostilities, for they held the Florentine army in contempt... The Sienese Council, observing the German soldiers' enthusiasm at the prospect of war with Florence, reached agreement to double their pay for the month as a further incitement to defend Siena. On computing the sum thus needed it was found that it amounted to one hundred and eighteen thousand gold florins. That was on Thursday, 2 September, and before the Council dispersed it was agreed to ask citizens to assist in raising the necessary funds, for naturally so much gold was not immediately to hand.

"In spite of all the endeavours of the Magistrate and his councillors, the required sum of money was not forthcoming, but a wise and wealthy old nobleman among them, Salimbene de' Salimbeni, arose and said: 'City Councillors, honourable and wise men of our city, although it may seem presumptuous on my part to speak in such an assembly I will take courage to do so because of the great need in which we stand. I will gladly lend our city the sum of a hundred and eighteen thousand gold florins in order that the necessary precautions may be taken in hand and that God may grant us victory over our enemies.' With great enthusiasm this offer was accepted, whereupon Salimbene left the building to bring the money from his palace. To lend greater magnificence to the occasion he loaded the gold on to a waggon covered in scarlet brocade and decorated with olive branches. He drove his load of gold into the square in front of San Cristoforo with great joy and in triumphal procession, for nearly the whole population of Siena came running together. On receiving the gold the city officials handed it, as arranged, to Count Jordan, his seneschal, and his knights, who returned to their quarters and summoned their officers and troops. Together these numbered eight hundred Germans, all of them tried soldiers and well armed. To them Count Jordan addressed the following words: 'Today we have received our full pay for the month in advance, and indeed double that amount, that we may prove our worth! Therefore let each man take his double pay!' Whereupon each of the German fighters took his money, and capering for sheer joy and anticipation they danced around the narrow room singing songs of their native land. After this they dispersed to buy as much thick sole-leather as the town offered, with which to protect the bodies of their horses. Those who hitherto had merely exchanged florins for thalers now became the providers of horse-blankets and leather protectors for the horses' flanks, while goldsmiths, painters, tailors, joiners, in fact every kind of craftsman, vied with each other to satisfy the needs of the German soldiery; indeed for the sake of the hoped-for victory over the Florentines nothing was denied them. But the time of waiting before they joined battle with the Florentines seemed to the Germans like a thousand years.

"The news of the unjust and arrogant demands of the Florentines spread quickly whilst the magistracy was attempting to raise the necessary funds, and soon the whole city was seething with excitement. In the Piazza Tolomei great crowds gathered picking up scraps of information: how Salimbene had loaned the money, what preparations were on foot for war with Florence, and so on, until the crowds in the Piazza and in the nearby streets were so dense one could hardly move. The City Council, seeing the tumult, realized that a leader must be chosen with supreme powers throughout the town and the countryside. Their choice fell unanimously on Buonaguida Lucari, a Sienese layman of noble birth and a man of irreproachable religious reputation. This decision proved to be a veritable inspiration...

"To the sound of many bells the Bishop of Siena, spiritual Father of the city, called together a gathering of priests, canons, and monks in the Cathedral, where he delivered a short address. He began with the words *tu tantum et in infernum regnum*, exhorting one and all to pray to the Most Holy Mother

Mary, Ever-virgin, and to all the Saints of Heaven; he earnestly bade them plead with God to spare the town, its inhabitants, and all the surrounding lands from destruction and from subjugation, as the Lord had in like manner freed his people from the yoke of Pharaoh and had rescued Nineveh through the preaching of the prophet Jonah and through prayer and fasting… The Bishop, descending from the pulpit, then asked all those present to take off their shoes and to move around barefoot in procession within the Cathedral, chanting psalms and prayers.

"Whilst the Bishop and his priests moved in procession within the Cathedral, Buonaguida Lucari, who had been chosen to be Mayor with supreme powers, appeared on the highest step before the door of San Cristoforo and cried with a loud voice that carried above the assembled crowd: 'Citizens of Siena, it is known to all that the fate of our city is entrusted to our liege-lord King Manfred. But at such a time as this it would seem to me to be right to lay ourselves, our possessions and the whole city of Siena at the feet of the Queen and Empress of Everlasting Life, the glorious and Ever-virgin Mother of God. And the better to present our gift I beg you all, for the love you bear Our Lady, to accompany me in what I shall do.' Hardly had he finished speaking when he divested himself of his outer garments, taking his girdle and knotting it around his neck, and removing his shoes and cap. Barefoot and with bared head he now received the keys of the city, and preceding the crowd he carried them to the Cathedral, weeping the while, followed by the assembled crowd from the Piazza, most of whom went barefoot and bare-headed. Those whom they met on the way to the Cathedral joined the procession after removing their cloaks, caps, and shoes. It was indeed a moving sight to see the people weeping as they cried: 'Holy Virgin, help us in our great need and free us from these lions and dragons who threaten to devour us!'—'Holy Mother, Queen of Heaven, Refuge of sinners, we miserable offenders beseech Thy forgiveness and pity.' In this wise they arrived before the Cathedral where they found the Bishop and his priests engaged in a procession which had just reached the High Altar. Here they were kneeling before the figure of the Mother of God, chanting *Te Deum laudamus*. As the psalm ended Buonaguida and all the citizens of Siena pressed in at the Cathedral door crying aloud: 'Have mercy upon us Holy Mother, Heavenly Queen!' Hearing this the Bishop and his priests turned to meet Buonaguida, and the whole company with one accord fell on their knees, Buonaguida prostrating himself to the ground. But bending down the Bishop raised him up, giving him upon the lips the kiss of peace, upon which each of those present greeted his neighbour in like manner. All this took place in the chancel of the Cathedral before the High Altar.

"Leading Buonaguida by the hand the Bishop then advanced to the altar before the Ever-Virgin Mother of God where they knelt in tears of supplication. Again Buonaguida prostrated himself to the ground, followed by all the people, both men and women, young and old, with tears and sobbing, where they remained for fifteen minutes. Then Buonaguida arose and stood erect before the altar of the Virgin Mary, those around him rising also to listen to him, whom he addressed in wisely chosen words ending with the following: 'Holy Virgin, glorious Queen of Heaven, Mother of sinners, of orphans and the widowed, Protectress of the poor and lonely, I, the most miserable of sinners, present into Thy protecting hands this city of Siena and all her lands, in token of which I herewith lay these keys to the doors of our city upon the altar.' Having laid the keys with great reverence upon the altar he begged a notary, who was present, to write a document to witness this solemn pact and the presentation of the keys.

"With great fervency Buonaguida then continued: 'O Mother, Heavenly Queen, I beseech Thee to accept this our gift even though it seems small compared with Thy riches. Madonna, Mother of God, I beg Thee to receive our gift with just such love as that with which I, miserable sinner though I be, lay it before Thee. Furthermore I pray that Thou wilt extend Thy gracious protection to the

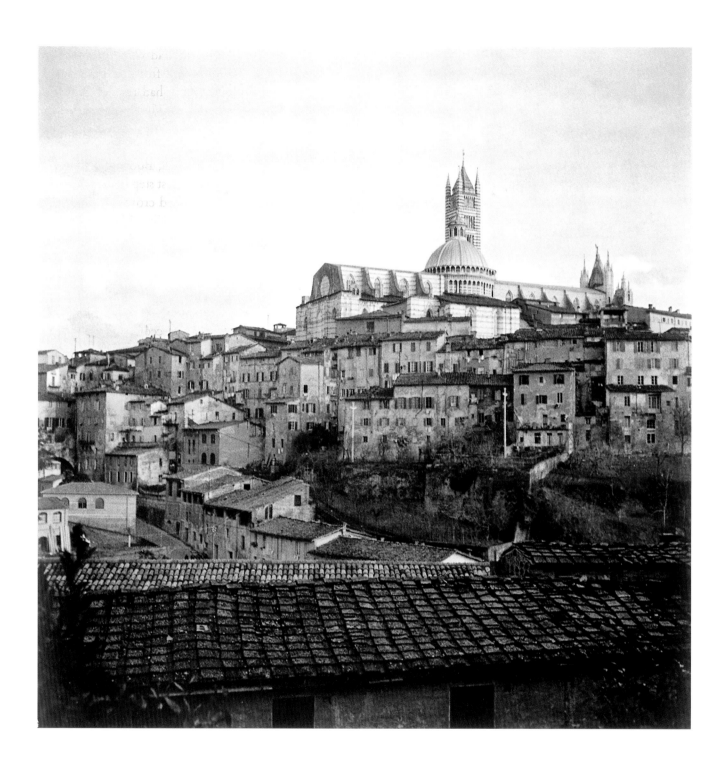

Siena Cathedral seen from San Domenico; evening.

inhabitants of this city and to its lands that they may be spared from the hands of the unjust and evil Florentine dogs and from all who dare to occupy, oppress and devastate this town.' Mounting into the pulpit the Bishop then preached a moving sermon in which he exhorted each and all to live at peace with his neighbour, asking them here and now to embrace each other, forgiving all misunderstandings, settling all quarrels, and to go to Confession and receive Holy Communion. And to show the adherence of the city, its inhabitants and its lands, to Almighty God, the Bishop enjoined them all to follow him and his priests in solemn procession.

"The procession now formed was preceded by a crucifix of special holiness, one carved in wood which now hangs in the Cathedral beside the bell-tower, upon which the Figure is carved with particular beauty of detail. First came all the monks walking before a great banner in red velvet, following which came a statue of Our Lady under a canopy, beside which walked the Bishop barefoot with Buonaguida Lucari also barefoot, without coat and with the knotted girdle around his neck. Behind them walked the canons of the Cathedral, all barefoot and bare-headed, chanting psalms and hymns, followed by the freemen of the city in order of their rank, barefoot and with bared heads. At the rear of the procession came the remainder of the population, the women, both old and young, without shoes and many with their hair loosened murmuring the 'Paternoster', 'Ave Maria' and other prayers, alternating with entreaties to Almighty God and the Virgin Mary for mercy. In this manner the slow procession pushed forward, but for no great distance, for there remained much else to be done. At the Piazza San Cristoforo they turned back and re-entered the Cathedral.

"Each person knelt in confession and made peace with his neighbour, and whoever had suffered the greater offence was first to go in search of his enemy to be reconciled with him. To the High Altar our Bishop and Buonaguida then advanced, where they knelt down giving thanks to Almighty God and the Blessed Virgin. The Bishop then gave Buonaguida his blessing and taking the keys from the altar laid them in his hands, whereupon Buonaguida with a few followers departed, taking the keys with him, and returned to San Cristoforo where the City Councillors were all gathered. To the standard-bearers guarding the gates he handed the keys of the city for safe-keeping and resumed his coat and shoes. Thereafter, together with the twenty-four councillors and other citizens he discussed the position with such wisdom as would seem to be inspired by the Lord Himself and the Virgin Mary. All this happened on Thursday, after nightfall...

"At sunrise three heralds were sent out, one for each section of the town, who proclaimed in the following words: 'Rise up, brave citizens, arm yourselves, grasp your weapons! In the name of the Lord and of His glorious Mother go each of you to the house of the standard-bearer of his appointed ward (terzo) of the city, and let each man dedicate himself to God and the Virgin who will lead us to victory against our foes!' Hardly had the heralds ended the proclamation than in feverish haste all the men of Siena had seized their weapons, no father waiting for his son and no one brother for the other, each man vying with his neighbour to be ready first. So to the Gate of San Viene which faces towards Perugia they hurried with their standard-bearers, the first to arrive there being the standard-bearer of the ward called San Martino which lay nearest. His name was Giovanni Guastelloni, bringing a goodly number of well-armed men with him. The second to reach the gate was from the ward called the 'City' under the standard-bearer named Giacomo del Tondo followed by a great number of armed men, whose banner was a white cross upon a scarlet ground.

"From Camollia, the third ward of the town, came Bartolomeo Renaldini the standard-bearer in charge, carrying the coat of arms of Camollia on a great standard of brilliant white silk, the largest of all the flags, denoting the unpolluted purity of the Virgin's cloak. This standard was made fast

to a long, thick pole and could be drawn up by means of ropes running over rollers to two masts of a much greater height, all of which was built into a heavy, four-wheeled waggon, richly decorated and drawn by men and horses. The banner itself was already twenty-six ells high and could be raised another twenty ells in the manner described. On foot and on horseback went many citizens, priests, and monks mingling with the crowd, some with weapons, others unarmed ready to bring succour to the wounded, but all actuated by one thought, to fight and if necessary to die for their city and their homes in combat with the evil Florentine dogs whose unjust demands threatened their existence.

The masts of the Siena war-waggon *(Carroccio)* and also those of the war-waggon of Florence are still to be seen attached to two pillars in the Cathedral of Siena.

"As the three standard-bearers with their troops on horseback and on foot, side by side with the crowd of civilians, reached the city wall, the gate swung open, but the standard on the war-waggon was so high that the masonry of the arch above the gate must needs be cut to let it pass through. At the head rode Count Jordan and his eight hundred German horsemen. Beside him rode Count Aldobrandino di Santa Fiore, head of the Sienese Council, with two hundred civilian horsemen. Following them came the three ward-leaders or standard-bearers, at the head of the armed civilians, so that the road from the gate to the turning towards Vigniano was one mass of men, some of whom carried candles, some lanterns and some torches. On reaching Vigniano, a halt was made to await the dawn, it being deemed advisable to approach the enemy by daylight and in ordered ranks...

"On that 3rd September the rising sun saw the army moving forward towards the little river Bozzone, following in close formation behind Signor Niccolò da Bigozzi, Seneschal of Siena, a man of great courage and wisdom, together with Count Jordan's seneschal, the Count of Arras. These two able men were responsible for the needs of the entire army. Calling aloud on the name of the Lord and on that of the Virgin Mary the combatants moved in closed ranks up the banks of the river Bozzone, arriving at last at the foot of a hill called the Heights of Ropole, opposite the encampment of the Florentine army..."

At the command of the Sienese captains each separate part of their army was to appear on the Heights of Ropole within view from the Florentine camp: first the German and the Sienese horsemen numbering together about one thousand, following them the citizen-infantry from the ward of San Martino; then those from the 'City' ward, and lastly those from Camollia. Each unit was distinguished by the differing colour of their uniform: thus those from San Martino wore red, those of the 'City' wore green and those of Camollia wore white. As each detachment showed themselves on the Heights of Ropole and descended to give place to another detachment, many exchanged their uniform for another colour and appeared before the enemy a second time, so that the Florentines judged the Sienese army to be far greater than actually was the case.

"...Watching this display one of the Florentine leaders exclaimed: 'How is it that these foolhardy Sienese dare to take the field against us?' To which another answered: 'To my thinking they outnumber us and are better equipped', while the officer in command added: 'It seems to me we have been wrongly advised'..."

The Florentine commander then asked the name of the district where the two armies were gathered, and he remembered a dream presaging his death in just such country.

"... From this moment his courage forsook him. He said: 'We are in a bad position: we ought to leave this place and re-encamp elsewhere, but the vesper-hour is passed, and it is too late to move tonight. Let us pack our saddle-bags to be ready to leave at dawn tomorrow, meanwhile setting guards all around the camp.'

"A continual supply of fresh provisions had been ordered by the Sienese commanders to be brought out from the city. Wines of the best vintage that Siena could offer, with roast chicken, pigeon, and other meats were served to the army, for roast meat gives a man strength without burdening him...

"As the night of Friday closed in, the Sienese commanders set guards at various points, each tending a great fire, the guards to be relieved at certain hours. In the enemy camp the Florentines also set guards and could get no rest, for they feared a night attack.

"While the Sienese army lay thus awaiting the dawn a strange sight was observed: a shadow as though cast by a cloak appeared to be spread over the camp. From the towers and walls of the city many people saw this strange phenomenon and some said: 'The smoke from the camp-fires is causing the shadow' to which others replied: 'That is impossible, for were it smoke it would move: its immobility shows it is not smoke.' And faith in heavenly protection welled up once more so that the shadow across the encamped army was held to be the spreading mantle of Our Lady protecting the people of Siena...

"At the same moment those in the camp looked across to the town and seeing a shadow shaped like a mantle encompassing the city walls they fell to their knees with tears of thankfulness believing it to be the mantle of the Holy Virgin protecting their city...

"When night was come, those who by order of the commanding officer had had some sleep launched an attack on the Florentine camp. The attacks, oft-repeated, were so organized that the enemy camp stood to arms the whole night through, the sound of battle never diminishing so that no sleep was possible. Confused and fearful, the night seemed to them to last a thousand years before the dawn crept in, enabling them at last to load their saddle-bags and strike their tents. Their movements were easy to observe from the Sienese camp and the news flashed from mouth to mouth: 'They are retreating! Are we to let them go?'

"When the captains of the Sienese heard the news and saw the Florentines preparing their retreat they sent messengers around the camp that every man be awakened and stand to arms. When all were ready they divided the troops for battle as follows:—

"The first detachment consisted of two hundred German horsemen and two hundred infantry, the flower of the city's manhood, with Count Jordan's seneschal, the Count of Arras, as their commanding officer.

"Six hundred German horsemen and six hundred well-armed infantry under Count Jordan made up the second detachment. With them went the banner of King Manfred carried by an officer called Signor Orlando della Magnia who had a slight squint but was an experienced soldier.

"The third detachment was made up of six hundred horsemen, noblemen of Siena, led by Count Aldobrandino da Santa Fiore, holding the highest military rank in the city. These were called the Knights of Siena and were followed by the remaining two hundred civilian horsemen who carried the city colours—the 'Balzana'. The three standard-bearers came last leading the civilian population of Siena. This latter detachment was preceded by the great white banner of Camollia on the war-waggon (the 'Carroccio') beside which rode Count Aldobrandino. Before him rode a hundred volunteer horsemen, gallant soldiers, under the command of Meister Heinrich von Steinberg, behind whom came another two hundred well-armed horsemen under his nephew Herr Walter. These all moved away ahead of the civilian troops, followed by the three standard-bearers and the rest of the inhabitants. At the very last rode another two hundred of the Knights of Siena commanded by Signor Niccolò da Bigozzi, the seneschal of Siena.

"To form an idea of the numbers involved be it known that the combatants on foot counted 19,000: from the 'City' section 8,500, from San Martino 4,800, and from Camollia 5,700. Add to these the German horsemen 800 strong, in the pay of the Magistracy another 200 and the 400 mounted Knights of Siena. Altogether the army numbered 1,400 on horseback and 19,000 foot-soldiers—a total of 20,400 combatants.

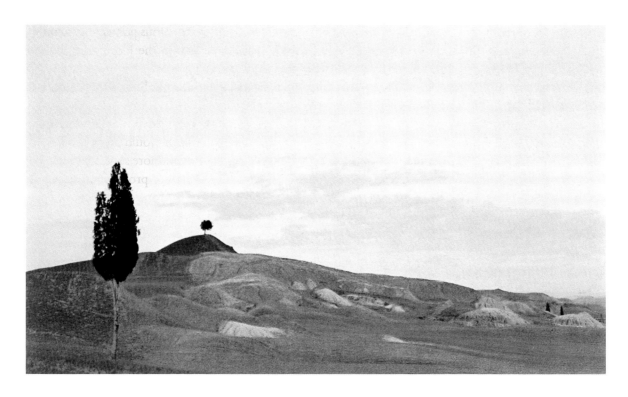

Countryside near Montaperto, showing the chalk hills characteristic of the district to the south of Siena; evening.

"...At dawn, before the Sienese had broken their fast, the Count of Arras called upon his German horsemen and his infantry to take up their position in ambush behind the hill, as had been previously arranged. In the name of the Lord and of St. George they rode away taking the holy name of St. George as their password. In concealment they rode through the valley of the River Biena towards Monte Selvoli and lay hidden awaiting the sound of the Sienese general attack to rush into the open and assail the Florentine flank. The order had gone out that no trumpet should blow and no drum be struck until the moment of attack, when each man should shout his loudest...

"... In this manner did they ride to battle leaving their saddle-bags and provisions on the Heights of Ropole. On reaching the level road Meister Heinrich von Steinberg rode ahead and saluting the commanding officer and the troops spoke as follows: 'Members of the house of Steinberg have been accorded by the Holy Empire the privilege of being the first to attack in every battle in which they fight. The honour of my house demands this of me and I beg your permission to allow me to precede you.' Accordingly his request was granted. Herr Walter however, seeing that his uncle Heinrich von Steinberg had been granted the honour of being in the forefront, came forward, dismounted hastily and threw himself upon his knees before his uncle saying: 'I, your nephew, son of your sister, will not rise from my knees without your promise to grant my request. I implore of you a favour— do not withhold it!' Many there were of the knights standing by who urged the older man to give way to his nephew... And eventually Heinrich von Steinberg consented to be preceded in the attack by his nephew, whereupon leaning from their horses they embraced each other and over his horse's neck the young knight bowed low to his uncle in gratitude for the great favour accorded to him. He then donned once more his gleaming helmet, fastened it firmly back and front, and opened the

visor. Meister Heinrich turned to him and said: 'Ride on! We follow you closely, ready to stand by you. Your courage will carry you through! Therefore lose no time but ride in the name of God, of the Virgin Mary, and of St. George, our helpers and intercessors!'

"Setting spurs to his horse Herr Walter dashed forward, fleet as a greyhound. Two types of armour protected his horse, the one consisting of fine steel chain and the other of a thick untanned leather caparison overlaid with a covering of crimson silk taffeta *(zendado)* encrusted with the greenish golden dragons of his coat of arms. Indeed the very horse himself seemed like a dragon, ready to devour all who encountered him... Such was Herr Walter, young and handsome, endowed with every chivalrous virtue and armed as no other Knight amongst them all. Behind him rode Heinrich von Steinberg accompanied by his horsemen and foot-soldiers followed by Count Jordan with infantry and horsemen. These were supported by the commanding officer, the standard-bearers and one third of the civil population of Siena, Signor Niccolò da Bigozzi bringing up the rear. Thus, in close formation, the army moved towards the little river in the Arbia valley on the road leading to Monte Selvoli, crossing the Arbia on reaching the plain. That was on Saturday morning, 4 September, shortly after daybreak.

"As the two armies drew nearer to one another, a drummer named Ceretto Ceccolini, standing guard on the Marescotti tower in the city of Siena, sounded his drum so that many men and women came running to hear what he had seen. From his place on the tower he called down to them: 'The Sienese are attacking! They have come down the hill and are approaching the river Arbia. Now they have forded the river towards Monte Selvoli. Pray to God to give them the victory!' And the listening crowd fell upon their knees. The drummer called again: 'Now they are leaving the plain and beginning to climb the hill. The Florentines do the same. Both armies, from different sides, are trying to get to the summit to have the advantage of greater height.' Just at that moment the Sienese reached a small high plateau. There Herr Walter, riding forward about as far as the flight of an arrow in front of the troops, perceived the enemy advancing. Lowering his lance, closing his visor, and making the sign of the cross he gave spurs to his horse and rode at the enemy uttering a wild battle-cry. On the tower in Siena the drummer watching these events cried: 'They have reached the summit! In hand to hand battle they clash with the Florentines! Lift your voices to the Lord: Misericordia!' The citizens below took up the cry: 'Lord, have mercy upon us!' Herr Walter's first opponent was Signor Niccolò Ghiandoni, a native of Lucca, whose lance met his but broke in pieces, leaving him unharmed and still firmly seated, whilst Herr Walter's lance pierced through his enemy's armour, unseating and killing him. Handling his lance afresh, Herr Walter accounted for a second and a third horseman, throwing them from the saddle. Still a fourth enemy pressed forward and found death at his hands till at last his lance snapped off, whereupon he drew his sword and fell upon those men of Lucca like a lion in anger, killing and maiming many: great was his slaughtering in that battle.

"Behind his nephew rode Meister Heinrich with poised lance. The first to engage him was Captain Zenobi of Prato. With a mighty thrust Meister Heinrich's lance pierced the man's armour into his breast killing both him and his horse, after which he proceeded to fall upon the men of Prato, followers of Signor Zenobi, massacring countless numbers of them... Then Count Jordan advanced, lance in hand, to grapple with Signor Donatello, commander of the men from Arezzo. With his sword drawn as well, Count Jordan towered above the men from Arezzo like another Hercules: indeed Hercules himself did not mow down the Trojans more ruthlessly than did Count Jordan the Florentines... All who witnessed the deeds of his German soldiers marvelled at their discipline and the way they dispatched their enemies! Meanwhile Count Aldobrandino with his standard-bearers and the armed civilians of Siena attacked the Florentines to the fierce cry of 'Death! Death!'...

16

"Little did it avail the Florentines to call upon St.Zanobi and the holy St.Liparata, entreating help and succour in their distress, for they were slaughtered by the Sienese as a butcher slaughters the Easter lambs.

"From hour to hour the battle was followed by the observer on the Marescotti tower in Siena, who called out: 'The Sienese are now attacking from all sides: pray God that He may give them courage and strength!' And again he called down to those waiting below: 'The standard-bearers with the civilian troops are pressing the enemy: persist in prayer for Heaven's protection!' Thus he continued reporting all that he saw, the time slipping by from the end of the third hour almost until the ninth, with the sun standing high in the heavens...

"Towards evening, at the vesper hour, when the sun dazzled the eyes of the Florentines, the Sienese took up once more their terrible battle-cry; 'Death! Death! Down with the Florentine traitors!' filled the air, drowning all other sounds and instilling the poison of despair into the heart of the enemy army.

"Under cover of this battle-cry Count Arras and his troops, horsemen and infantry, appeared from ambush and carried out the prearranged attack on the enemy's flank...

"Thus, in the thick of battle, the Germans and the Sienese approached the banners and standards of the Florentine army. These they seized and hurled to the ground, first tearing down the banner of the City of Florence from its place on high upon the great war-waggon. Around the flags there ensued great carnage and a bloody struggle taking toll of the lives of many on both sides. But at last all the enemy standards had been trampled and torn down, and on this there went up a mighty shout from the Sienese camp...

"We have told of the German soldiers and of their deeds of immense courage: but now let the same be said of the brave people of Siena and of their knights, for the story of their heroism is almost beyond belief. Each man went forth to defend his home and his honour, and to protect his city, so that as they fought and pressed back the enemy they could be heard shouting: 'Come on now! Come and demolish our walls! Come on! enter our city, erect your fortresses! Come! set up your governors to oppress us!'...

"The watcher Cereto Ceccolini, observing these events from the Marescotti tower, now called out: 'The enemy is being pressed back... The battle still rages while the Florentine flags sink one by one... Persevere in prayer to Our Lord and to His Mother!' The whole morning and beyond the vesper hour the din of battle continued unabated, by which time the ground was heaped with such numbers of enemy dead that the Sienese were exhausted with the sheer effort of killing. The paths ran red and the river Malena rose high in its banks scarlet with Florentine blood...

"The citizens of Siena, seeing their opponents in retreat, took fresh courage and many pursued them. Any Florentine falling into Sienese hands was pitilessly slaughtered. How many were killed God alone knows! In vain the cry: 'I surrender!', for each one was put to the sword. These deeds were done by the German soldiers: besides which it is reported that a certain Sienese woodcutter, axe in hand, entered the Florentine camp and massacred single-handed about twenty-five of the enemy...

"Now from the watch-tower came the cry: 'The Florentines are beaten! They are fleeing in all directions!' At these words a man, named Magisculo, at the foot of the tower took off his cape, whirling it round and round his head as he shouted: 'The victory is ours! The Florentines are beaten and dishonoured, pursued by our brave soldiers!'

"Amongst the few enemy survivors were natives of Lucca, Arezzo, and Orvieto, of Val d'Elsa, Prato, and Pistoia. These men saw the death of their comrades at the hands of the Sienese who were

killing them like cattle. Many of them therefore turned back, fleeing towards Montaperto where they again found themselves held up, for in that direction there was no outlet…

"At last the Sienese commander took counsel with the standard-bearers and with Count Jordan and some of his knights, saying: 'See the great slaughter of men and horses which surrounds us and let us have pity! Let us proclaim that each man who surrenders shall be spared and taken prisoner but that he who will still oppose us shall be put to death.' This being agreed upon, a herald was sent out. He did not need to read his proclamation more than once, for happy was the enemy who found a Sienese willing to take him prisoner, indeed many of them put themselves in fetters to save their lives by surrendering in groups. All those from Lucca, Arezzo, and Orvieto, and many another who had fled towards Montaperto, turned back on hearing the herald's proclamation, dismounted, and casting their armour to the ground presented themselves before the Sienese commander as prisoners…

"Strange things happened there. The story is told of a woman, a merchant of vegetables called Usilia living in Campansi in Camollia, who was bringing good things to refresh the fighters in the Sienese camp. She had loaded the stuff on the back of a little donkey—the very same one which the Florentines had pitched over the wall at the Gate of Camollia, as the story goes. But Usilia, when she saw that the enemy was beaten and many of them were in flight, left the Sienese camp on the Heights of Ropole where all the army stores lay and the great white Sienese banner stood on the 'Carroccio', and pushed forward on to the battle field where, single-handed, she took thirty-six of the enemy prisoner by binding them together with a shawl…

"It is said that of the Florentines and their allies 15,000 were taken prisoner and 18,000 fell in battle. From the heaps of dead and dying such a stench arose that the district was almost totally abandoned by its inhabitants. Those who escaped were but few: their number is not known…

"Early on 5 September the Sienese began to pack their saddlebags and re-entered the city in ordered formation with triumph and great rejoicing… On the back of Usilia's donkey they had fastened all the Florentine banners packed up in two bundles upon which they set the great bell called the Martinella [which the Florentines had borne into battle on their war-waggon]… One of the Florentine ambassadors who had brought the bad news to Siena was strapped to the back of another donkey, facing its tail, over which the proud flag of the City of Florence was carefully draped so that it should trail in the mud. Small boys ran alongside, taunting the ambassador: 'Come along! build your fortress in Camporegi, elect your governors in each section of our town!' And had not men intervened, the ambassador would have met his death at the hands of the boys.

"Next came the drummers, followed by King Manfred's standard and Count Jordan, the Count of Arras, and his brave German mercenaries, each man wearing a crown of olive sprays, singing their native songs. On the war-waggon drawn by two superb horses came the great white banner of Siena followed by the mass of prisoners… And leading on a rope her thirty-six prisoners came Usilia herself. Last rode Count Aldobrandino di Santa Fiore, the chief magistrate of the City of Siena. Thus they went, chanting thanksgivings to God and to the Virgin Mary, wearing the olive-crown of victory. Before the standard-bearers ran the citizens rejoicing and with leaping steps so light that their feet seemed hardly to touch the ground…"

The Florentines accounted for their defeat by saying that they had been betrayed by Bocca degli Abati, who was said to have given away their plan of battle to the Sienese. Bitterness about this still echoes in the verses of Dante, who was born at the time of the battle of Montaperto (or Montaperti). In the 32nd Canto of the *Inferno* he describes his meeting with Bocca degli Abati, who together with other traitors is frozen up to the neck in solid ice in the Antenora, the nethermost Hell.

"... and as we made
Towards the centre where all weights down-weigh,
And I was shivering in the eternal shade,

Dante, *Inferno*,
Canto XXXII, 73–111

Whether 'twas will, fate, chance, I cannot say,
But threading through the heads, I struck my heel
Hard on a face that stood athwart my way.

'Why trample me? What for?' it clamoured shrill;
'Art come to make the vengeance I endure
For Montaperti more vindictive still?'

'Master!', I cried, 'wait for me! I adjure
Thee, wait! Then hurry me on as thou shalt choose;
But I think I know who it is, and I must make sure.'

The master stopped; and while the shade let loose
Volleys of oaths: 'Who art thou, cursing so
And treating people to such foul abuse?'

Said I; and he: 'Nay, who art thou, to go
Through Antenora, kicking people's faces?
Thou might'st be living, 'twas so shrewd a blow.'

'Living I am,' said I; 'do thou sing praises
For that; if thou seek fame, I'll give thee it,
Writing thy name with other notable cases.'

'All I demand is just the opposite;
Be off, and pester me no more,' he said;
'To try such wheedling here shows little wit.'

At that I grasped the scruff behind his head:
'Thou'lt either tell thy name, or have thy hair
Stripped from thy scalp,' I panted, 'shred by shred.'

'Pluck it all out,' said he; 'I'll not declare
My name, nor show my face, though thou insist
And break my head a thousand times, I swear.'

I'd got his hair twined tightly in my fist
Already, and wrenched away a tuft or two,
He yelping, head down, stubborn to resist,

A page out of the great book of the Statutes of Siena, 1262. *State Archives, Siena.*

When another called: 'Hey, Bocca, what's to do?
Don't thy jaws make enough infernal clatter?
But, what the devil! must thou start barking too?'

'There, that's enough,' said I, 'thou filthy traitor;
Thou need'st not speak; but to thy shame I'll see
The whole world hears true tidings of this matter.'

(From the translation by Dorothy Sayers)

Two years after the victory of Montaperto, in the year 1262, the Council of Siena, strong in the knowledge of the city's freedom, laid down in writing the statutes of the city's constitution. The legal form of this constitution is exceptional for the singleness of purpose revealed in its structure, which neither overlooks nor underestimates natural developments. In this respect it is wiser and shows more understanding of human nature than many another such document of much later date.

THE CONSTITUTION OF 1262

Leadership was to rest with the people, though it was not to be decided by the pressure of the masses. The 'people', therefore, were not considered to be identical with the mass of the inhabitants as a whole but with a body of citizens recognized as being capable of bearing responsibility. Therefore the *Consiglio della Campana*—the Council of the Bell—called together by the sound of a bell for decisions relating to the welfare and destiny of the whole town, was formed by three hundred or more councillors nominated either by the magistrate, himself chosen from the Council, or by heads of the departments of the administration, or by representatives of the various guilds. Thus leadership was built up from below as well as by selection from above.

The permanent magistracy consisted at that time of twenty-four councillors chosen from all ranks and given, in the Roman style, the name of 'Vigintiquator partis ghibelline populi civitatis et comitatus Senarum'. Half of its members came from the knightship—the 'milites'—and the remainder from the 'populus', though wealth and nobility were to be found on both sides.

From the Council of the Bell were chosen the permanent administrative authorities *(balie)*, amongst others that of the *Biccherna*, a word possibly derived from the German 'Bücher', which was Siena's Fiscal Office, or Department of Finance. This office was also responsible for the upkeep of streets, bridges, the water-supply, and the fountains, as well as giving permits for the plans of public buildings. As director of the Finance Department a monk from San Galgano, the Benedictine monastery near Siena, was usually chosen, because a monk, who himself owned nothing, was incorruptible as chancellor of the city exchequer. Chosen from amongst the most respected citizens, four *provisores*, or inspectors, assisted the chancellor or *camerarius;* they together with him were all re-elected every six months.

At that time, in all Italian cities there was also a mayor, or *podestà*. His work it was to see that the laws of the constitution were properly applied. To this end he was generally chosen by the magistracy from some other town, preferably a Lombard town such as Bologna or Modena, famous for their schools of jurisprudence. The *podestà* was paid by the city, which also placed a palace at his disposal, and in course of time it became usual for the mayor, as long as he remained in office, to be confined to his palace, living there almost like a prisoner, withdrawn from all possibility of corruption.

The great book of Statutes of the year 1262 is divided into four parts or headings: the first devoted to the protection of religion and everything pertaining to Church management; the second to legal procedure; the third to the functions of the municipality; and the fourth to civil rights. Significant of the spirit in which the Statutes were drawn up are the opening phrases of the first part where, after

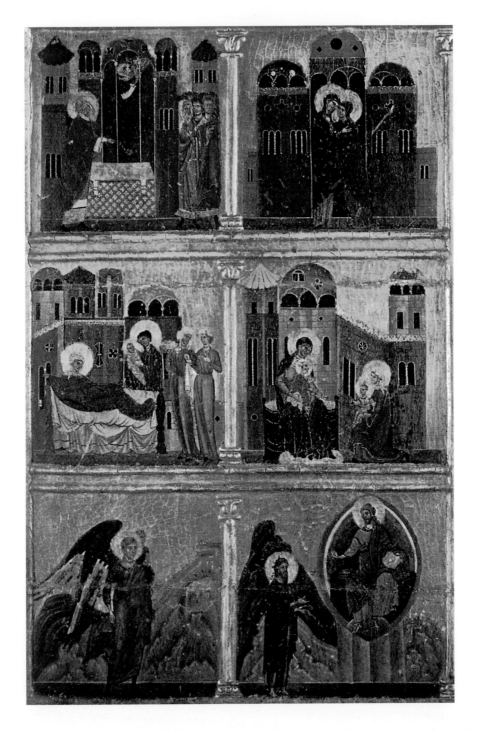

Left wing of an altar triptych by an anonymous Sienese painter between 1270 and 1280, in the Byzantine style. The triptych shows, in the centre, John the Baptist, with scenes from his life to left and right. *Picture Gallery, Siena.*

a detailed description of the duties of the *podestà*, the order is expressly laid down that two candles be kept burning, at the city's expense, before the altar of the Holy Virgin; and before the *Carroccio*, or war-waggon, which carried the great white banner of the Holy Virgin and which was regarded

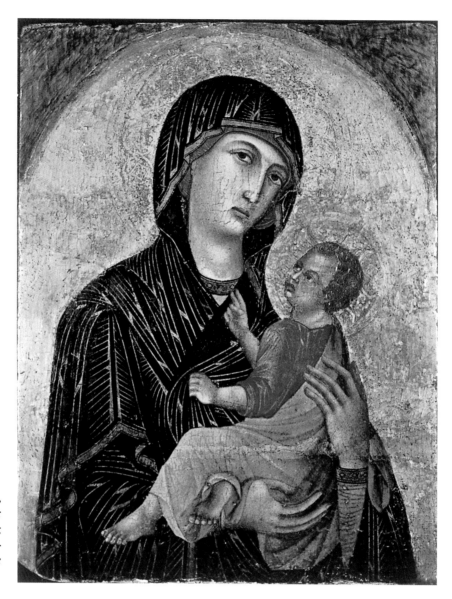

Icon of the Virgin and Child, from the Abbey at Isola, near Siena, possibly by the young painter Duccio di Buoninsegna, about 1300. *Picture Gallery, Siena.*

as the Palladium, or protection, of the city during the war, an everlasting light should stand with a guard of honour day and night. This chapter of the Statutes is followed by regulations for the maintenance of Church property, also rules for the administration of the Bishopric should a vacancy in office occur, and of the manner in which the head of the Cathedral Guild of Masons should be sworn in, and other such matters.

Maintenance of the city wall and the upkeep of streets, bridges, and fountains were among the duties of the municipal council. Strict limits were set to the liberty of citizens within the framework of law and order in the city, while keeping in mind the point at which the state must itself yield before the claims of individual rights.

Sienese painting in the thirteenth century was greatly influenced by Byzantine pictures reaching Siena from southern Italy and even more through Pisa; its origin is to be found in the liturgical art

THE 'MANIERA GRECA'

23

of the Byzantine East, which under the name of 'Maniera greca' had penetrated from Constantinople and Cyprus into the maritime trading town of Pisa. Scholars of the nineteenth century have called these paintings 'stiff' and even primitive; actually they are the expression of a highly conscious symbolical art, stressing the spiritual qualities of forms and colours and intentionally dispensing with perspective and with anything pertaining to naturalistic 'illusion'. At the same time, one could speak of a 'pure art of painting', giving its greatest intensity and depth to colour and its purest melody to line. Most of the Sienese pictures at this time were real icons, transmitting sacred prototypes; the radiant and solemn beauty of the so-calles 'maestri primitivi' of Siena dates from this point in the city's history.

NICCOLÒ PISANO
Owing to the victory over the Guelph party and the consequent leaguing together of the Ghibelline cities, Siena found herself more closely linked than ever before with imperial Pisa, which had long been the most important port for Sienese maritime trade. Pisa now took on the nature of a bridge-head between Siena and Sicily, the kingdom of King Manfred. It was therefore not surprising that in the year 1266 the sculptor Niccolò Pisano, who had just completed the famous pulpit in the Cathedral at Pisa, should be called on to erect an even more elaborate pulpit in the Cathedral of the Holy Virgin in Siena. Nor is it to be wondered at that Pisano's work brought to Siena the first indications of that anticipation of the Renaissance which had already taken root in the scholarly environment of Frederick II, the father of King Manfred. On the pulpit at Siena, Pisano's high reliefs, in which the figures in some cases stand almost detached from their background, are clearly reminiscent of late Roman work on sarcophagi and triumphal arches. Compared with contemporary Gothic sculpture in France and in the north, Pisano's work, being much closer to Roman art, is by this very fact more rationalized and earth-bound; it lacks the spiritual rhythm and the sensibility to light so significant of the great Gothic sculptors; under his hand detail is harder, more analytical, and a very tumult of light and shadow emerges from the richness of gesture he lends to his figures. On the other hand, some of his statues at the corners of the eight-sided parapet are of keen classic strength.

The Pisano pulpit is Gothic in its general plan: around the octagonal parapet scenes from the life of Christ are depicted, partly in bas-relief and partly in sculpture in the round, portraying the 'joyful' and the 'sorrowful' mysteries of Christ's life on earth: the Annunciation, the Visitation, the Nativity, the Presentation in the Temple, the Adoration of the Magi, the Flight into Egypt, the Baptism of Christ, the Crucifixion, and the Day of Judgement. Below these reliefs showing the manifestation of God on earth and pointing to the mercies to be vouchsafed there stand single figures portraying the various spiritual virtues whose presence is a necessary condition for receiving the manifestations of God's grace. These take the form of smaller female figures crowning each of the eight outer pillars of the pulpit. The bases of four of the eight pillars rest each on the back of a lion, symbol of Nature's power in leash. A central pillar, around which the lions are pacing, bears upon its base allegorical figures representing the seven liberal Arts: these, as in Dante, signify natural wisdom, inherited from the past, and preparing the way for the divine wisdom of Christ: the seven liberal Arts—consisting of the 'Quadrivium' of Arithmetic, Geometry, Music, and Astronomy, and the 'Trivium' of Grammar, Rhetoric, and Philosophy—are here taken literally as fundamentals for the higher art of salvation.

In the year 1284 Niccolò Pisano's son Giovanni completed the lower part of the Cathedral facade, for which he received the freedom of the City of Siena and life-long exemption from taxes.

24

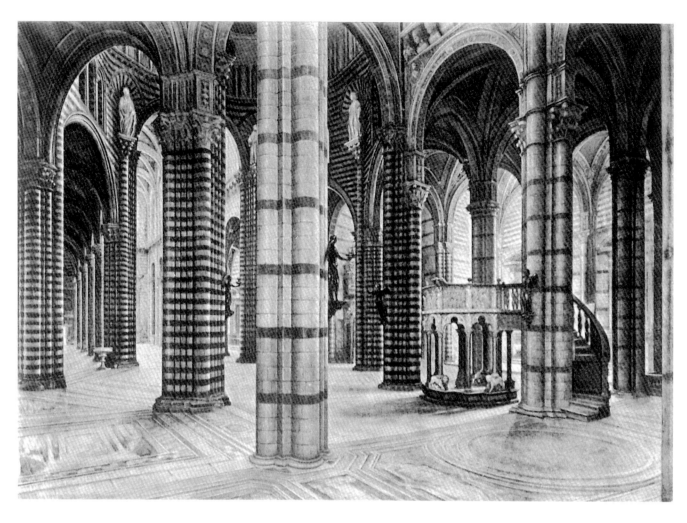

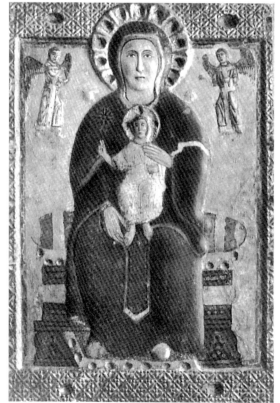

Interior of Siena Cathedral showing the pulpit by Niccolò Pisano.
On the eve of the battle of Montaperto the keys of the city were offered up before this picture, which is known as the 'Madonna with the Great Eyes'. It now hangs in the Cathedral Museum.

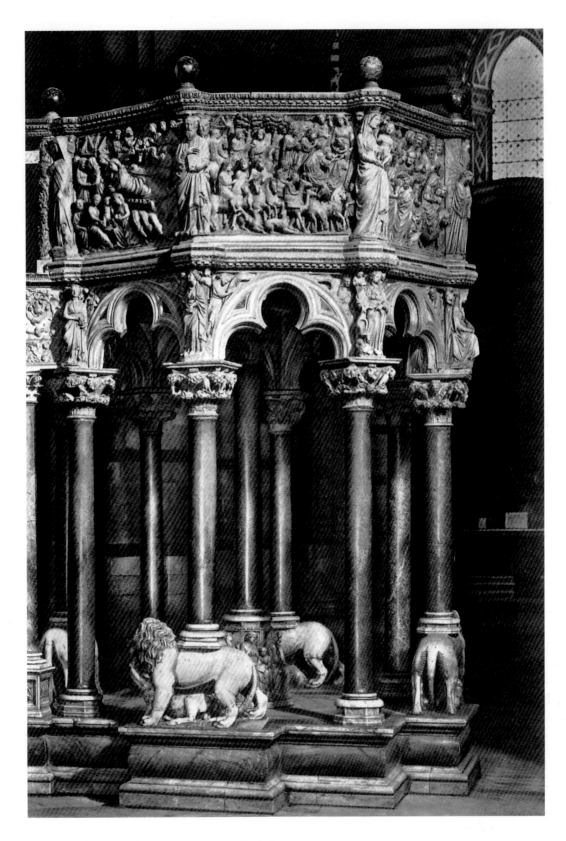

The pulpit by Niccolò Pisano in Siena Cathedral.

26

'IL BUON GOVERNO'

For the city of Siena the fourteenth century was the age of architectural activity. In the thirteenth century the townspeople had concentrated almost exclusively upon the building of the Cathedral, but now they turned their minds to the planning and shaping of the town itself, a task undertaken by the middle classes who had come into power towards the end of the thirteenth century.

The triumph of the Ghibellines over the Guelphs of Florence and the establishment of a strong Ghibelline alliance, with Siena at its head, had both proved to be barren successes: the Pope declared a ban on Siena, withdrawing his protection from its merchants, King Manfred fell in 1266 at the hands of the Papal party in the battle of Benevento, and lastly Provenzano Salvani, the great leader of the Sienese in the battle of Montaperto, was taken prisoner at the battle of Colle di Val d'Elsa in 1269 and was beheaded by the enemy Guelphs in that year.

In the year 1277 the Guelph party in Siena succeeded in unseating the magistracy of the city comprising twenty-four councillors, half noble, half patrician, electing in their place a board consisting of nine councillors, to which in future only 'Guelph merchants of good repute' could be nominated: the nobility was thus dislodged from the administration. At the same time peace was made with Florence.

The merchant class blamed the nobles for having laid more stress on keeping in with their great feudal lords than on representing the true interests of the township, involved as they were in wider imperial politics, fighting out their old clan-rivalries within the town instead of aiming first at its welfare. Especially disastrous to the Sienese merchants was the break with the Pope.

The Council of Nine remained in power from the spring of 1277 until early in 1355. Their policy was that of peace at any price, even to the length of allowing military supremacy in Tuscany to slip into the hands of the Florentines, for which, later on, Siena paid a heavy penalty. Meanwhile commerce and the arts and crafts flourished, fostered and carried on by the merchants and craftsmen.

Immediately after coming into power the new magistracy of 'Guelph merchants of good repute' decided to build a Town Hall, a fitting place to house their meetings which till then had taken place in the little church of San Cristoforo, on Piazza Tolomei. After seven years of planning carried out by a special committee, and another nine years spent in acquiring and preparing the site, building of the Town Hall was begun in 1297, the site chosen being on the market place or Campo. This position had its special significance for it belonged to none of the three sections of the city, standing at the confluence of all three. As the new Hall had to face towards the Cathedral, the only site where it could be built was at the lower end of the market place. Constructed on this spot it resembles the stage of an ancient theatre facing the circular sloping auditorium of the market place. Soon after this, in May 1297, the magistracy decreed that in order to create a harmonious whole all windows looking on to the Campo should be adorned with small columns:

"... an order has been formulated that all houses and buildings whatsoever around the Campo, which shall in future be built, re-built, or altered, and whose windows look down upon the Campo, shall have small columns inserted into the window-frame and shall furthermore be devoid of any kind of balcony. It is the duty of the mayor, or *podestà*, to see that this by-law be adhered to. Anyone erecting such a house or other building and failing to conform to this ruling shall be fined by the mayor

the sum of 25 Lib., and in the event of failure to fine the offender the mayor himself shall be liable to pay said fine out of his own pocket..."

Owing to the fact that the slopes below the Campo had first to be built up with enormous earthworks and foundation-walls, the building of the Town Hall itself (the Palazzo della Signoria) was immensely prolonged. It was not until the year 1310 that the lower walls were completed, while construction went on until 1342. The central body of the building was then two floors higher than the wings, thus appearing to tower even more strongly above them. In 1325 the foundation of the tower was laid, as a contemporary chronicle describes:

"The foundations of the Town Hall tower were laid at the time when Signor Gherardo de' Bruciati of Brescia was mayor of Siena. It was a great occasion: the priesthood assembled to bless the laying of the first stone with prayers and the chanting of psalms, the city architect depositing a sum of money at the foot of the tower. At each corner of the foundation a stone was set carrying Hebrew and Greek lettering to protect the tower from thunder, lightning and wind-storms..."

THE ALTAR-
PIECE BY
DUCCIO DI
BUONINSEGNA

To seal the new peace pact and to ensure the continued protection of the city's patroness, the Holy Mother of God, the magistracy presented a large new altar-piece to hang over the high altar in the Cathedral, a painting by Duccio di Buoninsegna of the Holy Mother in Her glory (the 'Maestà'). An anonymous chronicler describes in the following words the ceremony of installing the new altar-picture in the year 1311:

"At that time and under the government of the above-mentioned magistracy, the Council of Nine, the altar-piece was completed, brought to the Cathedral, and placed above the high altar after the previous picture had been removed: this one now hangs above the altar in the church of St. Bonifazio and bears the name of 'The Madonna with the Great Eyes' or 'The Holy Mother of Mercy'. This latter picture was the one which heard the prayers of the people of Siena at the battle of Montaperto when they vanquished the Florentines. The two pictures therefore exchanged places, the new painting being much more beautiful, larger, and more devotional. The back of the picture also shows scenes from the Old and New Testament. On the day when the new picture was brought to the Cathedral all the shops were closed, the bishop having ordered a great procession to accompany the new painting to its destination. Priests and monks therefore, together with the Council of Nine, the city officials, and all the inhabitants, marched in solemn procession. One behind the other the city worthies paced beside the great picture, each carrying a burning taper, with women and children bringing up the rear with great devotion. After this manner was the altar-piece brought to its resting place in the Cathedral. Right around the Campo the procession paced, as is usual: meanwhile the bells pealed the 'Gloria' in honour of the beautiful painting for the high altar. The picture was the work of the artist Duccio di Buoninsegna who had worked on it in the house of Muciatti by the Stalloregi Gate. During the whole day of the procession prayers were offered unceasingly and to the poor alms were distributed. To our intercessors, Our Lord and His Mother, prayers went up entreating Her in Her infinite mercy to preserve us from all evil and disaster and to protect Siena from the hands of traitors and enemies."

The altar-piece by Duccio shows the Holy Mother on Her throne surrounded by a heavenly assembly of saints and angels, and on the reverse side are scenes from the life of Christ. The following words appear under this picture of the enthroned Virgin:

MATER. SANCTA. DEI. SIS. CAUSSA. SENIS. REQUIEI. SIS. DUCCIO. VITA. TE. QUIA. DEPINXIT. ITA.
(Holy Mother, Virgin Thou, Siena's stronghold then and now: By the painter Duccio stand, for this picture by his hand.)

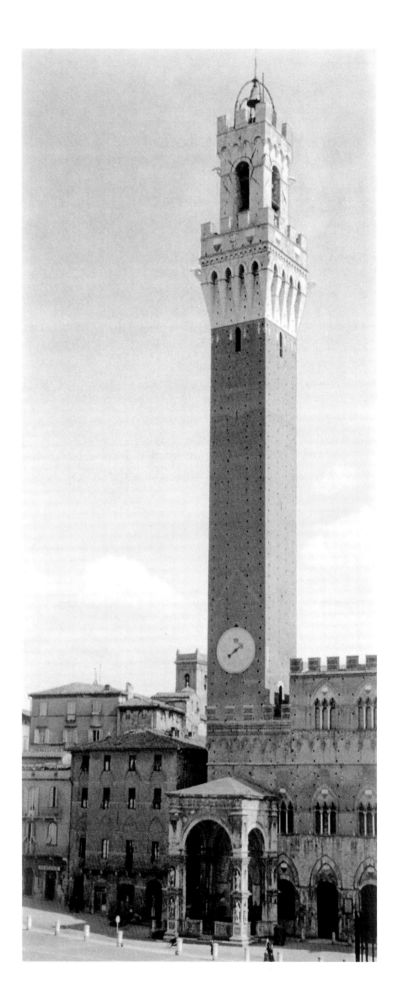

Tower of the Town Hall on the Campo,
known as 'Il Mangia' after a famous
local bell-ringer.

Duccio's art is founded on the 'maniera greca', the Byzantine icon-painting, from which it derives the hieratic composition, the fine linear treatment of the contours and the deep and intense colouring graded by means of translucent layers or washes of colour. Duccio's own idiom, however, appears in his placing of the figures within a definite and closed space and in the narrative character of the details. One might say that he translated the sublime language of Greek liturgy into the popular but still noble vernacular of Tuscany.

A spacious great wheel-shaped Cathedral window is also numbered among the works of Duccio di Buoninsegna's creative genius.

THE SOCIAL ORDERS The fact that town-government was no longer open to the nobility had disturbed the balance of social life in the city beyond all hope of readjustment. Although prosperity prevailed, in the living body of communal life disintegration had already set in.

What the four social orders or castes meant by way of maintaining a natural balance cannot be estimated in terms of the sociological criteria generally accepted today. The 'orders' originally arise out of a naturally established apportionment of human dispositions or talents which are everywhere to be found; therefore they have from the outset nothing to do with different levels of wealth, but they rest on different psychological 'types', whose proper distribution in the whole building up of society—according to the activities or offices which each is competent to exercise—contributes essentially to the stability of the whole. Heredity and education guarantee the perpetuation of a definite stock and definite skills within an enclosed layer of society; such divergences as may occur in the process of inheritance will, under such conditions, be much rarer than the instances of homogeneity.

The priesthood is the only calling which is not inherited, at least this is so in the Christian world. A man becomes a priest as a result of an inward 'call': herein lies a superiority arising from the freedom of conscious and personal choice, but it also contains a danger, since there is no method of testing the authenticity of the 'call'; renunciation of marriage and of monetary profit must in practice suffice as a touchstone.

The priesthood presupposes that human type for whom timeless truth is the very breath of life. The nobility, on the contrary, from among whom leaders are chosen, is founded on consciously purposeful character and on initiative: they are those to whom bold decisions and daring action come naturally. Only he who is ready to risk his life for his ideals can call himself a free and noble man: 'noblesse oblige'. The third social grouping, made up of the merchants, craftsmen, and independent peasants, is focussed upon the preservation and increase of property of every kind, both physical and intellectual: it consists of the practical men, in the widest sense of the word, not men of the militant-aristocratic type. The fourth caste is mostly made up of those who by nature tend to place all their thought in bodily well-being, and who only by giving service are able to find a place in the great structure of social life.

The above classification was as self-evident during the Middle Ages as the divisions of the material world into air, fire, water, and earth—a gradation not without some similarity to that of the social orders or castes.

The outline of social life during the Middle Ages would not be complete without a mention of the Monastic order. The monks belonged to no caste, as befitted those whose life was spent in unworldly matters: indeed this very fact constituted the 'open door' which offered an escape, for those who sought it, from the close interlockings of society.

It would be a mistake to imagine that the mediaeval caste-divisions produced a greater severance between man and man than the difference between rich and poor in later days: indeed, the contrary

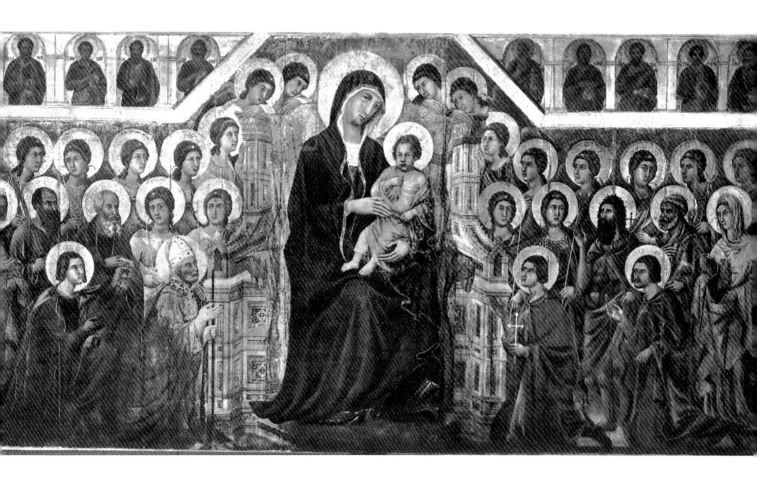

Duccio di Buoninsegna: Glorification of the Madonna *(Maestà)*. Painted for the High Altar in the Cathedral of Siena. 1311. *Cathedral Museum.*

Ugolino di Nerio: Mourning Madonna: part of the left arm of a large painted cross, of which only this fragment remains. Beginning of 14th century. *Picture Gallery, Siena.*

was the case. Society in the Middle Ages was built up on the patriarchal system whereby the higher and the lower orders were intimately bound together by the circumstances of daily life. The priest was the father of the faithful under his care and the high-born landowner looked upon his tenant-farmers as belonging in a sense to his own family, just as the rich merchant had many of his employees of lower caste living in his house. In this manner the different sections kept in touch with each other and a certain similarity of ideals was felt. The day of complete uprooting and segregation of the 'proletarian' had not yet come.

The Church strove to spiritualize special qualities in each section of the community by favouring the formation of Orders of Knighthood and by incorporating Guilds and Companies into liturgical life. This arose not so much out of a policy of retention of religious power as from a fundamental knowledge of man's manifold propensities for good and evil. Not only does each caste possess special abilities which can develop into virtues, but it also has its special weaknesses, and these will become dangerous once the status of the social orders is imperilled. Thus the outstanding tendency of the aristocracy is their combination of courage with generosity, of sword and love. A degenerate aristocracy, on the other hand, gives rise to immoderate pride coupled with a destructive passion which may start a veritable conflagration.

In the face of a declining nobility the third order, that of the merchants, craftsmen, and independent peasants, has the advantage that it instinctively seeks an adjustment, tending, like water, to smooth over difficulties and to find its own level. The virtue of the third order is a sense of moderation: its weakness is greed of gain. This gets the upper hand when the superior orders lose the sense of responsibility towards those who are subordinate. When, however, the middle class deteriorates it is not long before the fourth caste—whose chief virtue is a patience as of earth—rises up in rebellion against the whole traditional order.

Although the power of the nobles had been paralysed by their removal from political life in the city, the secret family feuds between them had not in any wise diminished. Indeed, they increased in violence to such an extent that on 17 April 1313 the two most influential families in Siena—the Salimbeni and the Tolomei—engaged each other in open battle. It became necessary for the Council of Nine to interfere: they stood a lighted candle in a window of the Town Hall and let it be known that if the two enemy-families did not lay aside their arms before the candle burnt out they would stand deprived of their freedom and their property. As a result, open hostilities between the two families ceased, but in secret the fires of hatred smouldered on. A contemporary chronicler reports as follows:

"The discord and hatred between the two families—the Salimbeni and the Tolomei—was a cause of great anxiety to the Nine Councillors, for a state of war still existed between them and they had not hesitated to attack each other within the precincts of the city. They therefore sought to cut off the two families from any friends living outside in the province, fearing that adherents might gradually gather together to help one side or the other. An order was therefore formulated forbidding the presence in the city of any stranger from the countryside under whatsoever pretext he might try to enter the gates: and whosoever disregarded this order should have his foot hacked off. Many there were who considered this order to be quite unjustifiable; there were others who had some good reason of their own for entering the city, while many were simply dare-devils. No one could really believe that so great a penalty would be exacted and they took it for granted that three days in the lock-up would suffice... But agents of the mayor searched the city and seized seven peasants from the surrounding country in one day. The following morning there stood before the mayor's palace the block

Muratori

and the axe, ready to cut off the foot of each delinquent. While this rough court of justice was being prepared the Campo gradually filled with a seething crowd of citizens protesting against the crippling of so many men for so small an offence. Hardly had the mayor brought out his seven prisoners than stones began to fly in all directions, thrown by the crowd and by the shopkeepers on the Campo. The blinding hail of stones wounded many of the mayor's attendants and covered the escape of six of the prisoners. The mayor, a man of ungovernable temper and now blind with fury against the populace, led his one remaining prisoner to the upper storey of his house, had the block and the axe brought to him, and there and then beheaded the peasant, throwing the body out of the window down upon the crowd as a warning. The head he hung by the hair from the upper window. Whereupon each man took up his weapon, and because of this one man, undeservedly executed, the State was within a hair's breadth of being overthrown. But so great was the wisdom and diplomacy of the Nine Councillors who had bound over the Salimbeni and the Tolomei to keep the peace, that they succeeded in reconciling the citizens with the mayor. By their order each man laid down his weapon and, for the time at least, peace was restored."

It was not only among the aristocracy that radical changes were discernible at this time, for among the middle classes manners were being moulded upon those of the nobility, so that, in a sense, the mental outlook of the aristocracy became pronouncedly characteristic of the Sienese and has left its mark on them even to the present day. Indeed, at this period of its history Siena became the crucible of the social orders.

SIMONE MARTINI Simone Martini, perhaps the greatest of all the Sienese painters, adopted a pronouncedly chivalrous and aristocratic style. In a mural painted by him in the great room in the Town Hall which he began in 1315, he shows the Holy Virgin with the Child sitting on Her throne under a wide tent-shaped canopy. She accepts the homage of Her attendant saints like a noble lady presiding at a 'cour d'amour'.

In his work Simone Martini indicates space only in so far as it does not interfere with the harmony of outline and colour. He lends to outline a restrained melodious flow and to colour the translucence of spring. The great picture of 'The Annunciation' in the Uffizi Gallery in Florence is also by his hand and in later years Martini was summoned to Avignon to decorate the Pope's palace.

Dedication inscribed on the cover of a municipal account-book (*biccherna*) of the year 1320.

34

Virgin and Child under a canopy, surrounded by saints and angels: centre section of mural by Simone Martini in the Town Hall, Siena; post-1315.

FOLGORE DA
SAN GIMIGNANO
Wealthy nobles, unable to occupy the position to which they were born and having no political responsibility nor any call to engage in a legitimate war, frequently gave themselves up to a life of ease and pleasure—when they had enough money—as described in the following lines by the poet Folgore da San Gimignano. Folgore, who lived at the turn of the century, occasionally took his turn to stand guard on the walls of Siena. Like so many of the dispossessed knights or swordsmen, he sought to retrieve his fallen fortunes in the service of the great lords. He was one of the few Sienese poets whose verses have survived through all the centuries, in spite of the overshadowing fame of their great Florentine rival, Dante. We give a translation of one of his poems:—

Tozzi
"A wide valley in August I would wish me
Where thirty castles stand 'twixt grass-clad hills,
From sea-winds sheltered, there to pass the days
In peace and health like to the brightening stars.

And gaily saddled horses I would have
To ride upon at morn and eventide.
But let not distance separate each home:
A paltry mile the day's ride be between,

For every bridle-path should homeward lead.
With waters wide the valley should be spanned
Whose mirror sinks not, flowing swiftly on.

In dappled shade I'd pass the noontide hour
In merry mood, and with full purse agape
Let tasty Tuscan dishes loose the tongue.

In winter I would seek a lowland town
With ground-floor eating-halls and crackling fires,
Where walls are tapestried, where gaming plies,
And there by yellow torch-light throw the dice.

Let host be drunk with greed, it matters not,
If studied artistry prepare the pork
That all may feast upon the savoury fare,
And casks stand high as San Galgano's dome.

The finest tailoring should be my wear,
Warm-garmented with long well-padded coats
And over-long the ample cape and hood.

Thus only can one spurn the niggardly,
Wretched, unwanted, alien, unfriended miser;
Have naught in common with such men as these!"

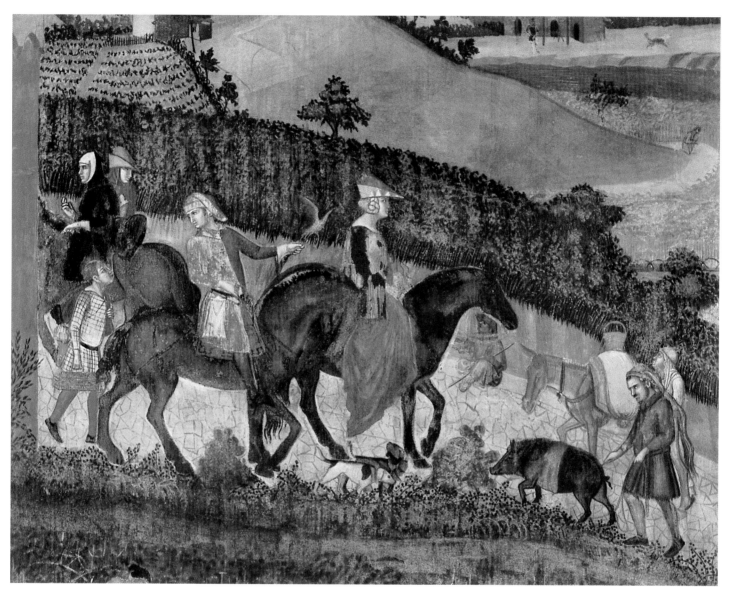

Detail from Ambrogio Lorenzetti's great mural painting in the Town Hall in Siena: a hunting party rides out of the city gates; peasants come in to market; a beggar sits at the roadside. Post-1337.

In the year 1316 the Magistracy of the City of Siena decided to expand to almost double its existing THE CATHEDRAL: size the hundred-year-old Cathedral, built in the Romanesque style. Neither the facade nor the dome FIRST was to be touched but approval was given to the daring plan of lengthening the chancel over the ENLARGEMENT steep slope down towards the 'Vallepiatta' by adding several more arches supported upon a church on a lower level, the Baptistery of San Giovanni, built into the slope and serving as a base for the new part of the Cathedral. The intersection of the nave and the transepts, with its dome, thus fell almost exactly in the centre of the total nave-length. At the same time it was planned to prolong the transepts.

In 1321, when the new part was already higher than the floor of the old building, it was discovered that, following a subsidence in the foundation walls, the joins between the old and the new building

had begun to gape. The Director of the Cathedral Guild of Masons (known as the *operaio*), who on behalf of the government administrated the income and expenditure for the building and was responsible for the employment of the several different contractors (known as the *maestri*), therefore invited a number of independent consulting architects, some of them Florentines, to give expert advice. The following report, as presented on 17 February 1321, contains a most interesting summary of their consultations, for it throws much light upon contemporary conceptions of church architecture:—

Milanesi

"In the Name of the Lord our God, Amen. We, Lorenzo, son of the Master Mason Maitano, and Niccola Nuti of Siena, Cino son of Francesco, Tone son of Giovanni and Vanni son of Cione of Florence, being consulting masons have been called in consultation by the Director of the Guild of Masons of the Cathedral of the Holy Virgin Mary in Siena. As experts in our profession and with the knowledge and permission of the Council of Nine who direct the City of Siena, we have been requested to give an opinion on the present condition of the new building and on the future plans for the enlarging of the old Cathedral over the lower level. We have carefully tested every part and conscientiously examined the dimensions of the present edifice and have discussed what, in our opinion, can be done with it: wherefore, after debating the matter among ourselves and after calling upon the Name of Christ and taking the oath of our profession, we offer the following advice:

"First, it is our opinion and our conviction that the foundation walls of the new building, destined to expand the said Cathedral, are insufficient, for at certain places they have already begun to subside.

"Likewise we consider that the pillars of the said new building are not adequate in strength, not being massive enough to support such a great weight nor susceptible of being carried to the height which has been planned and which the new building demands. For the pillars of the front façade of the above-mentioned church, opposite the Hospice of Santa Maria della Scala, are themselves more massive and better built than any in the new building; in the new building the pillars should be even more massive, stronger, and better built than those in the old building.

Left: Conjectural ground-plan of the old Cathedral before the year 1316. Right: Ground-plan of enlarged Cathedral as it stands today. From Vittorio Lusini.

"Likewise it is clear to us that the new foundation-walls do not exactly coincide with the old walls so that in the join between the old and the new masonry patchwork will be evident, the old foundations having already sunk, whereas the new walls have still to suffer the usual amount of subsidence.

"Accordingly we deem it right to advise the discontinuance of the new building plan as it stands at present: the partial demolition of the old building and its union with the new cannot be carried out without endangering the dome and the existing arches of the aisles.

"Likewise we consider the new building should be discontinued because the dome of said Cathedral would no longer indicate the real centre of the cross where it naturally belongs.

"Likewise we advise the discontinuance of the new building because the old church as it stands is well proportioned: breadth, length, and height correspond harmoniously. Consequently, should need arise to make additions in any direction, it were far better to demolish the old church entirely and to rebuild it and enlarge it in accordance with accepted standards for church architecture.

"Our advice is that a new church should be begun, to the glory of God and His most blessed Mother, the Virgin Mary, who was and is and ever shall be the Patroness of the City of Siena. The new church should be vast and most beautiful, with over-all measurements of length, height, and breadth in the perfect harmony of proportion which a fine church demands. It should be finished with the artistic decoration befitting such a famous Cathedral wherein our Lord Jesus Christ and His most blessed Mother and their celestial assembly will be praised and worshipped, thereby guarding and protecting the City of Siena from disaster..."

The advice of the five consulting architects was not followed: possibly because the existing Cathedral inspired too much respect for it to be replaced by a new building, or perhaps because the space available was insufficient. Be that as it may, the plans for enlargement were carried out and ensuing technical difficulties cleverly concealed. Those perfect proportions, which were of paramount importance to the consultants, could not be achieved. It is a fact that the cupola, rising as it does today from a nave that has been raised on both sides, sits too low: also the Cross formed by the intersection of nave and transepts has, as a result of the nave-like extension of the choir, lost much of its unity as also its symbolic shape.

In Siena, in spite of the great communal tasks which were being carried out, the tension between the hostile parties did not abate. The city was divided into different groups or parties, each of which adhered to one or the other of the noble families, and very little was needed to stir up bitterness. A chronicle of the year 1325 gives us the following picture:

"On the Sunday before Shrove Tuesday, 13 February, a boxing match took place in Siena. On the one side were those from the San Martino ward together with the men of Camollia; on the other side were those from the City ward, from each of the three sections six hundred men. So the Campo was crowded with men in jerkins, their heads wrapped round with a strip of cloth, their eyes and cheeks protected by blinkers, and with padded fists, as is customary. In the course of the game it so happened that the team of the wards aforementioned pressed the men of the City ward back off the Campo. At once stones began to fly and some there were who started to use sticks, till gradually the masses were fighting in earnest. From apparently nowhere, banners and shields appeared, helmets were donned and lances, swords, and even javelins were used, the noise increasing to such a roar that it seemed the world was turned topsy-turvy, so great was the crowd of struggling men. Troops of armed soldiery were ordered to the scene accompanied by the mayor and his attendants. The Nine Councillors sent a herald to proclaim order: the noise however was so great that his voice was not heard and the fighting continued. The Captain of the troops and the Mayor himself threw themselves

39

between the opposing sides in a vain attempt to persuade one or the other party to desist, but with no result. Many of the soldiers' horses were killed and even a few of the soldiers themselves. Meanwhile more and more fighters, fully armed with cross-bows, axes, and knives, entered the Campo, so that the battle assumed still greater proportions: neither the Councillors nor any other authority seemed able to stop the destruction which was going on. At last the Bishop ordered the priests and the brotherhoods of monks to accompany him to the Campo. They appeared carrying the Crucifix before them and paced slowly in and out among the combatants: whereupon a slight cessation of the struggle was felt. Finally, succumbing to the persuasion of the bishop, priests, and monks, the crowd gradually dispersed till all fighting ceased…"

'IL BUON GOVERNO'

The continued disaffection among the citizens forced the governing body of rich merchants to take increasingly severe measures. To show the city the benefits of a just and peace-loving government and perhaps to justify their strict decrees, the Council in 1337 ordered two murals for a room in the Town Hall to be painted by the artist Ambrogio Lorenzetti, portraying 'good government' *(il buon governo)* and 'bad government' *(il cattivo governo)*, with scenes setting forth their contrasting effects on public life. The Council's intention, in accordance with the attitude of the mercantile government, can be summed up in the words: It is not warlike fame, but peace, that makes a city's strength and wealth.

A hundred years later, the holy St. Bernardino of Siena preached to the still divided citizens exhorting them to reconciliation and referred to the two murals by Lorenzetti in the following words:—

Pacetti

"…While I was preaching outside Siena on War and Peace those pictures came to my mind, which were painted for you, and which offer indeed a wonderful lesson. When I turn towards the picture of Peace I see merchants buying and selling, I see dancing, the houses being repaired, the workers busy in the vineyards or sowing the fields, whilst on horseback others ride down to swim in the rivers; maidens I see going to a wedding, and great flocks of sheep and many another peaceful sight. Besides which I see a man hanging from the gallows, hung there in the cause of justice. And for the sake of all these things men live in peace and harmony with one another.

"But if I turn my eyes to the other picture I see no commerce, no dancing, only man destroying man: the houses are not repaired but demolished and gutted by fire; no fields are ploughed, no harvest sown, no riders go down to bathe in the river, nor is the fullness of life in any wise enjoyed. Beyond the gates I see no women, no men, only the slain and the raped; no flocks are there except those which have been plundered; man kills man in mutual betrayal; Justice lies in the dust, her hands and feet fettered and her balance broken apart. And wherever man goes, he goes in fear and trembling…"

AMBROGIO LORENZETTI

The work of Lorenzetti is unmistakably reminiscent of the Roman classical school: without imitating it literally it is vigorous and gaily narrative, contrasting with the knightly elegance of Simone Martini's style. At the same time Lorenzetti makes constant use of allegorical representation which is eminently adapted to portray ethical truth, virtue, and vice. Allegorical representation goes with moral reflection, while symbolism—which predominates in art in the twelfth and thirteenth centuries—corresponds to contemplation. Metaphysical truth may be imparted not only by the figures in Bible history, which, in addition to their historical importance, involve a timeless significance, but also by such simple symbols as the sun, the eagle, the dove, or the rose. Directly and intuitively we understand their speech without the circuitousness of thought which the allegorical style of art imposes. Allegorical art makes an appeal that is far more thought-bound and indirect than the symbolic art which was the prevailing style in the Middle Ages. Moral precepts, however, cannot easily be represented otherwise than by allegorical figures carrying out certain prescribed actions or bearing

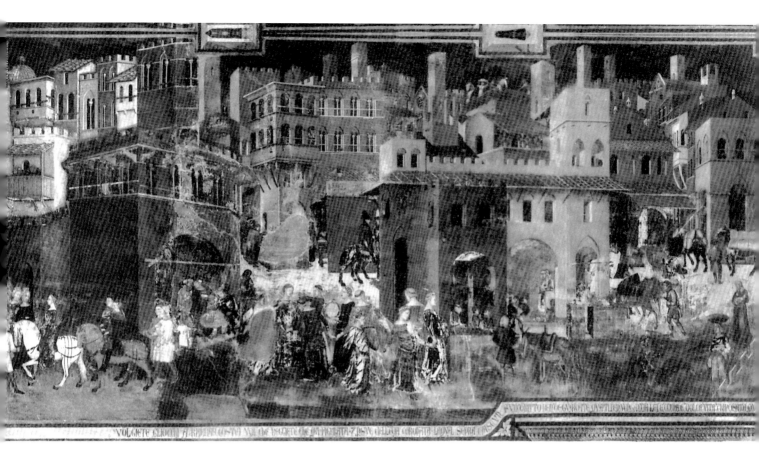

Above: Part of mural by Ambrogio Lorenzetti in the Town Hall of Siena, portraying Siena in time of peace.
Below: Continuation of the above, showing the countryside beyond the gates of the city.

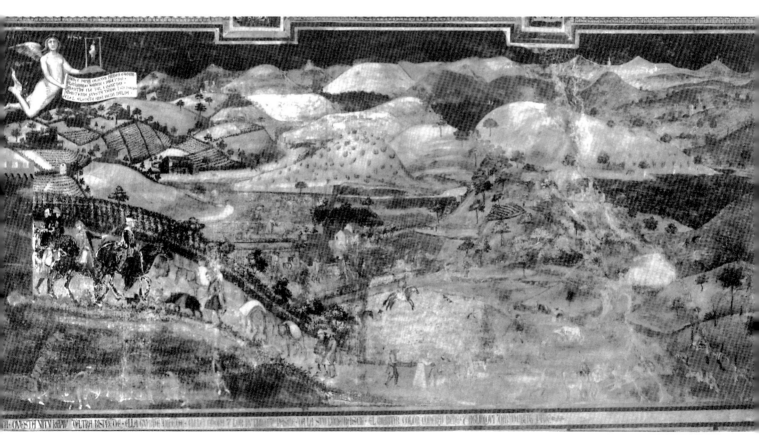

Above: Part of mural by Ambrogio Lorenzetti in the Town Hall: an allegory of 'good government'.
Below: Another part of the above mural: an allegorical representation of 'bad government'. Only fragments of this portion are still discernible.

certain attributes. This type of art corresponds to the needs of the third social order, whose primary ideal in life should be the ethical laws regulating trade and traffic and likewise, on the plane of the soul, profit and loss, merit and demerit. For the noble order the measure of action is honour and its inward value; for the third order it is the fruit of the action that counts.

On her throne Justice balances with both hands the scales held by a winged figure of Wisdom above her. Over the head of Wisdom are seen the words: 'Diligite justitiam qui judicatis terram'. From the left scale bearing the word commutativa (exchanging justice) leans a winged spirit handing to one kneeling figure a sword and spear, and to another money. From the right scale with the word distributiva (meted-out justice) another figure leans to behead one kneeling man before her, while to the other she hands a crown. Two ribbons hang down, one from each scale, to be gathered together in the hands of a woman sitting below the throne of Justice and holding on her knees a plane with the inscription concordia: she passes the ribbons on into the keeping of twenty-four citizens walking two by two towards an old grey-bearded man bearing the sceptre and city coat-of-arms. He is the embodiment of the city authority: he rests his feet upon the back of the she-wolf with Romulus and Remus. Above his head appear three half-length figures: Faith, Hope, and Charity. To right and left sit three female figures: Peace (pax), Fortitude (fortitudo), and Prudence (prudentia); and Magnanimity (magnanimitas), Temperance (temperantia), and Justice (justitia). Particularly noticeable is the figure of Peace: a female figure leaning back on her couch, wearing a wreath of laurel and clad in a classically flowing garment. Soldiers on horseback, leading prisoners, emerge from below the feet of the old man who personifies the city authority.

A horned male figure sitting on a throne and with one foot resting on the back of a black ram portrays Tyranny. On either side of him sit three figures each of which bears its name: Cruelty (crudelitas), Betrayal (proditio), Fraud (fraus); and Fury (furor), Discord (discordia), and Treachery (perfidia). Above the head of Tyranny are the winged forms of Avarice (avaritia), Pride (superbia), and Vanity (vanagloria). Before their feet lies Justice, her hands and feet bound with thongs, being tortured by the executioner's attendants.

The following report by Agnolo di Tura il Grasso gives us a clear idea of the wealth of Siena at this point in her history:

"In 1337, Benuccio di Giovanni Salimbeni held the post of chamberlain (camerlengo) in the family of Salimbeni. His duty it was to see to the paying of taxes and to act as banker for this noble family, distributing among its many branches both income and silver and copper articles. In the course of a few years the monies he administered for the heads of the sixteen Salimbeni families amounted to 100,000 gold florins. In 1338, the above-named Benuccio had received a large sum in silver and copper when, as was customary, the great Syrian merchant arrived at Porto d'Ercole to barter his goods, which consisted largely of silks; they were purchased by Benuccio in exchange for silver, copper, or hides, or with currency.

He bought silken shawls, some ornamented with gold-leaf and all with gold-foil and with pomegranates or moons and stars radiating golden rays, to the amount of 50,000 fl.; velvet in all colours, some striped, some plain, for 25,000 fl.; girdles of silk and gold in the Syrian style, for 15,000 fl.; bridal purses made of gold and silver, with square hinged frames, for 10,000 fl.; similar purses, half the size of the above, with two-sided frame, in the same materials, for 5,000 fl.; head-bands, cordgirdles and sewing-silk for 15,000 fl.; yellow-dyed ribbon, trimmings, wedding flowers for the bride and small-sized albs, for 10,000 fl.

All these things were laid out to view in the houses of the Salimbeni family and the inhabitants of Siena were allowed to inspect them, for such beautiful wares presented a sight of great novelty."

In August 1339, proud of the city's wealth, the 'Council of the Bell' decided to begin building a new Cathedral which should surpass in magnificence and in size the churches of any other Tuscan town. The existing Cathedral with its lengthened chancel was not to be demolished: it should remain standing and serve as the transept of the new church, bringing the immense nave practically due north and south. In the Cathedral Museum two plans have been preserved showing two variations of the proposed alteration (see below). They are probably both by the architect and goldsmith Lando di Pietro, who was at that time called to Siena as Master of the Guild of Masons. The chief difficulty confronting the architects lay in adapting the new nave, designed in the formal Gothic style customary in cathedral architecture at that period, to coincide with the existing pillars of transept and aisles. The new nave with its high vaulting would have to cut through the old nave, which would involve the reconstruction of the cupola.

The planned new orientation of the Cathedral would mean that a facade (the framework of which rises to this day above the Campo) would have brought the entire edifice into direct relationship to the Campo, as the new centre of the life of the city. Probably the intention was to pull down a few houses between the façade and the Campo to make room for an entrance to the Cathedral by means of a flight of steps.

Meanwhile, without demolishing any part of the old Cathedral, the elongation of the nave in the slender Gothic form was taken in hand.

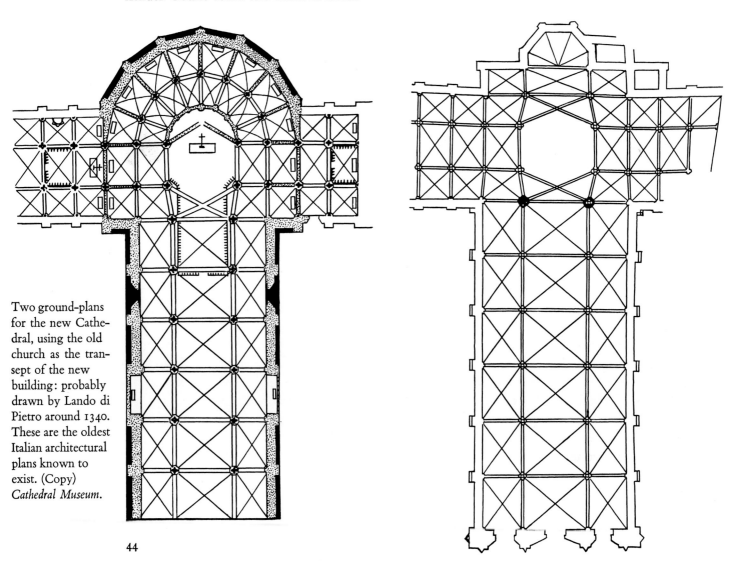

Two ground-plans for the new Cathedral, using the old church as the transept of the new building: probably drawn by Lando di Pietro around 1340. These are the oldest Italian architectural plans known to exist. (Copy) *Cathedral Museum.*

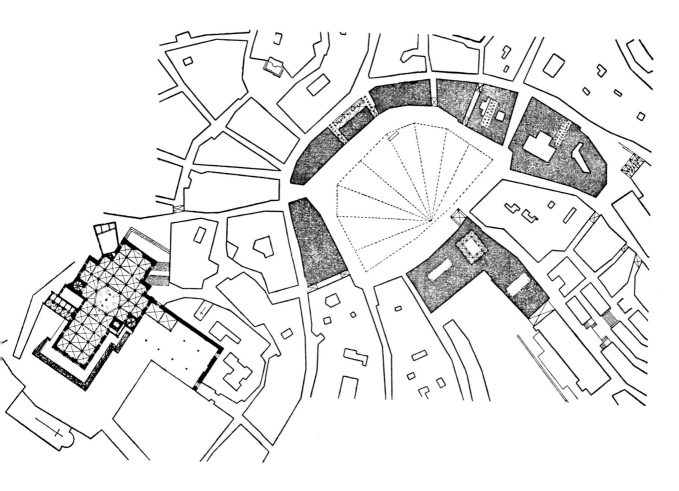

Plan showing position of Cathedral with the unfinished new nave in relation to the Campo and the Town Hall. After Wolfgang Braunfels.

Following a period of great scarcity the plague broke out in the city, in the year 1348. Agnolo di Tura il Grasso writes of the 'Black Death' in Siena in the following words:

"It was in May that the first deaths occurred in Siena. It was all so dreadful, so cruel, that I hardly know where to begin to describe the terror that reigned: one felt that the very sight of so much suffering would drive one crazy. There are no words to relate these horrors, and he is fortunate who has never faced such ghastliness. People died almost as they stood: a swelling under the arm and one in the groin, and still speaking the victim fell down dead. Father fled from son, wife from husband, and brother forsook brother; each deserted the other, leaving him to his fate, for their diseased breath was sufficient to spread the infection. Indeed, it almost seemed that the very sight of the sick was infectious. Loneliness encompassed the dying, for there was nobody who would bury the dead either for money or for old friendship's sake. If they could do so, blood-relations would carry their own dead to the grave without priest, without ceremony, without funeral-bell. In many parts of the city great collective graves were dug, for men were dying day and night in their hundreds. Into such a pit the corpses were thrown until it was full, when it would be shovelled level while another pit was dug.

"I, Agnolo di Tura, named 'il Grasso' [the fat man], buried all my five sons with my own hand. They were among those who were left too near the surface, so that dogs came and scratched them up,

devouring the bodies on the open streets. No man there was who wept for his dead, for each awaited his own last hour. Death claimed so many that men thought that the end of the world was at hand. Neither medicine nor any other remedy availed, indeed it seemed as if the more one combatted the disease the sooner death stepped in. Three citizens were chosen by the governors of the town, to whom one thousand golden florins were given to aid the dying and for the burial of the dead. Even to look back on the horror of it all makes me, the writer of this report, feel faint: I must therefore refrain from relating any more details. The epidemic lasted until the end of September and it would take too long to tell the story...

"Later, the number of deaths in Siena of people under twenty years of age was estimated at 36,000. This number, together with the many aged people and others of various ages, totalled 52,000. Besides these, the deaths of [grown-up] people in Siena and the suburbs amounted to 28,000, bringing up the total in the city and surrounding villages to 80,000. The population of Siena and its suburbs at that time numbered 30,000 men, of whom now less than 10,000 remained alive, and those who did survive were beside themselves with despair. Buildings and many other things were neglected, for example the silver, gold, and copper mines in the Sienese district were abandoned: for in the country many more deaths occurred, so that whole districts and villages were bereft of their inhabitants. I will not describe the horror of those days in the country, where wolves and wild animals devoured the bodies lying in shallow graves, and where worse horrors were endured, for this would prove too painful for the reader.

"The town of Siena appeared to be deserted: one met almost nobody in the city. But gradually, when all danger seemed to be past, those who had survived the plague craved now for distraction: monks, priests, nuns, and laymen, men and women, gave themselves up to the pursuit of pleasure. Money had no value, either that which was spent or which was lost in gaming, nothing was grudged. Those who had been spared and to whom life beckoned considered it riches enough, yet no one could sit and enjoy life quietly..."

DANGER
THREATENS
THE CATHEDRAL

For the duration of the famine and the plague, work on enlarging the Cathedral was at a standstill. On resuming the task it was found that joins in the masonry gaped and pillars were off-centre. To continue the building not only seemed dangerous but also the expense was now beyond the reduced state of the city coffers. In 1356 the Director of the Guild of Masons obtained an expert opinion from the Master Mason Benci di Cione in which he declared the already finished parts of the new building to be not only in a weakened state but also defective in construction:

Milanesi

"... First be it said that the four pillars cannot be repaired in any other way than by taking them apart: before this can be done the vault, the arches and the walls supported by these pillars must be taken down, as said pillars are placed exactly opposite each other. My reason for the above opinion is that I found the vaults and the walls subsiding, which points to the pillars being too weak to support the weight from above... My advice is that the above-mentioned four pillars, the vaulting, and the walls—all of which are imperfectly supported—should be taken down and reconstructed..."

Acting on the advice of the above report the new Master of the Cathedral Guild proposed to abandon altogether the enlargement of the Cathedral:

"In the Name of the Lord and of His Blessed Mother, our beloved Lady. We, the Master Mason Domenico son of Agostino and the Master Mason Niccolò son of Ceccho del Mercia herewith address ourselves to the Director and Consultant of the Guild of the Holy Mother of God in Siena, after consultation and due reflection on the whole subject pertaining to the building of the new church, and we submit the following items. Let us first consider all that must be demolished in the existing church, i.e. the tower, the cupola, the vaulting, as well as the vaulting in San Giovanni, together

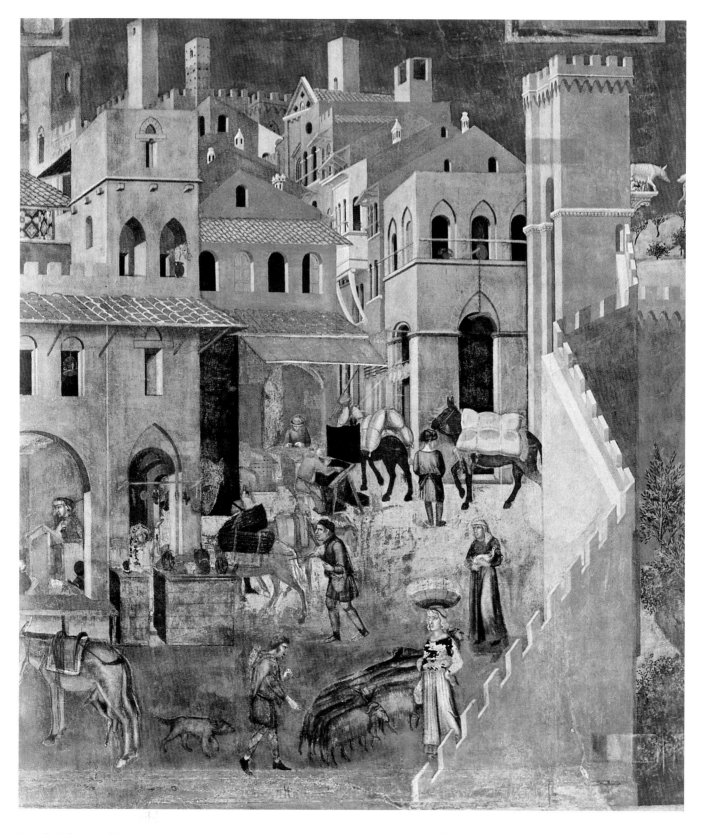

Detail of the mural by Ambrogio Lorenzetti. A street of shops in the town. On the right, one of the city gates bearing the emblem of the Roman she-wolf.

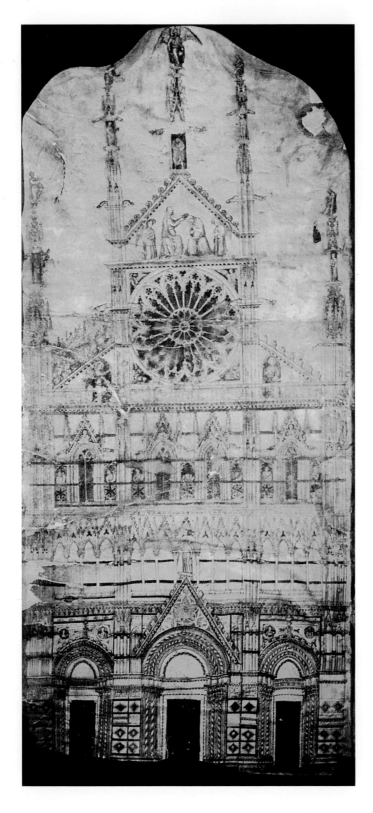

Design for the façade for the Baptistery of San Giovanni, by Mino del Pelicciaio. Cathedral Museum. Only the lower half of this façade was carried out (c. 1381).

48

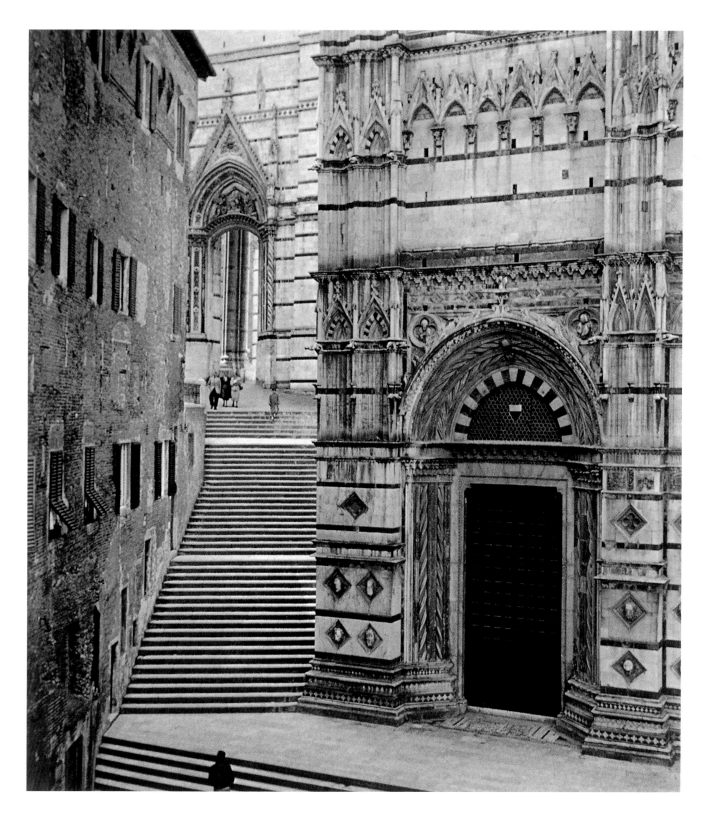

Right: part of the façade of the Baptistery of San Giovanni, underneath the Cathedral choir. To the left, the steps leading up to the side entrance of the unfinished new nave of the Cathedral.

Sketches showing (above) the façade of Orvieto Cathedral and (below) that of Siena Cathedral.

with all that is planned to be reconstructed again elsewhere, to wit the pulpit, the Cardinal's tomb, the Bishop's palace, and the entire dwelling-house of the Hospice of St. Agnes. To accomplish the above plans, if they are all to be carriet out, will cost the city over one hundred and fifty thousand gold florins. May we also point out that should the new church be built according to such plan and in the dimensions conformable with the part already in progress, a hundred years would not suffice to finish it. For this reason, and taking everything into consideration, it seems wiser to let the old building remain where it stands and the extension already in progress be continued over the church of San Giovanni on the lower level. This work could be brought to completion, endued with all the ornamentation the aforesaid church requires, within five years' time, when, in our estimation, the people of Siena will be in possession of their new church and divine service will be taking place.

"We suggest that the parts of the new church already in progress be completed as a separate edifice, to the glory of Our Lord and His Holy Mother, the Virgin Mary, and of blessed John the Baptist. It should have eight arches and a cupola in the centre rising considerably higher and embellished like a tabernacle, as befits such a church. Its dimensions should measure 56 by 60 *braccia*, with a tribune at one end, in the centre of which a font for Holy Baptism should be placed..."

The proposal of the Master Mason Domenico d'Agostino to erect a baptistery in place of the half-finished nave was not accepted. The new part of the building has remained unfinished. Instead, the chancel of the original Cathedral was extended over San Giovanni and completed. In the year 1358 the extension of the vaulting was also finished and the great chancel window by Duccio di Buoninsegna moved from the old part of the building to its present position. The old main aisle was raised in 1369 to correspond with the extension of the choir. But it was not until 1377 that the façade begun by Giovanni Pisano was completed, when its original early Gothic style suffered modern complications somewhat to its artistic detriment.

In the style of its architecture the façade of the Cathedral at Orvieto, built early in the fourteenth century by the Sienese architect Lorenzo Maitani, had considerable influence on the second phase which the façade of Siena now underwent. On comparing the two façades of Orvieto and Siena one immediately realizes that in the style of the latter the eye remains somewhat unsatisfied. There is a certain discrepancy between the perpendicular form of the lower part and the horizontal of the upper half of the building.

SACRED ART The first Guild-book of the Sienese painters, of the year 1355, opens thus:

"From now, henceforth, and for evermore be this our Guild founded in the Name of God Almighty and of His Mother the Holy Virgin Mary, Amen. We are, by God's grace, the portrayers, for those untutored souls who cannot read, of marvels which have come to pass by virtue of steadfast faith. Our

Milanesi own belief is firmly fixed on God the Three in One, to whom belongs infinite power, infinite wisdom, infinite love and never-failing mercy. Nothing, however humble it be, can begin or end without these three things, namely without power, without knowledge or without love, therefore only in God is to be found perfection. To inspire us in our humble profession and in order that we may produce, in all we undertake, work that is well begun and well ended, we hereby entreat the help and blessing of God and begin this, our Guild-Book, to the honour and glory of the Holy Trinity. Wherefore, as spiritual things are the more precious and have precedence over worldly things, we will begin by proclaiming the manner in which is to be celebrated the Feast of our venerable and laudable Apostle and preceptor, St. Luke. Not only did he picture the form and presence of the blessed Virgin Mary, but he also described Her virtuous life and Her blameless conduct, honouring thereby our profession as artists..."

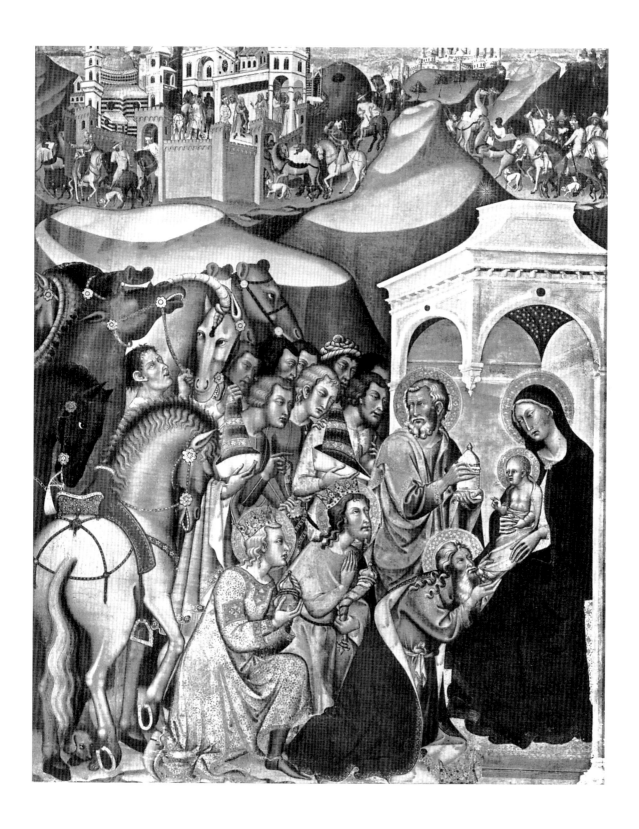

Bartolo di Fredi: Adoration of the Magi, 1370/1380. *Picture Gallery, Siena*. At the left, above, is a town with a black and white cathedral reminiscent of that in Siena.

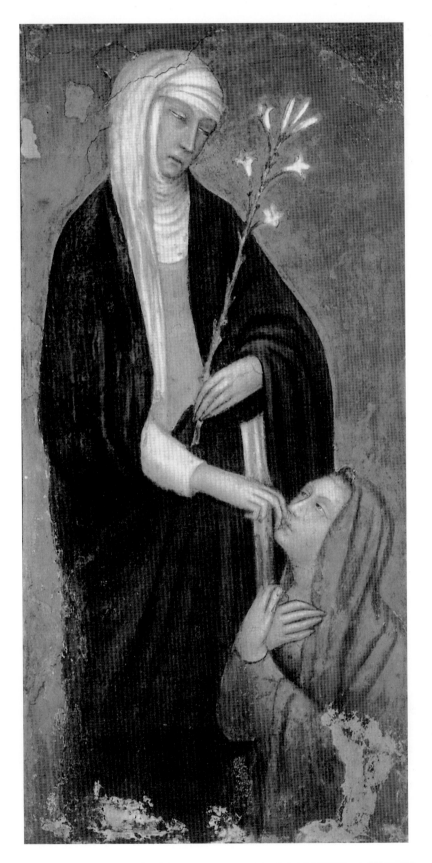

St. Catherine, after a picture by one of her disciples, Andrea Vanni, in the 'Vault Chapel' of the Church of San Domenico in Siena. In 1369 Andrea Vanni was director of the Cathedral Guild of Masons and in 1379 he became captain of the citizen-army of Siena.

THE CITY OF THE SOUL

In the words of St. Catherine of Siena, the city is the image of the soul, the surrounding walls being the frontier between the outward and the inward life. The gates are the faculties or senses connecting the life of the soul with the outer world. The intellect, according to the saint, questions each one who approaches the gates whether he be friend or foe, thus watching over the security of the city. Living springs of water rise within it; gardens lie protected by its walls, and in the centre, where beats the heart, stands the Holy Sanctuary.

The symbolic construction of Siena carries out this simile: it can indeed be likened to the image of man's soul. For like the soul it stands transfigured in the light of heaven when in the early morning, coming up from one of the terraced gardens, one watches the first golden shafts of light strike the city towering aloft, with only the happy cries of darting swallows breaking the stillness; or again, at sunset, looking down on to the town from San Domenico, when houses and towers are steeped in the glowing red of the sinking sun and the Cathedral, as if built of pearl and jasper, seems suspended in the air, translucent in the last rays of day. Then indeed one sees Siena as that which her founders dreamed of— a holy city.

In the construction of Siena there are two distinctly recognizable phases or stages of development: the first one is limited to the ancient town, gathered close around the Cathedral which towers above like the Citadel of Sion or the Temple above Jerusalem; the second is indicated by the situation of the monasteries and their respective churches. These are built at the far end of the foothills of the city: to the east San Francesco, to the west San Domenico, and to the south and south-east Sant'Ago- stino and Santa Maria dei Servi. The presence of these monastic churches on the outer limits of the town but still within the City Wall tells of a time when the ascetic life of the monasteries, formerly completely withdrawn from the worldly life of the city, had begun actively to influence the lives of the citizens themselves. Until the beginning of the thirteenth century monastic life was devoted entirely to meditation and contemplation and monasteries were founded and built in the wilds *(desertum)*. But in the thirteenth and fourteenth centuries the city itself was invaded by friars of the begging and preaching orders, who brought about a renewal of religious fervour, their ideal of active love appealing to the inmost heart of the people. In Siena, the monastery churches are all influenced in their architecture by the ascetic sobriety of the Cistercians, the only church to be rebuilt at a later date being that of Sant'Agostino, which was altered during the seventeenth century.

That the inhabitants of Siena during the Middle Ages were deeply rooted in religious faith is clearly seen in the events which preceded the battle of Montaperto, when the people called down the assistance of heaven by prayer and penance, and also in their consecration of the city to the Holy Virgin.

The Brotherhoods of the preaching and charitable monks began to intervene in worldly matters just when the theocratic unanimity of the citizens of Siena was weakening. Henceforth they built their monasteries within the confines of the town, with the aim of rebuilding the 'City of the Soul'.

Worldly events in the second half of the fourteenth century, however, had almost paralysed the influence of the monasteries, when—as though to compensate for the threatened disintegration—all the spirituality which had enriched and beautified the life of the town was suddenly reawakened and incorporated in the single figure of St. Catherine. Through her deeds and words all the pious lore of the city, which hitherto had appeared like a divine mystery-play, experienced by the people at

large in a childlike and unconscious way, now suddenly was lifted out of the realm of the purely pictorial and customary, in order to receive thus its deepest meaning.

THE BLESSED
ST. CATHERINE

Caterina Benincasa, the daughter of a simple master-dyer, had neither wealth, position nor power, yet through the magnetism of her personality she influenced the lives of individuals and whole communities far beyond the confines of her native city, and even eventually induced the Pope, against the will of most of his cardinals, to forsake Avignon and return to Rome. In her character, she combined in a spiritual way all the qualities of the Sienese: their political outlook found its spiritual expression in her conception of the unity of all Christendom; their chivalry found its echo in the love which she radiated and reciprocated; the robust, full-toned speech of Tuscany—which to this day endows the women of Siena with beauty as a dance enobles the body—became supernatural music on her lips. If Siena has produced a counterpart to the great poet of Florence it is to be found in the writings of St. Catherine.

The genius of a St. Catherine is however not to be explained by the laws of heredity; such greatness transcends all that can be inherited from ancestors or nourished by environment or intention. The key to this greatness of soul lies in the words which Catherine, in a state of religious ecstasy, heard from the very mouth of Christ: "I am He who is and thou art she who is not". The 'thou' has no 'being' of its own when separated from its divine derivation; it expresses that frail web of changing impressions and desires which man is wont to call his 'ego'. Its chief characteristic is self-

THE
INNER LIGHT

love which Catherine compares to a cloud veiling the Divine Light in our hearts. Considered from the level of our human nature this light is our ability to distinguish between right and wrong, good and evil; on the higher plane it is the power given to us by God's Grace to perceive the Godhead. It is "the Light that lighteth every man that cometh into the world" (John I.9). In Him alone each soul finds its own abiding reality.

In her writings St. Catherine returns again and again to this fundamental truth. Among many such letters may be cited the following, written to one of her disciples, Ristoro Canigiani, of Florence:—

Epistolario

"We have been endowed by God with a natural, inborn light enabling us to distinguish between good and evil, perfection and imperfection, purity and impurity, light and darkness, and between the infinite and the finite. Is is the one selective power which God has placed in our hearts and experience shows us repeatedly that we do possess this ability. You will say: 'If this power of discrimination is ours, how comes it that we so often cling to that which is harmful?' To which I would reply: 'That comes from self-love veiling the divine Light, just as the light of the sun is veiled by a cloud'. Therefore our mistakes come not from lack of light but from the cloud which darkens it. And so it happens that we blindly choose that which harms instead of that which benefits the soul. By her very nature the soul inclines towards the good and perfect thing; but error comes from the fact that self-love, depriving the soul of light, causes her to seek for good where it is not to be found. Therefore these deluded people set their heart and their love on the things of this world, things as transient as the wind. Oh Man! beyond all foolishness the most foolish! Who but thou would seek the good where the greatest evil lies and the light where only darkness crouches? There, where death is, thou seekest life; where poverty reigns thou seekest riches and lookest for infinitude among the finite things of this world. Good will elude the seeker so long as he seeks it where it cannot be found. To find Good we must turn to God Himself, to Him who is everlasting perfection; and seeking it there, we shall assuredly find it, for in our God is no shadow of evil, only incomparable goodness. Just as the sun, the giver of light, could never give us darkness, so God cannot give us other than that which is in His perfect Self. Then we shall recognize—if we see by the aid of the divine Light—that all God sends us and all He permits life to bring us of trouble, pain or fear, is intended to lead us

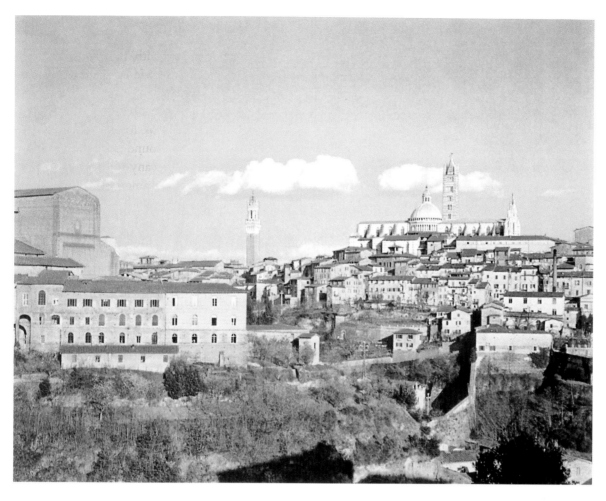

View of the City at evening. To the right the Cathedral; left, Monastery Church of San Domenico; centre, the Tower of the Town Hall with in the foreground part of the City Wall.

upward and to teach us not to look for good in this world but in the Lord God Himself. Perfection is not in this world, neither in riches nor in any other condition which earthly life can offer us: for on the earth bitterness and sorrow reign. If, without the recognition of God's hand leading us, man may yet seemingly possess the whole world, his soul suffers and grace is withheld. Therefore He vouchsafes to us that which is good and perfect, namely the grace truly to seek Him, while man, blinded by his own imperfection, thinks that to be bad which is for his good. His own wrong-doing robs him of God and of God's grace, the which he fails to recognize as an evil, and so he continues in his delusion.

"We should therefore strengthen the natural light of perception which has been given us by avoiding evil and practising virtue, seeking by this same light perfection where alone it can be found. And truly seeking we shall find it in God. Only then shall we begin to comprehend the unspeakable love that God has bestowed upon us in the gift of His Son, and the ineffable devotion of His Son who shed His blood for us.

"By consciously tending this inborn, though imperfect light, we shall attain with God's grace to the perfect supernatural Light which leads us in the paths of truth and gives us steadfastness at all

times and in every condition of life into which God may lead us. His loving-kindness will grant us this grace, for His only desire is our sanctification. I repeat, if we awaken this power of discrimination, this inner light in our nature, it will cut us off from actual evil; but the higher, or Divine Light, is supernal and leads us to virtue and to the highest Good..."

Caterina Benincasa was born in the Fontebranda quarter of Siena in 1347, just one year before the outbreak of the Black Death, described by Agnolo di Tura, which raged throughout the city. At the age of seventeen she entered the Dominican Third Order, living as a nun in the house of her father. In 1374, when the plague broke out once more, Catherine and a few Sisters of the Third Order whom she had gathered around her devoted themselves to the care of the sick, without considering the danger to themselves. Even before this, a group of young people of both sexes, drawn from all social circles and professions, had already rallied around her. By the time she was twenty-three years old this group of disciples was meeting regularly for spiritual discourse in the Chapel of the Vault under the Hospice of Santa Maria della Scala—where to the present day the Brethren of St. Catherine still meet for devotions. The circle of her devotees and followers gradually spread beyond Siena. With advice and exhortation Catherine intervened in public life: she reconciled hostile families, particularly the two powerful Sienese aristocratic clans of the Salimbeni and the Tolomei, aroused and exhorted to greater watchfulness princely Church-dignitaries who had become negligent, and challenged royal princes to participate in crusades rather than carry on war against each other.

POLITICAL DISSENSION At that time Siena was torn by internal party dissensions. The government of the 'Nine', consisting of rich merchants, had fallen from power in 1355. There followed a series of political subversions, brought about each time by militant intervention of the deposed aristocracy. The rule of the merchants was replaced by that of the small shopkeepers headed by a council of twelve senators. The rich merchants as well as the nobility, having both been excluded from political power, had now produced a strong counterpoise, against which the Twelve-Senator Council could only retain office by resorting to terrorism. In the year 1368 they were supplanted by the rule of the craftsmen who called themselves the 'Reformers'. These Reformers succeeded to a certain extent in preserving the balance of power by admitting, as collaborators, representatives of previous ruling parties, or so-called 'Monti' (prominent people), into the Council of their democratic government. So, for a while, political peace was restored, the remaining fragments of the earlier hierarchy being more or less levelled down into the ground-foundation of the people, at the expense of what had been formerly the many-sided organism of the township.

Against this historical background must be viewed the following event in the life of St. Catherine. A young nobleman named Niccolò Tuldo, of Perugia, had incited his friends in Siena to oppose the then ruling party of the 'Reformers'. He was arrested and condemned to death by the executioner's axe. In prison, he lost his faith in God. In vain his father-confessors endeavoured to release him from his blasphemy. St. Catherine's pity for him was awakened and under her influence his heart was changed. What then occurred is related in the following excerpt from a letter from St. Catherine to her father-confessor and spiritual son, the preacher Father Raimondo of Capua.

In this letter she speaks repeatedly of the Blood of Christ, meaning the Grace emanating from the sacrifice of the God-incarnate welling up like the blood flowing from His wounds. She uses the word 'blood' in the sense of compassion, love, and the moving of the Spirit.

"Up, up, sweetest my father! and let us sleep no more! For I hear such news that I wish no more bed of repose or worldly state. I have just received a head in my hands, which was to me of such

sweetness as heart cannot think, nor tongue say, nor eye see, nor the ears hear. The will of God went on through the other mysteries wrought before; of which I do not tell, for it would be too long. I went to visit him whom you know: whence he received such comfort and consolation that he confessed, and prepared himself very well. And he made me promise by the love of God that when the time of the sentence should come, I would be with him. So I promised, and did. Then in the morning, before the bell rang, I went to him: and he received great consolation. I led him to hear Mass, and he received the Holy Communion, which he had never before received. His will was accorded and submitted to the will of God; and only one fear was left, that of not being strong at the moment. But the measureless and glowing goodness of God deceived him, creating in him such affection and love in the desire of God that he did not know how to abide without Him, and said: 'Stay with me, and do not abandon me. So it shall not be otherwise than well with me. And I die content.' And he held his head upon my breast. I heard then the rejoicing, and breathed the fragrance of his blood; and it was not without the fragrance of mine, which I desire to shed for the sweet Bridegroom Jesus. And, desire waxing in my soul, feeling his fear, I said: 'Comfort thee, sweet my brother; since we shall soon arrive at the Wedding Feast. Thou shalt go there bathed in the sweet Blood of the Son of God, with the sweet Name of Jesus, which I will never to leave thy memory. And I await thee at the place of justice.' Now think, father and son, his heart then lost all fear, and his face changed from sorrow to gladness; and he rejoiced, he exulted, and said: 'Whence comes such grace to me,

The Fontebranda fountain, near the house where St. Catherine was born.

that the sweetness of my soul will await me at the holy place of justice?' See, that he had come to so much light that he called the place of justice holy! And he said: 'I shall go wholly joyous, and strong, and it will seem to me a thousand years before I arrive, thinking that you are awaiting me there.' And he said words so sweet as to break one's heart, of the goodness of God.

"I waited for him then at the place of justice; and waited there with constant prayer, in the presence of Mary and of Catherine, Virgin and Martyr. But before he came, I prostrated me, and stretched my neck upon the block; but my desire did not come there, for I had too full consciousness of myself. Then up! I prayed, I constrained her, I cried 'Mary!' for I wished this grace, that at the moment of death she should give him a light and then I should see him reach his goal. Then my soul became so full that although a multitude of people were there I could see no human creature, for the sweet promise made to me.

"Then he came, like a gentle lamb; and seeing me, he began to smile, and wanted me to make the sign of the Cross. When he had received the sign, I said: 'Down! To the Bridal, sweetest my brother! For soon shalt thou be in the enduring life.' He prostrated him with great gentleness, and I stretched out his neck; and bowed me down, and recalled to him the Blood of the Lamb. His lips said naught save 'Jesus!' and ,'Catherine!' And so saying, I received his head in my hands, closing my eyes in the Divine Goodness, and saying, 'I will!'

"Then was seen God-and-Man, as might the clearness of the sun be seen. And He stood wounded, and received the blood; in that blood a fire of holy desire, given and hidden in the soul by grace. He received it in the fire of His divine charity. When He had received his blood and his desire, He also received his soul, which He put into the open treasure-house of His Side, full of mercy; the primal Truth showing that by grace and mercy alone He received it, and not for any other work. Oh, how sweet and unspeakable it was to see the goodness of God!"

THE ADVENTURERS
The exclusion of the nobles from government in Italian city-states had brought bitter retribution: robbed of the military element on their councils, the towns were not capable of defending themselves against the many adventurers willing, as mercenaries, to carry on war for some princely employer: these soldiers of fortune, when their services were no longer required, roamed the land terrorizing and blackmailing the cities. Among these gangs, which were mostly led by German or English *condottieri*, were to be found a number of deposed and degenerate nobles. In the years 1364–65–66, the Sienese territory was periodically ravaged by one of these bands led by Sir John Hawkwood—named 'Aguto' by the Italians. In vain did the Republic—at the cost of considerable payments of money— exact promises from this *condottiere* that Siena should in future be spared; he accepted the monies and then broke his promises. St. Catherine sent Father Raimondo of Capua to Sir John Hawkwood, exhorting him to give up his raids and to take part instead in a crusade, but her intervention failed of success.

The result of deposing the council of the rich merchants was that commerce dwindled, riches decreased, and a city placed like Siena suffered the gradual loss of her far-flung commercial connections.

Confusion ruled not only in Siena but in the whole of Italy. The Emperor was powerless. Charles IV was overruled and humiliated by the Sienese when, while staying in the city in 1368, he offered his support to the aristocracy and the ruling 'Twelve' to raise an insurrection against the democratic government of the 'Reformers'.

THE POPE
Since 1309 the pope had resided in Avignon, thereby losing support and the confidence of the Italian people.

A walled fruit-garden in the city. In the background, the Church and Monastery of San Francesco.

St. Catherine recognized that the root of this evil lay not only within the framework of city politics or in the spiritual decline of the clergy, but more particularly in the fact that the head of the Church no longer lived in the holy city of long and consecrated tradition, but in exile under foreign protection and influence. She therefore concentrated the power of her prayer and exhortation on achieving the return of the Pope to Rome. She was successful in restoring peace between the cities of Tuscany and in reconciling them with the Pope. The following is an excerpt from a letter of St. Catherine to Pope Gregory XI:

"Ambassadors from Siena are coming to see Your Holiness. Now if there are any people in the world who can be won over by love, it is they. Therefore I beg of you that you try to win them over in this way. Be a little lenient towards their excuses for the fault they have committed; for they are sorry for it; and it seems to them that they have gone so far that now they know not what they should do. May it please Your Holiness, sweet my Father, if you should see any way in which they could act towards Your Holiness which would be pleasing to you, and whereby they might no longer remain in the war at the side of those to whom they have allied themselves, I beg you to tell it to them. Uphold them for the love of Christ crucified. I believe that, if you will do this, it will be of great benefit for Holy Church and a lesser source of evil." *Epistolario*

The Saint was not afraid either of reproaching the Pope with the depravity of the clergy or of imputing half-heartedness to him personally:

"In the Name of Jesus Christ crucified and of sweet Mary.

"To you, most reverend and beloved father in Christ Jesus, your unworthy, poor, miserable daughter Catherine, servant and slave of the servants of Jesus Christ, writes in His precious Blood: with desire to see you a fruitful tree, full of sweet and mellow fruits, and planted in fruitful earth—for if it were out of the earth the tree would dry up and bear no fruit—that is, in the earth of true knowledge of yourself. For the soul that knows itself humbles itself, because it sees nothing to be proud of; and ripens the sweet fruit of very ardent charity, recognizing in itself the unmeasured goodness of God; and aware that it is not, it attributes all its being to Him who Is. Whence, then, it seems that the soul is constrained to love what God loves and to hate what He hates.

"Oh, sweet and true knowledge, which dost carry with thee the knife of hate, and dost stretch out the hand of holy desire, to draw forth and kill with this hate the worm of self-love—a worm that spoils and gnaws the root of our tree so that it cannot bear any fruit of life, but dries up, and its verdure lasts not! For if a man loves himself, perverse pride, head and source of every ill, lives in him, whatever his rank may be, prelate or subject. If he is a lover of himself alone—that is, if he loves himself for his own sake and not for God—he cannot do other than ill, and all virtue is dead in him. Such a one is like a woman who brings forth her sons dead. And so it really is; for he has not had the life of charity in himself, and has cared only for praise and self-glory, and not for the name of God. I say, then: if he is a prelate, he does ill, because to avoid falling into disfavour with his fellow-creatures—that is, through self-love—in which he is bound by self-indulgence—holy justice dies in him. For he sees his subjects commit faults and sins, and pretends not to see them and fails to correct them; or if he does correct them, he does it with such coldness and lukewarmness that he does not accomplish anything, but plasters vice over; and he is always afraid of giving displeasure or of getting into a quarrel. All this is because he loves himself. Sometimes men like this want to get along with purely peaceful means. I say that this is the very worst cruelty which can be shown. If a wound when necessary is not cauterized or cut out with steel, but simply covered with ointment, not only does it fail to heal, but it infects everything, and many a time death follows from it."

In the year 1376 St. Catherine journeyed as mediatrix between Florence and Pope Gregory XI to Avignon, whence she wrote to the 'Eight of War', the Magistrature chosen by the Commons of Florence, a letter, the most important passages of which are cited here:

"But I complain strongly of you, if what is said in these parts is true, that you have imposed a tax upon the clergy. If this is so, it is a very great evil for two reasons. The first is that you are wronging God by it, for you cannot do it with a good conscience. But it seems to me that you are losing your conscience and everything good; it seems as if you cared for nothing but transitory things of sense, that pass like the wind. Do you not see that we are mortal, and must die, and know not when? Therefore it is great folly to throw away the life of grace, and to bring death on one's own self. I do not wish you to do so any more, for if you did you would be turning back, and you know that it is not he who begins who deserves glory, but he who perseveres to the end. So I tell you that you would never reach an effective peace, unless by perseverance in humility, no longer insulting or offending the ministers and priests of Holy Church.

"This is the other thing that I was telling you was harmful and bad. For beside the evil I spoke of that comes from wronging God, I tell you that such action is ruin to your peace. For the Holy Father, if he knew it, would conceive greater indignation against you.

"That is what some of the cardinals have said, who are seeking and eagerly desiring peace. Now, hearing this report, they say: 'It doesn't seem true that the Florentines want to have peace made;

for if it were true, they would beware of any least action that was against the will of the Holy Father and the habits of Holy Church.' I believe that sweet Christ on earth himself may say these and like words, and he has excellent reason to say them if he does.

"I tell you, dearest fathers, and I beg you, not to choose to hinder the grace of the Holy Spirit, which by no merits of yours He by His clemency is disposed to give you. You might bring great shame and reproach upon me. For nothing but shame and confusion could result if I told the Holy Father one thing and you did another. I beg you that it may not be so any more. Nay, do you exert yourselves to show in word and deed that you wish peace and not war.

"I have talked to the Holy Father. He heard me graciously, by God's goodness and his own, showing that he had a warm love of peace; like a good father, who does not consider so much the wrong the son has done to him, as whether he has become humble, so that he may be shown full mercy. What peculiar joy he felt my tongue could not tell. Having discussed with him a good length of time, at the end of our talk he said that if your case were as I presented it to him, he was ready to receive you as sons, and to do what seemed best to me. I say no more here. It seems to me that absolutely no other answer ought to be given to the Holy Father until your ambassadors arrive. I marvel that they are not here yet. When they shall have come, I shall talk to them, and then to the Holy Father, and as I shall find things disposed I will write you. But you, with your taxes and frivolities, are spoiling all that is sown. Do so no more, for the love of Christ crucified and for your own profit. I say no more. Remain in the holy and sweet grace of God. Sweet Jesus, Jesus Love.

Given in Avignon, the 28th day of June, 1376."

To persuade the Pope to return to Rome was the chief object which St. Catherine pursued, and in convincing Gregory XI himself of the necessity of his return she was successful. But the French cardinals had, from the beginning, done all in their power to pour ridicule on St. Catherine's efforts and to vilify her character; they now multiplied their efforts, producing every conceivable obstacle to prevent the departure of the Pope from Avignon. Catherine, who had preceded the Pope to Rome, now wrote him the following letter:

"In the name of Jesus Christ Crucified and of sweet Mary.

"Most holy Father in sweet Jesus Christ, your unworthy and miserable daughter Catherine commends herself to you in His precious blood, with the desire to see you as a firmly planted rock, fortified in good and holy resolve; so that however many and contrary the winds that batter you, whether from men holding office in the world or from deception or devilish malice, they may not harm you. For they only want to hinder all the good that may come about from your departure [from Avignon]. I understood from the letter you sent me that the Cardinals claim that Pope Clement IV, when there was anything he had to do, would never do it without the advice of his brother Cardinals; even if it often seemed to him that his own view was the more useful, nevertheless he would follow theirs. Alas, most holy Father, they adduce the example of Pope Clement IV, but not that of Pope Urban V, who, when he was in doubt about something, whether or not it were better to do it, would take advice; but on the matters about which he was sure and certain, as you are about the need for departure, he did not depend on the advice of others but followed his own counsel and took no heed even if all were against him. It seems to me that the advice of good men has regard only to the honour of God, the health of souls, and the reformation of the Holy Church, and not to their own self-interest. I say that the advice of such men is to be followed, but not that of those who care only for their own lives and for honours, rewards, and pleasures; for their counsel turns on where their own preference lies. I beg of you in the name of Christ crucified that it may please Your Holiness to make

(From the translation by Vida D. Scudder)

61

haste. Employ a pious deception: give the appearance of readiness to stay on, and then act quickly and soon, since the sooner you act the less will you stay among these embarrassments and troubles. It also seems to me that they are giving you to learn from the example of wild animals, who, when they once escape from a snare, never return to it. Till now you have evaded the snare of their counsels, after they had once caused you to fall into it when you delayed your coming; and it was the devil that caused that snare to be laid, so that all the harm and evil might befall which in fact befell. You, being wise and inspired by the Holy Spirit, will not fall into that snare again. So let us go quickly, sweet my Father, and without fear. If God is with you, no one will be against you. Go quickly to your Bride [the Church] who awaits you with blanched cheeks until you bring the colour back to them. I will not burden you with further words, though there is much more that I might say. Abide in the sweet and blessed favour of God. Forgive me my presumption. Humbly I ask your blessing. Sweet Jesu, Jesu Beloved."

At last, in January 1377, Pope Gregory XI entered Rome where, a few months later, he died. To the day of his death St. Catherine remained his adviser. To her great sorrow she lived to see the schism which rent the Church after the death of Pope Gregory; this had resulted from the choice of Urban VI in Rome itself and of the anti-pope Clement VII in Avignon, whom the French cardinals supported. She fought for the recognition of Urban VI as the rightful successor of St. Peter. In 1380 St. Catherine passed away, suffering and exhausted by this deadly dissension among Christians. The year of her death saw the birth of St. Bernardino of Siena.

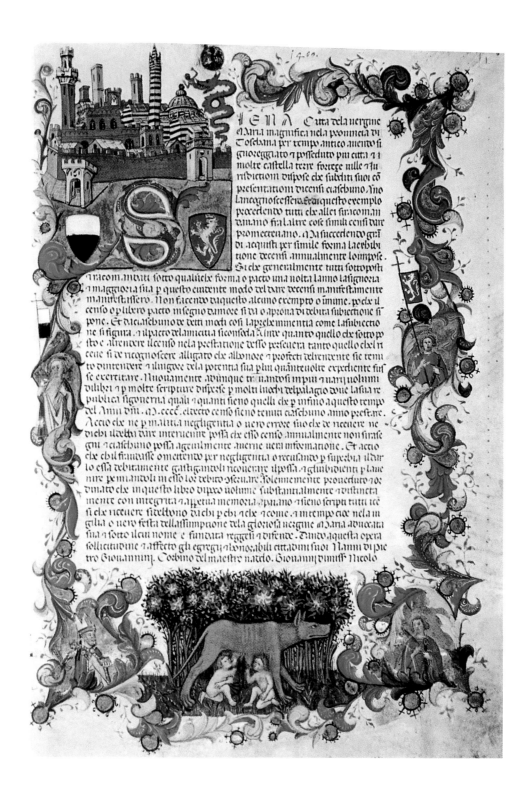

Illuminated page from an account-book *(biccherna)* of the year 1400. Above: over the letter 'S' of the word Siena is a simplified view of the town with the dragon of the Visconti, Dukes of Milan, with whom at that time Siena was allied. Below: the Roman she-wolf with the twins Romulus and Remus, the mythical ancestors of the Sienese. *State Archives, Siena.*

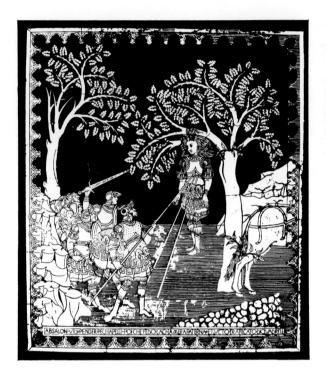

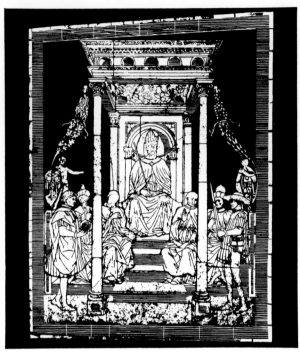

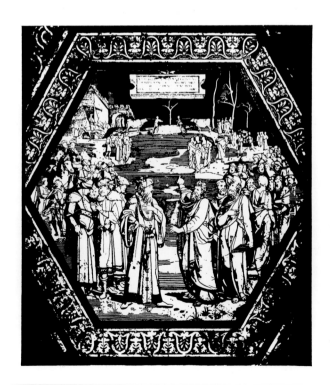

Three squares of the black and white tesselated pavement of the Cathedral in Siena. Above, left: the death of Absalom, by Pietro del Minella (1447). Above, right: Emperor Sigismund on his throne, by Domenico di Bartolo (1434). Below: the pact between Elijah and Ahab, by Domenico Beccafumi (1517). See text, p. 66.

CIVITAS VENERIS

In the fourteenth century the Renaissance was ushered in by an introductory event described as follows by the Florentine sculptor Lorenzo Ghiberti in his book of memoirs:

"A statue [of Venus] similar to the one in Rome and in Florence was found in Siena in 1345, which called forth much rejoicing. Experts considered it to be a remarkable work. The name of the sculptor, signed on the pedestal, was that of Lysippus, the famous master. Beside Venus a dolphin reared up, upon which she was leaning. I did not see this statue myself, but only a sketch of it by the hand of the great Sienese painter Ambrogio Lorenzetti, who was intimate with an old Carthusian Brother. This Carthusian, named Jacomo, was a goldsmith, as was his father before him; he was also a good draughtsman and sculptor. He it was who told me how the statue was found while foundations were being dug there, where formerly the houses of the Malavolti family used to stand. All the collectors and experts in sculpture, the goldsmiths, and all the well-known painters came to inspect this wonderful piece of statuary. It was praised beyond all measure: indeed, in the opinion of every painter living in Siena at this time, it was a masterpiece. With a great show of honours, as for something quite exceptional, the statue was set up on the Campo, on the site of the fountain, and the occasion was celebrated by a great feast..."

But this figure of Venus seemed to bring misfortune to Siena. It was held responsible for the defeat which Siena suffered in the war with Florence which flamed up anew, for it was said that the homage given to Venus had perhaps offended the holy Protectress of the city. And perhaps Venus was also the cause of the adulteries and other moral lapses which had suddenly become prevalent; so, after two years, the Council decided the statue should be demolished and the pieces buried. Some of the Councillors even advised that the fragments should be scattered over Florentine territory.

For a short period—barely fifty years—it almost seemed as if the first green shoots of the Renaissance had been cut off and trampled into the earth: but the beginning of the fifteenth century saw the reappearance of a thousand signs of life. Not only in art but in the daily life of the people Venus attained such dominance that Aeneas Sylvius Piccolomini, the well-known Sienese humanist, who later became Pope Pius II, ironically named Siena 'Civitas Veneris'.

From our modern point of view the action of the Council in destroying the figure of Venus may seem superstitious. In point of fact it was an act of sound self-defence on the part of a period which still belonged to the great Gothic tradition, a discipline which had spiritualized all shape and form. At the same time, with interest awakening in all kinds of natural phenomena, and because of the prevalent over-valuation of the craftsman's skill, people were open and susceptible to the special sensual charm emanating from the ancient naturalism. The fact that at the beginning of the fifteenth century the idea of a 'rebirth' of ancient science and art had intoxicated the imagination of nearly all the 'intelligentsia' in town and country showed that already mediaevalism was a thing of the past. Not that people as a whole were ready from the outset to bow down to a new philosophy, for that was the privilege of the few; but general opinion had changed imperceptibly owing to the break-up of the traditional structure of society, a structural order which had lent clear-cut and intelligible contours to communal life. For some time the true gradations of caste had already been undermined; worldliness had invaded the church; and noble birth counted less than the possession of wealth. Office was no longer an expression of cosmic law, of which man was to be merely the instrument: one was no longer 'invested' with office, or only ostensibly so; in reality office was wrested by force or

bribery. Thus it came about that the traditional forms lost spiritual significance, so that they were looked upon as narrow or rigid and finally were discarded. Then came the release: expansion made itself felt on every hand, the arts blossomed afresh; science sensed new horizons, while men's natures, striving for power, saw the way opening before them.

HIERARCHICAL
LAW The view of life on which mediaeval culture rested, and which Dante has outlined as if by way of a final summing-up, recognised hierarchy as the highest law, in virtue of which all that has existence derives tier upon tier from Eternal Being, so that each component thing in existence finds its own principle in the fact that it represents an image of something higher. In the light of Christianity this law derives from the doctrine of the incarnation of God's eternal and divine Word, for were it not that man is the distant image of God, God would never have taken on the human form of man.

Hierarchy is the Unity revealing itself in multiplicity through a differentiation which yet does not divide, being of a qualitative nature, so that each separate element, according to that particular character and rank that belongs to it, still remains an expression of the total order. In like manner light, broken up by a prism, scatters its manifold colours yet remains, despite all this store of wealth, a perfect and undivided whole.

When therefore this grading of reality breaks down, inasmuch as each separate element strives to become the whole, not only does each drop out of its place in the eternal order of things, but also it forfeits its special and inimitable character and is no longer its own self.

THE TESSELATED
PAVEMENT IN
THE CATHEDRAL

(See illustrations,
p. 64) An apparently superficial but nevertheless significant example of the above-mentioned development can be observed in following the history of artistic life in Siena, namely during the laying of the tesselated pavement in the Cathedral between the years 1370 and 1550. Strictly speaking, this floor is decorated not with mosaics but with a kind of inlay-work of different-coloured marbles. It is a particular technique demanding draughtsman's skill, and ornamental composition suitable to a surface upon which one can walk and the decoration of which one does not contemplate like a picture on a wall. The custom of having a floor laid with mosaics goes back to ancient times and had never quite died out. It is possible that Dante, with his description of a path inlaid with instructive pictures whereby he ascended the heights of Purification (*Purg.* XII, 13 ff.), inspired the Sienese to plan the tesselation of their Cathedral floor. The earliest parts of this flooring, laid soon after 1370, are in an almost heraldic style, so that the floor still appears as a flat expanse and does not in any wise come into conflict with the architectural whole. The compositions laid at the beginning of the fifteenth century, by Domenico di Bartolo or by Pietro del Minella, being drawn in perspective, sweep aside the above-mentioned principle, yet still in so restrained a manner that the floor remains a flat area. But at the beginning of the sixteenth century, when Beccafumi laid the middle sections, every means at the disposal of the draughtsman to portray distance is brought into play: perspective, light and shade, great cloud effects and so on. The artist no longer took into account the structural harmony of the building as a whole in which his works were to lie, leaving people to walk over his compositions; his black and white panels strive to be everything at once—painting, plastic art, and architecture—and thus they only succeed in producing an unreal and disturbing effect.

CHANGES IN THE
SCIENTIFIC
FIELD A somewhat similar change was in progress in the realm of science: for the first time learning and research began to be cultivated which no longer had any direct connection with the integral nature of the human soul. Up till now a rightly exercised knowledge of science was held to bestow a real wisdom on its possessor. The various liberal sciences—which were formerly characteristically named the 'liberal arts'—were supposed to confer a deeper knowledge of the intrinsic oneness of the world, built as a divine cathedral. Thus, all inherited knowledge had, up till now, possessed a spiritual background susceptible of being comprehended only intuitively. This conception, however,

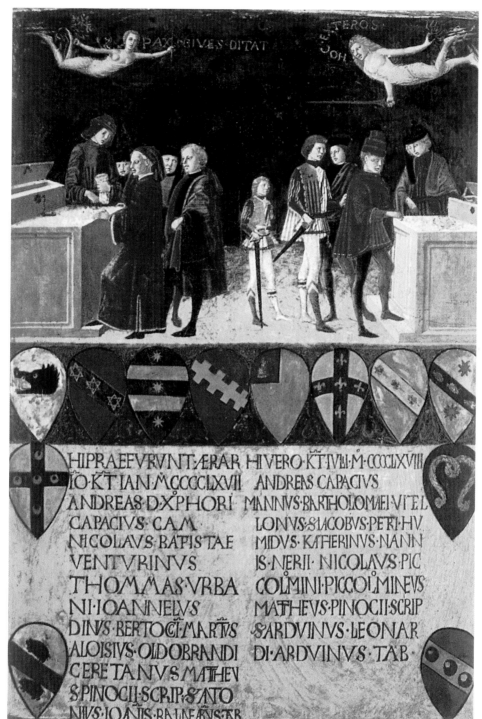

PAX CIVES DITAT ... CETEROS ... IOH

HI PRAEFVRVNT ÆRAR HI VERO KT IVLII M CCCCLXVIII
IO KT IAN MCCCCLXVII ANDREAS CAPACIVS
ANDREAS DXPHORI MANNVS BARTHOLOMÆI VITEL
CAPACIVS CAM LONVS SIACOBVS PETI HV
NICOLAVS BAPISTAE MIDVS KATHERINVS NANN
VENTVRINVS IS NERII NICOLAVS PIC
THOMMAS VRBA COLMINI PICCOLMINEVS
NI IOANNELVS MATHEVS PINOCII SCRIP
DINVS BERTOCI MARTVS SARDVINVS LEONAR
ALOISIVS OLDOBRANDI DI ARDVINVS TAB
CERETANVS MATHEV
S PINOCII SCRIP STATO
NIVS IOANIS BALNEARVS TAB

State Ministry of Finance in peace and in war. Left, the receipt of taxes; right, payment of mercenaries. A miniature on the cover of a municipal account-book *(biccherna)* of the year 1468. *State Archives, Siena.*

began to be overlaid by a certain intellectual routine just at the time when the Renaissance was awakening. Now science was to be released; scientific research was to be promoted for its own sake and art to be cultivated for the sake of art. Hitherto it was something unheard-of that science should no longer pursue a spiritual purpose, one that kept in view man in his wholeness, as an immortal being reaching even beyond death. The immediate result of this change of outlook was a moral disruption

which took a more serious form among the intellectuals than in the population at large. In Siena the laxity of late Grecian times became accepted as a pattern of life that justified everything. Evidence of this can be found in a book by a former member of the Sienese *Studium generale* called *Hermaphroditus* in which every conceivable kind of orgy, heterosexual as well as homosexual, is meticulously and provocatively described under the heading of 'figurae Veneris'.

POLITICS Politically speaking the Renaissance was the golden age of strong but harsh commanders. Siena, herself lacking in princely leadership, became indirectly involved, for she had to bend first to one and then to another foreign power, carefully steering her barque through rough seas to avoid capsizing. At first, from 1399 till 1402, it was Gian Galeazzo Visconti, Duke of Milan, then from 1408 to 1409 King Ladislas of Naples, from 1432 until 1439 the Emperor Sigismund of Bohemia, and then from 1478 to 1480 Alfonso Duke of Calabria, each of whom imposed his will, with more or less force, upon Siena.

PAINTING Perhaps the hesitation of Sienese painters of the early fifteenth century to accept completely the naturalism of the Renaissance was partly due to the fact that Siena was not ruled by princes: for the faithful people, to whom this art was meant to appeal, was inclined to cling to the traditional prototypes sanctified by miracle and by old observance. In consequence, ecclesiastical art remained for a long time Gothic in style. A certain cautious representation of space and of light and shadow newly introduced into religious pictures at first sight lent them a special appeal, something intimate, warmer, more expressive: indeed, one could almost call it a re-blossoming of the Gothic idiom in painting. However, this apparent enrichment of representation did not increase the spiritual appeal of sacred pictures; rather did it, on the contrary, diminish their symbolic character. The representation of holy personages in a homely, domestic setting, like friends or relations of the painter dwelling in commonplace surroundings and clad in conventional city garments, deprived them of their divine inviolability. One can follow the process of change by comparing the many Sienese pictures of the Madonna: the face of the Heavenly Queen is no longer, as in earlier pictures, mysteriously set apart in the aura of Her halo; now it is only a noble but already naturalized female figure seen against a golden circle suspended behind Her head. The unfathomable blue of the Virgin's cloak, characteristic of all the Madonna pictures of the thirteenth and even of the fourteenth century, is now of a hard, almost crude colour, indicating in light and shade the contour of a three-dimensional figure. From the moment painting cut loose from the hierarchic order, assuming the qualities of sculpture, the enlightening power of colour and the direct language of line had been sacrificed. Painting was no longer content to indicate the divine; it attempted to produce an imitative illusion, becoming all too sophisticated and dependent on the emotions alone. When the full Renaissance finally stepped in with the triumph of cool reason and an openly admitted sensuality, it could only come as a release.

(See pictures on pp. 22, 23, 31, 32, 35, 51, 69, 75 and 94)

THE FONTE GAIA BY JACOPO DELLA QUERCIA In this respect sculpture vied with painting; for Siena possesses in the Fonte Gaia of Jacopo della Quercia one of the earliest pieces of Renaissance stone carving, created between the years 1409 and 1412. At first it adorned the Campo: today, in place of the original, there stands a passable copy of it, made at a later date. The remaining fragments of the former fountain wall, cut in reliefs and figures, have been preserved intact and placed on the balcony of the Town Hall.

'Fonte Gaia' means the 'Joyous Fountain', and it is true that there is something of youthful animation about this particular piece of sculpture that allies it to Greek art, compared with later works of the Renaissance which are expressive of Roman pathos. From the Gothic tradition Jacopo della Quercia has taken over its traits of nobility and charm and from the antique school its carefree serenity. His sketches for the fountain have been carefully preserved: they show how strongly the artist still relied on Gothic tradition.

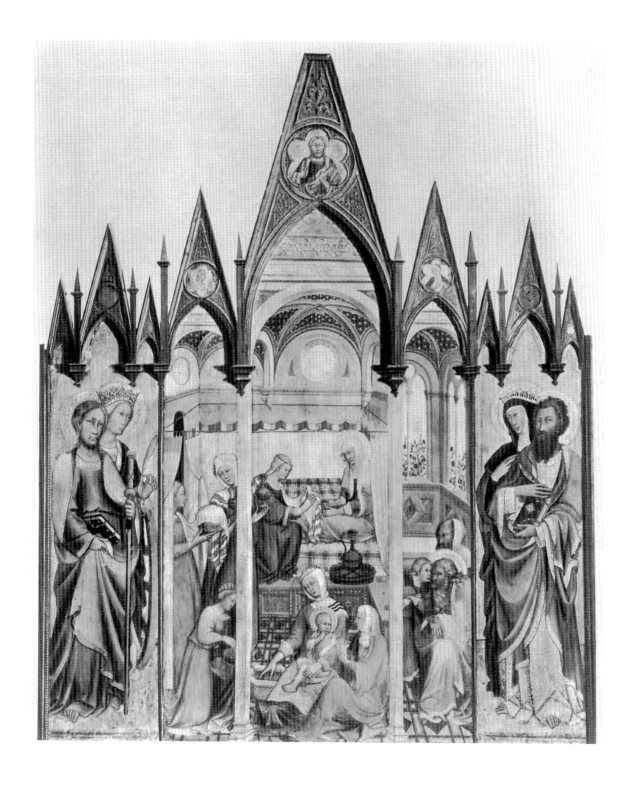

Paolo di Giovanni Fei: Birth of the Virgin. About 1400. *Picture Gallery, Siena*. The picture is an example of the new mode of representing space, showing the influence of the Renaissance, but retaining at the same time the traditional Gothic line.

Above: Sketch for the Fonte Gaia by Jacopo della Quercia. *Victoria and Albert Museum, London*. By comparison with the sculptural execution of this subject, the sketch is still strongly under Gothic influence. Below: a fragment of the Fonte Gaia preserved on the loggia of the Town Hall, Siena.

To this earlier period of the Renaissance belongs an aristocratic movement consciously trying to break loose from what had by then become the narrow life of the Guilds, as prevailing in city life in the fourteenth century. This trait finds expression in a story written by Gentile Sermini, a Sienese nobleman, in 1425. This story, together with a number of rather bold, outspoken farces, appeared at a time when the possession of money was considered to be the deciding factor in life: it reflects a yearning for the lost golden age of the aristocracy:

"In the beautiful old town of Siena there lived a very aristocratic youth of the Salimbeni family, son of Signor Salimbeni, whose name was Anselmo. He was a handsome, well-built lad, with great charm of manner, and was very wealthy. Anselmo had fallen violently in love with a refined, well-born maiden of the Montanini family, named Angelica. This girl had neither parent living, only one brother, Carlo, with whom she lived alone quietly and unpretentiously. Although of noble descent they were both poor, their only possession being the house on their estate in which they lived. This estate was the envy of a rich citizen for whom the place was conveniently situated: he was so determined to buy the property that he repeatedly offered them 1000 florins; but Carlo had no intention of selling, for the estate was an old patrimony; for this refusal the would-be buyer cherished a secret grudge against the owner. It so happened that Carlo had to fight a duel, whereby he wounded his opponent, another influential citizen. His enemy, seeing his chance to force a sale, persuaded the judge to sentence Carlo to pay a large fine, hoping that he would thus be compelled to part with his land. Carlo was imprisoned and sentenced to pay within fifteen days a fine of 1000 florins, or to have his right hand cut off. And so, in deep despair, the young man endured the first few days as a prisoner. In order to avoid losing his right hand he was now forced to try and realize money on his property; but meanwhile his enemy assumed an air of importance, offering him only 800 florins for the estate, while at the same time making sure that no one else made an offer for the property, thus driving Carlo into an impossible position. Being neither willing to impoverish his sister, nor yet to be himself defrauded, Carlo gave himself up to the mercy of God. Meanwhile, Anselmo, who had been away, returned from his journey and learned what was happening. Deeply concerned by the event, and also because he aspired to the hand of Carlo's sister, he intervened in the affair; being a wealthy man he paid the 1000 florins without Carlo's knowledge and released him from prison. Carlo gave grateful thanks to Almighty God and to his benefactor. But when he attempted to discover how his release had been obtained, Anselmo simply answered: 'Think no more about the whole matter, for your debt has been discharged.' Nevertheless it was not long before Carlo found out that it was Anselmo who had paid the 1000 florins, whereupon he said: 'You have done me a favour which puts me under an obligation such as I owe to no other man alive. Let us seek an advocate, for I will now transfer to you our property, so that we shall have adequately repaid you.' But Anselmo would hear of no such transaction, nor did he let himself be overpersuaded by Carlo's importunity. On returning home Carlo related to his sister all that had transpired and how Anselmo had given services for which he refused repayment. The brother and sister then discussed the matter from every angle, coming to the conclusion that nothing is worse than ingratitude: and Carlo, a man of honour, could find no rest unless he were able, in some way, to make restitution for the service rendered to him, esteeming gratitude to be his first duty. He was not long in realizing that Anselmo was deeply in love with his sister, for whose sake he had intervened on behalf of the brother. He argued to himself: 'Oh Carlo! Here is one who saved you from having your hand cut off, who paid the 1000 florins for you and without your entreaties released you from prison: are you yourself such an ingrate that you must be begged to do something for him in return? Do not you see that both of you, you as well as Angelica, are in duty bound to him in every sense of the word? Of a truth, if he will take neither money nor

property in repayment, you can only serve him by putting yourselves, your persons, at his disposal: and you know full well what he is longing for.' Of the result of these his ruminations he made insinuation to his sister and observed that she was sensible and not devoid of real gratitude for what Anselmo had done for them. Carlo therefore decided to go direct to the point in speaking to Anselmo. He said: 'My noble friend, you have reinstated the honour of my sister and myself and have rescued me personally from a terrible fate. I beg you to consider what service she and I are worthy to render to you: for anything within our power which would satisfy you we would gladly do in return for your kindness.' In a low and gentle voice Anselmo murmured: 'It was little that I did for you and your sister: for me to possess your friendship is reward enough!' As he fell silent Carlo went on: 'I know of your love for my sister. Your intervention in my affair was a sign of regard for our good reputation and I can see that your kind deed was done for her sake, so we are both in your debt. You refuse to take the money in the form of our property—then dispose of our persons. You possess my whole heart already: but I am conscious that I alone am not adequate to wipe out such a debt. It is Angelica who must do that. Expect her this evening, for she will come to you bearing a purse filled to overflowing. For the sake of her reputation however, it is I myself who will bring her to your study at three o'clock in the morning. See to it that we can enter unperceived.' This offer awakened in Anselmo such a tumult of emotion that he almost swooned. Speechless, he could only stare at Carlo with widened eyes. Having recovered somewhat, he replied, trembling and with tears in his eyes: 'Brother, be it as you wish.' On parting, each began his preparations, Anselmo to arrange for their secret entry into his house and Carlo to persuade Angelica, putting before her so many good reasons that she, convinced at last, agreed to her brother's proposal. With the greatest circumspection he accompanied his sister at three o'clock to Anselmo, saying to her: 'Now repay him for all he has done for us in your own way.' Thereupon he left them together and returned home alone. And now, dear reader, I must leave it to your own imagination to visualize the passionate reception Anselmo gave Angelica and her shy, sweet behaviour; and yet I hardly fancy your best efforts could fully conceive of what that first quarter of an hour together meant to the two lovers. Later, as by mutual consent they prepared to lie down together, Anselmo's emotion was so great that my pen has no words to describe it. Arrived at last at the moment he had so long desired, the young man—from whom the maiden withheld no favours—was suddenly assailed by doubts. After a moment's silence, heaving a great sigh, he said: 'Oh you most noble-minded and most lovely of girls, whom I love and desire intensely, a devotion far beyond all riches has moved you, without consideration for your own reputation in the eyes of the world, in the glory of your virginity to come to me, only wishing to give me pleasure, generously surrendering yourself to me, ready to do my will in everything, allowing me to take bodily possession of all your treasure. You have shown me that you hold my happiness dearer than your own honour. What ought I to do now? Must I not hold your virtue to be dearer to me than my own temporary satisfaction? Surely that would be right and I should be thankless indeed to appease my desire at the cost of your shame: therefore will I let honour and right-feeling draw rein upon my burning desire. I earnestly beg of you to accept me, unworthy though I am, as your betrothed and future husband, if your brother Carlo and your family will agree. If that can come to pass then you will go to our marriage a virgin, which means far more to me than to see you now dishonoured. Although you said, "No one but ourselves will ever hear about this day", you yourself would always remember it with shame. I will not be the cause of your sadness, so don your clothing once more, for now I will go back with you to your dear brother.' To this the maiden replied thoughtfully: 'My dear kind friend! I see that your saying that I, Angelica, love you more than myself, concerns not me, but you: for you are he that loves me more than himself, not in the

QVESTA·E·LENTRATA·ELVSCITA·dICHECHO·dICHECHO
CINVGHI·CHAMARLENGHO·dICABELLA·PVNO·AÑO·COM
INCIÃdO·AdI·PRIMO·dIGENAIO·MCCCCLXXII·EFINEdO·AdI
VLTIMO·dIdICENbRE·MCCCCLXXIII·EdVGO·bVONAGIONTA·IS
OVESTI·SONO·IPRIMI·ASIGH·ERITORE·EdIPIERO·dALdObRANdO
VITORI·MEO·dITOTO·BAS ... GESI·CERETANI·E·IACOMO·dIGALGANO
NICOLO·dIMS·bARTALOMEO·bICHI·E·dIFRANCIESCHO·dISLA
dIMATIO·dANTONIO·dINFRI·CARO·EdITOMAXO·dI
dANGOLO·MALAVOITI·MAVRITIO·LVTI·E·dI8
EdI8ARdVINO·NOTAIO·dOMENICO·dIXFANO·N ... TA

Nobleman's wedding. Miniature on cover of a municipal account-book (*biccherna*) of 1473. State Archives, Siena.

reverse sense: for you know full well that I do not deserve to be your wife. You, who are a descendant of one of the most noble families in Italy, you, the son of a great lord, rich in possessions, in good qualities and in knowledge, handsome, charming and courteous, you combine every quality that can

make a young man desirable and it is meet that your wife should be of high descent or even of royal blood rather than a girl like my poor self. Take from me all you desire: do not humble yourself in my honour. You have my entire trust and confidence and I know I am not mistaken in you.' Thereafter they exchanged many sweet and loving words. At last, being of one mind one with another they returned to Carlo, who was pleased beyond measure, thanking Anselmo in heartfelt words for his honourable dealing. They then discussed in what manner the marriage should take place so that it should not appear to be a kind of bargain agreed upon by them...

"The next morning Anselmo visited one of his relations, Signor Cino Barducci. Bowing courteously he said: 'You know that I love Angelica Montanini. I have come to beg you to do all in your power to achieve her consent to be my wife.' Signor Cino, a wordly-wise and well-meaning relative of the young man, proceeded vehemently to dissuade him from this project, giving many reasons for his opposition, suggesting instead the names of the best families in Siena: the lad had only to choose whomsoever he desired and if she be worthy of him, Cino would give him his assistance. But Anselmo interrupted him, saying: 'I shall never marry any other woman', adding, 'and do not let us be miserly about the dowry, for I have, thank God, everything needful to keep her in comfort without any money from her family. The maiden herself is capital enough for me. If you will gain her favour for me I shall be grateful and I earnestly beg you to do so; but if you will not, I shall seek someone else who will serve me without all these provisos.' He concluded with the words: 'I shall never take any other woman to wife, and should it ever happen that she marry another man, I shall conduct myself in such a way that all those connected with me will rue the day. Therefore bring forward no more reasons to dissuade me, for my mind is made up.' When Signor Cino saw that his decision was unshakeable, and further reflected that after all the maiden was well born and of noble descent, he decided to help Anselmo...

"Within a few days the business of the marriage contract was completed and the wedding was celebrated in San Donato, where Anselmo made the following speech: 'I thank God Almighty for the blessing He has granted to me in that Carlo and his family consent to give me the noble maiden Angelica, to be my wife: I have long desired her, knowing her many virtues. But feeling that I do not deserve such a treasure I will accept no dowry from her: she herself is enough, I ask no more. And knowing she deserves much more than I, I herewith endow her with all my worldly possessions. Please note that down in writing, Signor Giuliano. The good qualities and sweet nature of her brother Carlo are characteristics very dear to me and, should he agree, I wish him to become not only my brother-in-law, but to be my own brother. If he will still live with his sister in my house, I wish to transfer to him the half of all I possess.' So saying he turned to Carlo, asking him: 'Do you agree to what I propose?' And hurrying to embrace him, Carlo answered: 'Take note, Signor Giuliano, that I agree to all Anselmo's proposals', adding that he too wished to share with Anselmo his own property: 'but as he has a hundred times more than I, it shall be my duty to undertake the functions of his business administrator; he should lead a life of freedom.' A great deal more was spoken of on both sides, after which the marriage contract was drawn up while all parties concerned engaged in lively conversation. At the end of the month, with a great show of honours and after a festive gathering, Anselmo led his bride home. The same morning the two men, Anselmo and Carlo, had dressed alike in the garments of brotherhood and for the wedding, for the marriage festivities were to continue for a whole month. And so, for the rest of their lives, these three lived together in perfect harmony and love. Now, dear reader, do thou look back on all the evidences of true friendship each showed to the other and decide which of the three was the most magnanimous and which the most exemplary."

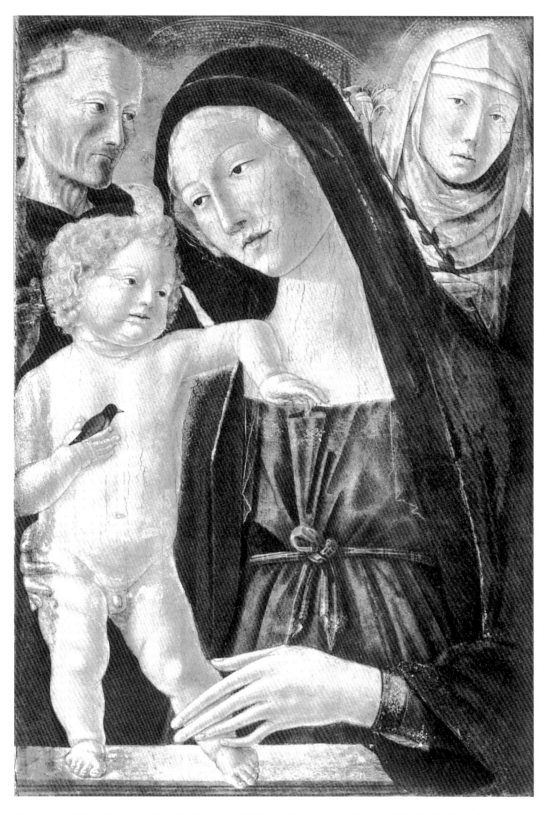

Neroccio di Bartolomeo: the Virgin and Child, with St. Bernardino and St. Catherine. About 1490. *Picture Gallery, Siena.*

St. Bernardino of
Siena, polychrome
wood by the Sienese
sculptor Lorenzo
di Pietro, known
also as 'Il Vecchiet-
ta'. Early work,
before 1470.
Bargello, Florence.

THE HOLY MONOGRAM

In each of the years 1425 and 1427 St. Bernardino preached in Siena day after day for six weeks. At
first he chose the monastery of San Francesco, or the square in front of it; later, when the square
became overcrowded with the number of listeners, he preached on the Campo. Moved by his words
many deadly enemies were reconciled; political party differences were cleared up and the Town Coun-
cil issued enactments against slander and usury; furthermore the holy monogram painted on a board,
and which St. Bernardino was wont to hold before him while preaching, was carved by order of
the Council on the front wall of the Town Hall, where it can be seen to this day.

Bernardino degli Albizzeschi, a descendant of an aristocratic family in the town of Massa Marit-
tima in Sienese territory, was brought up in the city of Siena, where, still very young, he studied
philosophy and civil and canon law before entering into the strict observance of the Franciscan Or-
der of friars. When the Black Death once more broke out in Siena, although then only seventeen
years old, he devoted himself to nursing the sick in the hospital of Santa Maria della Scala, inciting
other young men to follow his example, in the same way as St. Catherine had done in the first out-
break of the plague. In later years he travelled throughout Italy preaching and exhorting the masses
in Milan, Venice, Brescia, Ferrara, Bologna, and Florence, leaving everywhere a deep and lasting
impression. In 1425 he had preached during Lent in Florence, whence he received the call of the
Sienese Council to come to that city.

At a time when reverence for Christian tradition seemed to be on the wane he restored to his hearers
veneration for the order of the priesthood, the dignity of whose calling does not depend alone on
the human perfection of the priest himself. The sermons of St. Bernardino also revived reverence for
the sacrament of marriage, as well as belief in the immortality of the soul and respect for God's name.
He used the familiar idiom of the people that all might follow his words, lashing out fiercely against
the sins prevalent at that time, giving free rein to a certain cutting humour of his own, appealing
often to the common sense and good judgment of the intellectuals, while from his own rich store
of knowledge, in unexpected flashes of intuition, he threw light upon words from the Scriptures by
means of countless similes and parables.

Excerpts from a sermon by St. Bernardino on wedlock:
"...Two extremes: It is very profitable to preach [on the subject of wedlock], for no other theme
in the world is so much discussed, yet are people in general strangely ignorant about everything
appertaining thereto. On the other hand people say it were disgraceful to preach openly on the subject
or to offer advice about it. In the confessional it is mentioned with hesitation for fear it should be
said the father confessor teaches evil ways; and from the pulpit wedlock is seldom spoken of for two
reasons: lest ignorant people mock at the preacher, or lest he, feeling some embarrassment, should
interrupt the thread of his discourse.

"The fact that wedlock is discussed neither in the confessional nor from the pulpit has given rise
to the prevailing ignorance of its true nature; therefore you follow your natural bent with all its
mischievous practices, living as the animals without reverence for the high sacrament of marriage,
that God established in the terrestrial paradise. It was the first and greatest of His gifts and you have
desecrated it. You have come to believe that wedlock consists only in bodily contact, whereas it is
made up of mutual trust and confidence between the man and the woman.

"These are the two extremes: one person will say: 'Speak as frankly and openly about it, as one would about any dishonourable action.' But another will cry: 'Do not do so: it would be immoral. You will lay yourself open to evil-speakers.'

"So what will you do now, Brother Bernardino? If you remain silent for fear of incurring mockery, or from a personal feeling of embarrassment in discussing the subject, or if you should be moved by any other consideration and refrain from speaking about wedlock, you are heading for damnation. You have been instructed to preach, to remonstrate with evil-doers and to hold up their misdoings before them, to lead them back into the way of salvation. Therefore take this burden upon you: say what must be said and let people talk as they will...

"In his epistle the apostle Peter writes: 'Which vessel is the weaker?' Surely the woman is the weaker: therefore be mindful of her and treasure her, as if you possessed a frail and precious crystal vase...

"... Should a woman complain and regret being a woman, being small, or being dark complexioned, or hairy, or crooked, she will never attain to salvation until she is content with the nature God has given her...

"... Of itself the soul does not incline to unnatural practices or to any action definitely opposed to the natural order. Think of the misery of the wife of a libertine drawn by her husband into all manner of dissoluteness! It were better for your daughters to have their throats cut than to marry them to such reprobates; for were their life taken at least their soul might have been saved, whereas when delivered into the hand of sodomites both body and soul are lost...

"... Wisdom and discernment: one can indeed be in great doubt. What is to be done? Their dispositions are dissimilar, not really suited to each other. No general rule can be laid down here, just as one cannot insist that everybody should eat two loaves a day, for there are those who eat their three loaves while others eat only one, and again others who hardly touch bread and a few who eat none at all.

"Three things are to be considered:

 firstly, bodily nature;

 secondly, the nature of the soul;

 thirdly, the particular state of grace.

Firstly I will speak about the bodily considerations: I am young and she is young; or I am old and she is young; or I am young and she is old.

"Never marry your daughter to an old man, for she will only have grief and worry and will be liable to become a prey to countless sins. Nor should you, you older woman, ever marry a younger man, for when he has despoiled your treasure he will turn against you. Look at your man from every viewpoint: is he strong? is he weak? healthy or ailing? Let not the strings of your lute be tuned at such tension that they must snap! Be wise enough not to comply with his desire when it smacks of bestiality...

"Secondly, the aspect of soul: Should you be in danger of losing God's grace and the state of grace of your own soul, let yourself go only as far as is meet and seemly, so that grace quit you not. However, since there exist few such natures, I will not say much on the subject. But I will give you an example: ... Supposing a woman is richly endowed with the grace of God and wishes to live continently if only she be able; but she finds it not easy to decide which mode of life is the better one. Let her first seek advice from Lady Wisdom, then from Lady Conscience and lastly let her seek the counsel of Lady Compassion, from these three noble women: but also let her turn to the love of God, to her own soul and to her love for her husband; she will then surely be well advised..."

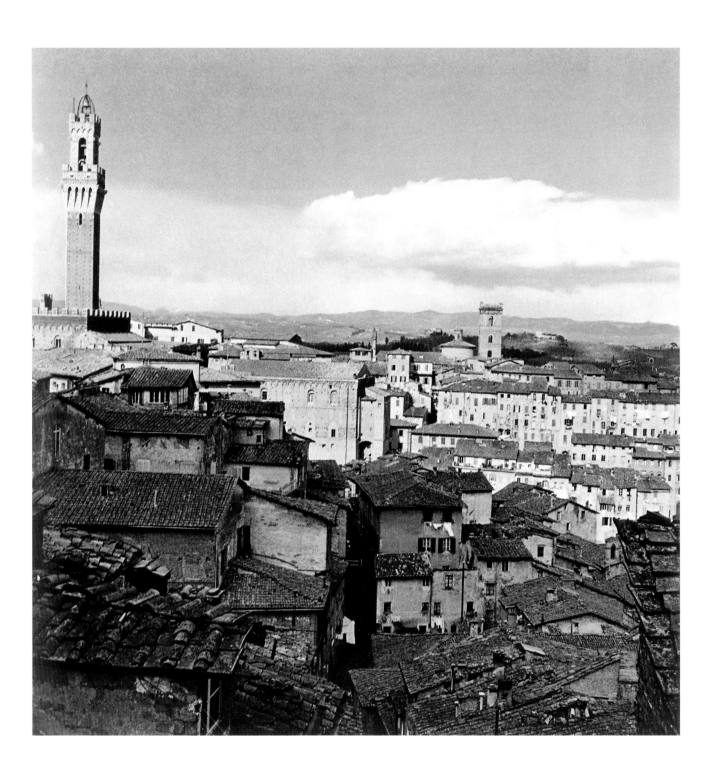

The city seen from Casato di Sopra, looking towards San Martino.

The words of St. Bernardino are full of imagery, as for instance in the following excerpt from a sermon he preached during Lent in Florence, in 1425:

"...Secondly, the subject of worldly pleasure: Of pleasure it has been said: *mane floruit, et transeat:* blossoming at morn, yet doomed to wilt away. It is as in the month of May. See the flowering fields!

"Let us consider four meadows set with blossoms, for there are four such promised to us in this world of deception. But unless you will accompany me you will not understand what I mean. Will you come? 'Yes.' What is your name? 'Merryman.' Good! and now, my pleasure-seeking friend, let us climb that peak, Monte Morello, and I will point out to you the four entrancing meadows or gardens of flowers.

"First comes that of the town; then of the sea; thirdly the garden of commerce; and fourthly that of marriage.

"Let us consider well the garden of town-life.

"You see now, my friend, that I brought you up this mountain so that you could look down upon the garden of Florence; from this height you see how it has been laid out, an example to many another town. Do you see nothing, my merry friend? Look carefully. What is it you can see? 'I can see the house of a wealthy citizen of the higher order, full of wares for which he can scarce find room, the warehouse full of wheat, a prosperous family indeed! *Filii tui sicut novellae olivarum:* His sons are as the young shoots of the olive-tree. I see that his family consists of many souls, that he commands and is obeyed. He has stewards for the many farms he possesses. Letters reach him from France and from Paris. To me he appears to be like her of whom the prophet David said: *Sicut novellae plantationes in iuventute sua. Filii eorum circumornati ut similitudo templi. Promptuaria eorum plena. Oves eorum foetosae, abundantes in egressibus suis:* 'She is like unto the fresh young plant, her sons are adorned like the Temple. Her granaries are filled with corn. Her flocks are well-fed and fat, slow to move.' I can also see that he possesses much cattle and that his house in every part stands firm.'

"And that is a good thing? or what do you think about it? 'Yes, it seems to me that he is in paradise: *Beati dixerunt.* People say how fortunate he is.' But what do you yourself say? 'I cannot exactly tell: but then I myself only want to enjoy life.'

"But now look you more closely: is there nothing else you discern? 'Well yes, there is.' What is it you notice? 'It looks to me as if a sickness had taken hold of his sons and they are all dead!' Anything more? 'Yes, the father is so unhappy that he thinks to take his own life; and his wife, who used to be so contented with her lot, is now a miserable woman.' And what else have you noticed? 'I can now see that the sickness has spread and the father himself is contaminated. His stewards hide away the account-books and carry off all the money and the house is crowded with creditors demanding their payment. Yes, and now he too, the father, lies dead while the sickness spreads to his cattle. One stranger after another comes in, each taking away some object in the house, now the rest is swept out by his creditors who begin to empty the whole house: indeed, the house now looks like a low pot-house.' Well, is not that justice? What is your opinion? 'I think that David's words are true: *Beatus populus cuius Dominus Deus est...*'

"Now let us look down on the second flowering pasture of life, that of the sea.

"Look now: tell me what you notice about this vast expanse of water. Is there anything special to be seen? 'Well of course, I can see a ship approaching, bringing the sounds of happy people ever nearer. They have shipped the oars. There are a few sodomites amongst the crowd.' Anything else? 'To me it is obvious that they are all well-off people for whom the wind of life is in the right quarter and who are prosperous.' Good! and now look again and more carefully. What else can you tell me?

80

'Ah, now a sea-fog is creeping up and the wind is rising: on board men are running hither and thither.' And what is happening now? 'They are throwing their goods overboard in great haste: one man vows to make a pilgrimage to St. James and another will go to St. Anthony.' And now what are they doing? 'Oh! the mast snaps off, the ship bursts asunder and they all drown!' And what do you suppose is the cause of all this? 'Oh, deceptive world! with what tempting pleasures you have led them astray only to ruin and destroy them!'

"The third field of pleasure is commerce: let us look down at that. Now, my good-natured friend, look down upon this part of the world's gardens and give me your impressions: can you see anything particular? 'Yes, indeed: it looks as though all those I see approaching are merchants, though among them are a few strollers. They are in joyous mood celebrating some happy event, walking as if on air. Among them a few are bringing wool, spices, gold pieces and numbers of other kinds of goods, obviously returning home wealthy. I can see how carefree they all are, many of them busy tightening up their saddle-bags.' What impression does that give you? 'Well, it all seems to me to be in excellent order.'

A flock of sheep by the Arbia, near Siena.

"Well now, you merryman, notice carefully, what else do you see? 'Well, certainly it does look now as if an armed ambush awaits the crowd of merchants to fall upon them and to rob them, yet none of them realizes the danger! I can see how the robbers send a man up a tree to spy out the travellers, while the rest of the band get ready for the attack; the robbers, moreover, are in the majority, more in number than I at first imagined.' Anything more? 'Yes indeed! for now the robber-band is closing in on the merchants, attacking in cold blood, and the whole crowd is in dire trouble. If you could only see what is going on! Some are robbing, some fleeing, some weeping! One merchant has been killed and the rest taken prisoner.' My young friend, what do you say to that? 'To me it would seem that this world is indeed full of treachery!'

"And now comes the blossoming garden of marriage for us to consider.

"So look at it with care, my merryman, and tell me what there is to be seen here. Is there nothing special? 'Yes, I see a house where a wedding is taking place and the maiden is given to her husband decked out as if she were a queen. There is singing and dancing and great festivity.' And that pleases you, my young sir? 'Well, in my opinion, it does look good: it is the sacrament of mariage.'

"But now look more closely still and notice every detail: anything special to tell me? 'Yes, there certainly is.' Well, and what might that be? 'Hardly three days after the wedding I see them quarrelling. The man is a bully and a sodomite and his wife is already distracted.' Anything further? 'Yes, many sons are born to them who all have devilish tempers. In this home they are continually shouting at one another: what I took for a paradise I can now see is hell.'

"You see now that David spoke truly: *mane floruit et transeat*: in the morning it is a field of flowers but the next moment it wilts away. That explains why Christ strove only for spiritual, never for material wealth: His way led Him neither in the first garden, that of riches, nor did His life lead Him across the seas: He took no part in commerce nor did He take Him a wife. Thereby he taught wisdom..."

The custom of having a coat-of-arms had become usual even among commoners. Every party, every guild, every clan and family aspired to the possession of a coat-of-arms. All these aspirants to special worldly honour were now confronted with the Holy Monogram, held up before them by St. Bernardino. It was the visible Name of Jesus represented by the three letters IHS derived from the Greek Name of Jesus set in a circle of light. This alone was the sign that men were to honour and to which they were to go for refuge.

There was more significance attaching to this monogram than was apparent at first sight. Through familiarizing people with this symbol, St. Bernardino made devotion to the Name of Jesus accessible to all men in an immediately understandable manner, that devotion which in its most direct form, as concentration upon the inwardly spoken Name, has been from time immemorial one of the chief means of spiritual concentration. The worship of the divine-human Name of Jesus runs like a scarlet thread throughout Christian mysticism from the time of the Fathers in the Theban Desert to the Spanish mystics of the sixteenth century and continues up to the present day. Indeed, not only in Christianity but also in the mysticism of all other religions this concentration on a divine or on a divine-human Name, which is sometimes presented in visible form, plays a significant part. The holy man of Siena thus made one of the most inward treasures of contemplative tradition outward and popular, doing so deliberately with the object that for many, through its compelling power, it might become inward again:

"When the Name of Jesus lives in your heart of hearts, your desire also to gaze upon it will be all the greater... If your heart is empty of the Name, the best way to achieve its possession is to place it visibly before your eyes..."

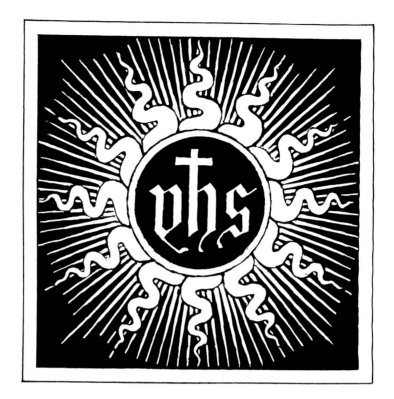

The Monogram of the Name of Jesus, drawn in contemporary manner after the verbal description given by St. Bernardino. The three first letters 'IHS' of the Greek form of the Name of Jesus are reproduced in Gothic lettering. Later this was reinterpreted to signify the initial letters of the words 'Jesus Hominum Salvator'.

The following is an excerpt from a sermon on the virtues of the Name of Jesus given by St. Bernardino both in Florence and in Siena, in the year 1424.

"...Today let us speak of the shining countenance of the Seraphim. St. Paul says: 'Before the Name of Jesus every knee bows whether in heaven or on the earth or in hell...' Believe me, whosoever is not of the devil will this day tell of the wonder of the Name of Jesus. Yet how shall I adequately express the virtues of the Name? Whether in speaking or in crying it aloud my words are but as silence; I can with my words uplift His Name, yet it is a degradation of it; I can affirm and negate a thousand times to explain Him, yet leaving Him unexplained... What I want to convey to you is that the virtues of the Name of Jesus are so great that the more I say, the less I reveal. If all the grains of sand in the sea, all the leaves on the trees, and all the stars in the heavens were tongues praising and glorifying the Name of Jesus, all of them together could not say more than a hundred-thousand-thousandth part of what one single tongue could tell. The reason for this is that the Name of Jesus is Origin without origin: that before the creation of the sun and until the burning-out thereof, the Name was pre-ordained, from everlasting to everlasting, until the end of Time and thereafter. As worthy of praise as God Himself is the Name of Jesus. David the prophet says: 'Thy Name of Jesus is as praiseworthy as Thou art Thyself, O Lord.' Should all the angels of Paradise, from the lowest choir to the highest, and all men on earth who are, who were and who ever will be, give themselves up to praising the Name of Jesus, it would still not suffice for a Name of which it is written at the beginning of the Book: 'My Name is the foundation of those who are saved.' In this Name of Jesus all are saved. Through faith in His Name the Holy Fathers were saved...

"Everything that God has done for the salvation of the world lies hidden in the Name of Jesus.

"Read the Scriptures, the Acts of the Apostles, the letters of St. Paul and other apostles, the Apocalypse, indeed the whole Bible, and if you can point to a single sinner, sick in soul or body, who

FROM A SERMON ON THE NAME OF JESUS

Cannarozzi

83

called for help in the Name of Jesus and was spurned, I will breathe my last breath! Look at the story in St. Luke's Gospel of the blind man who begged, crying: *Jesu, fili David, miserere mei!* Jesus called the man to him and spoke, saying: 'What wilt thou that I do unto thee?' The blind man answered: 'Lord, that I may see.' *Respice:* 'See!' He, the Son of God, spoke the words in a spiritual sense. The blind man said: '*Lord Jesus*, that I may see Thee', for therein alone lies our entire happiness, namely that we may see the very Countenance of the Lord Jesus; and from this you can judge how truly He is the refuge of the contrite heart...

"Devils flee before the Name of Jesus and are rendered powerless by it. God first gave the Name to the Apostles, giving it afterwards to us all, wherewith to combat devils. This means that you can guard yourself against the Devil himself and not simply against those who have become possessed by him. In the last chapter of St. Mark's Gospel Jesus says: 'In my Name shalt thou cast out devils...'

"One day, as St. Bernard was going on his way in the streets of Milan, a woman possessed of an evil spirit was brought before him. At once, recognizing the woman's sickness, the Saint, filled with pity, kneeled down beside her to release her. Thereupon, through the mouth of the sick woman, the Devil spoke, saying: 'You can do nothing against me.' St. Bernard answered: 'Not I, but the Name of Jesus will exorcize you', and so it happened. So holy and fearful is the Name of Jesus! It is holy to men who are holy and good and terrifying to the Devil, to the wicked and to the possessed. All the more is it to be revered by merchants and craftsmen and under the superscription of His Name all their books and manuscripts should begin. Let all that we aspire to do be begun in the Name of Jesus... For the usurer and the libertine the Name is fear-filled, for Jesus is humble, mild, full of earnestness and every sort of truth... From the sweet-scented flower of the vine, snakes slink away: in like manner the Devil flees before the fragrance of the Name of Jesus...

"In Padua, while listening to a sermon on the Name of Jesus a maniac was restored to sanity. Likewise in Alessandria della Puglia, a woman was instantaneously healed of her soul's sickness when a boy touched her with the monogram of the Name of Jesus...

"You, you merchant trading overseas, carry it with you! You, soldier at the wars, and you, traveller, take it everywhere with you and have faith that the Name of Jesus will protect you from every harm...

"Take the Name of Jesus into your homes, into your rooms, into your hearts...

"In the words of Solomon: 'A strong tower is the Name of the Lord.' Thousands of experiences have shown us this, and its truth is renewed afresh every day, that carrying the Name of Jesus in the hand one is safe from robbers and highwaymen, saying the words: *autem transiens per medio illorum ibat*, or just simply: 'Jesus, Jesus, Jesus'; for whosoever turneth to the Name of Jesus will find protection...

"Consider the body, namely, the fleshly body: there is no man's spirit be it ever so wrathful, uncontrolled, proud, lustful, mean, greedy and covetous, or otherwise filled with vice, which, if he accept the Name of Jesus with faith and love, will not immediately be released from every temptation...

"Christ said: 'If you lay hands upon the sick in my Name, they shall be healed.' But make it a rule to remember what I mentioned earlier, namely, that should you not receive the grace you pray for, it is either because your faith was weak, or else the grace was withheld for the good of your soul...

"God says: 'My Word today is no less strong than it used to be in the early days of the Church.' All the miracles wrought by the Apostles, and by others who were not apostles, were performed in the Name of Jesus. Indeed, once the Apostles said to Jesus: 'See yonder Pharisees, who are not Thy disciples, yet they cast out devils in Thy Name.' What more proof can one have of the power of the Name of Jesus?...

"Cry aloud: 'Jesus, have mercy on me!' when great difficulties face you, and no harm can come to you. Carry Him with you to lay Him next to your heart; soon you will turn to Him out of very habit. In every trouble, cry: 'Jesus, Jesus', and your heart will become humble, be it as hard as diamond…

"…A Comforter is He in every sorrow and anxiety… To those who endure in patience He is their Refuge. He will bring you joy. In the midst of torture the Apostles were full of confidence. Take heed, Brother Bernardino! Unless you are ready to rejoice in persecution for the Name of Jesus, you deserve to come to shame. 'Be of good cheer, rejoice and be exceeding glad', said Jesus to His Apostles, 'for great is your reward in heaven if you are presecuted for my Name's sake'.

"Once, as St. Peter was entering the Temple, a lame man begged of him an alms. St. Peter said to him: 'Gold and silver have I none, but that which I have I give thee. In the Name of Jesus rise up and walk.' The man arose and ran rejoicing into the Temple. In like manner in whatsoever trouble your soul may be, it will arise rejoicing at the Name of Jesus…

"The best inscription of the Name of Jesus is that to be found in the innermost heart of hearts: the next best is in words, and finally the visible Name written or carved. If the bodily eye be constantly

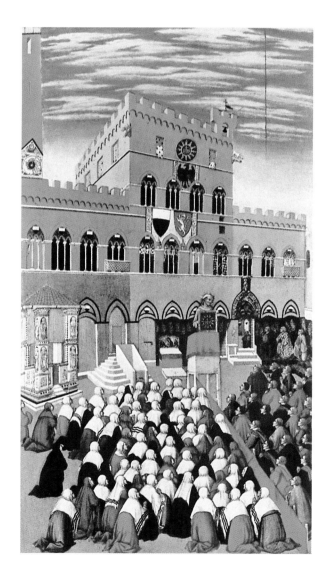

St. Bernardino preaching on the Campo, after a panel painting by Sano di Pietro, about 1444. Hanging in the Cathedral Sacristy, Siena. On the left of the picture is seen the Memorial Chapel built in 1376 to commemorate the Black Death in Siena.

confronted with it, it will soon become visible to the eye of the heart, that inward spiritual eye of the soul. Often you will speak His Name aloud with reverence, love, and faith, until it becomes a habit with you, a habit which will imprint itself ineradicably upon your soul in whatsoever difficulty life brings to you. 'Jesus, Jesus', you will have in your heart and find yourself repeating, like the holy Bishop Ignatius who was martyred for Jesus' sake: at each blow he received he said the word 'Jesus' aloud and no other word passed his lips. Accordingly, when they had killed him, having marvelled at his patience, they cut him open and on his heart was found the Name of Jesus in golden letters. On dividing the heart into two parts they found the Name of Jesus on both sides; and however small the pieces into which his heart was cut, on each smallest part stood the Name of Jesus, proving that indeed he carried the Name in his heart...

"Hear the words of St. John in his Gospel: 'Whatsoever thou askest of the Father in my Name shall be given unto thee...'

"Have we not heard of our blessed Brother Aegidius, one of the first disciples of our father, holy Francis, that each time he was uplifted in contemplation, the Name of Jesus was in his heart? Or, more truly, every time he reminded himself of it he was uplifted in contemplation...

"Under the Old Covenant the High Priest could only enter the Holy of Holies with the Name of Jesus bound about his forehead or borne upon his mitre—the 'tetragrammaton', as it is called in Greek, which signifies that into that Paradise which is the Holy of Holies only he may enter who bears the sign of Jesus on his forehead..."

Concerning the pictorial representation of the Name:

"It is surrounded by twelve rays denoting the twelve Apostles, or the twelve clauses of the Creed: in between there are eight or ten or twelve other smaller rays standing for the doctrine of Holy Church, or the perfection of the Apostolic life. Its rightful place is on the escutcheon of Holy Church.

"When Antichrist enters this world he will appropriate for himself all the names of the Almighty; but of the Name of Jesus he will not presume to take possession.

"The background of the Monogram is blue, the sign of faith, love and hope. St. Paul says: 'Take the Name of Jesus for your shield and buckler.' A wondrous weapon it will be when raised aloft against the hosts of Antichrist.

"About the three initials: To him who carries the Monogram they denote the Trinity, to be imprinted on his innermost heart: to him who thus dedicates his soul it is not only a sign, it is a miracle of Grace...

Entry in the minute-book of the Sienese Council referring to the decision to place the Holy Monogram on the front of the Town Hall, 1425. *State Archives, Siena.*

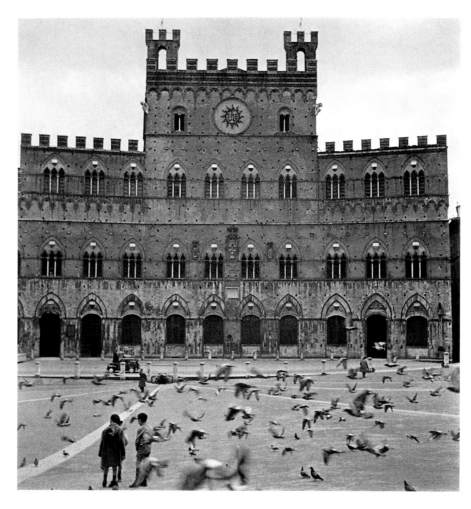

Town Hall, Siena, with the Monogram of the Name of Jesus. The blue background has crumbled away and the gold become weather-worn.

"Let us now consider the place of the Holy Monogram: it is in the sun, whose rays illumine the soul. Twelve is the number of the ecstasies of unswerving faith. The main blessings vouchsafed correspond to the larger rays, the remainder denote the *gratia gratis data*. The whole is framed in a square, signifying the four cardinal virtues.

"*Domine Dominus, quam admirabilem nomen tuum in universa terra!*

"I will describe the monogram in a simile: either you carry the Name of Jesus in your heart, or you do not. But he who does so will all the more long to have it visible before his eyes. A lover bearing the picture of his lady in his heart's eye sees her likeness in a thousand outward things. The more one's heart is possessed by it, the more pleasing is it in visible form. And so it is with the Name of Jesus; he who possesses it inwardly longs for it outwardly. The Apostle Paul was filled with the Name both within and without. Should your heart be empty of Him, the means to attain Him is by placing Him before you and confessing Him openly.

"The great Constantine carried His Name emblazoned on his banner, whereby he was victor in every battle. In Verona I saw an old book in the Sacristy, a Gospel, the pages of which were coloured in purple as the garments of Christ. All the lettering was in silver except there, where the Name of Jesus occurred, which was written in gold to show that the Name of Jesus is above all other names, as gold is above all other precious metals..."

The wave of religious fervour which followed this sermon on the Name of Jesus, and which swept over the Sienese people, is something beyond our present-day powers of conception to grasp. It shows that Renaissance rationalism had not yet undermined the capacity of men's souls to sense the imponderables of spiritual reality which a mere symbol is able to convey.

The Council of the city decided that the Monogram of the Name of Jesus, such as St. Bernardino was wont to hold before him as he preached, was to find a permanent place on the façade of the Town Hall in the form of a large coloured relief. Many citizens had the same sign, either painted or carved, placed over the entrance to their homes, so that it has become almost a second coat-of-arms of the city. And in other Italian cities where the Saint had passed at some time or other one finds the same sign on buildings and on articles of daily use.

In the year 1427, the Pope wished to appoint Martino Bernardino to be Bishop of Siena, but the Saint refused the office. Six years later he founded the Monastery of the Osservanza—the Order of Strict Observance—on the hill which bounds the horizon to the north-east of the city.

ENEA SILVIO PICCOLOMINI Among those who listened to St. Bernardino was a young nobleman named Enea Silvio Piccolomini. Just at that time he was studying in Siena, the town of his birth, and leading a somewhat worldly life. So overwhelmed was he at the Saint's words that he considered entering a monastic Order. To enable him to decide he sought counsel with St. Bernardino, following him on the way to Rome. The Saint however gave him comfort and reassurance and advised him to return and finish his course at the university. Later on Enea Silvio became secretary to one of the Cardinals of the Concilium in Bâle, whence he entered the diplomatic service and lastly embraced the priesthood, becoming Bishop of Siena. Not for long did he remain in his bishopric, being soon appointed Cardinal and finally becoming Pope Pius II. Although all his life he had cherished a deep reverence for the two great Sienese mystics—for Catherine whom he canonized and for Bernardino whose oratorical gifts he so much admired—he remained spiritually somewhat separated from them both by his trend of thought, bearing as it did the imprint of Cicero and Virgil. His spirit radiated a gentle influence, a light broken up, as it were, by the prism of the *Ratio*, which left no traces behind in the souls of the people of Siena as a whole. He was famed in intellectual and political circles; in his outlook on life he had already crossed the threshold of the Renaissance.

Pius II visited Siena in the spring of 1459, bringing the city a precious relic, namely the right arm of John the Baptist. Furthermore he requested the Council to re-admit the nobility to government office, to which demand the Council complied only with half-measures; the Piccolomini family alone were permanently reinstated to political office in the city.

The death of Pius II occurred in 1464. Shortly before the end he exhorted Christian princes to take part in a great crusade against the ever-growing might of Turkey. His desire was to win back for Christendom Constantinople, which had been conquered by Mahomet II in the year 1453. As none of the ruling princes threw in their lot with him, he proceeded alone to his fleet, hoping that others would emulate his example, but he was already suffering from exhaustion, and death intervened before his ships left port.

His nephew, Cardinal Francesco Piccolomini, built the Cathedral Library and named it the 'Libreria Piccolomini', as a memorial to the great humanist Pope; during the years 1502 to 1507 Pinturicchio painted the murals, many of which depict scenes from the life of the deceased Pope. The well-known group of the three nude Graces used to stand there—a late Roman copy of the famous Greek sculpture: it is somehow appropriate to the classicism of Enea Silvio.

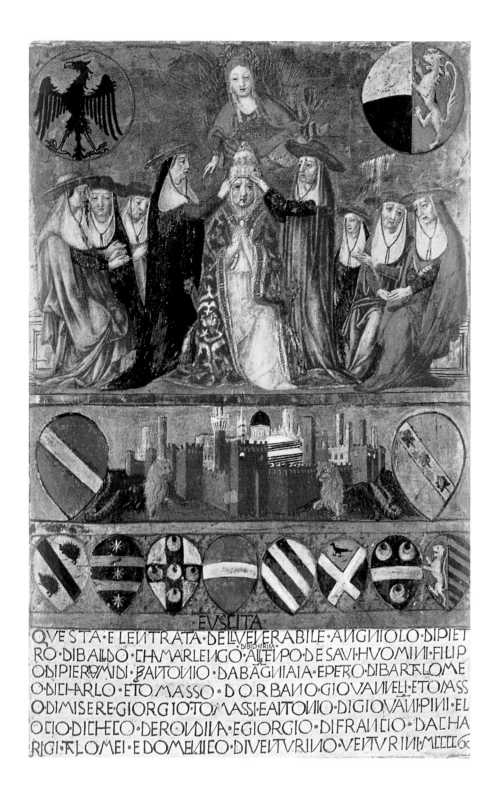

Coronation of Pope Pius II (Enea Silvio Piccolomini). Below: a simplified representation of the City of Siena. Miniature on the cover of a municipal account book *(biccherna)* of the year 1460. *State Archives, Siena.*

The letter in which Caesar Borgia bids the Sienese tyrant Pandolfo Petrucci and his confederates to Sinigaglia, with the intention of putting them all to death. *State Archives, Siena.*

THE TYRANTS

Tracing the history of the forms of government of old Siena—which, broadly speaking, resembles the history of other civic constitutions in Italy during this period—one sees that it coincides remarkably with the law indicated by Plato concerning the decline of city states, and about which Averroes wrote a commentary: the ideal Government, says Plato, is carried out by judges who represent a timeless, impersonal wisdom and not their own interests; expressed in Christian terms, this describes the essence of sacerdotal government, regardless of whether it is a question of Guelph ideas about the Church or Ghibelline principles as to the upholding of the Holy Roman Empire. When this ideal form of government declines, the nobility, the caste of warriors, is the next to place itself at the helm. The city state then enters into a phase of wars; it becomes powerful through conquest, but eventually bleeds to death through its own infatuation with power. Following upon this the merchant class takes possession of the state and what now becomes of paramount interest is not honour, as was the case under the aristocratic rule, but money. Whereas the rule of the nobles, in spite of certain shortcomings, showed farsightedness and a sense of grandeur, possessions now become the main object of people's exertions. There now grows up a too blatant distinction between rich and poor. Together with the decline in the military virtues, this fact tends to bring about the fall of government by the rich merchants, and power passes into the hands of the people, for the majority of whom only one thing is of importance, to wit directly tangible and enjoyable pleasures. Since however the average member of the untutored populace does not know what is or is not possible in the matter of providing pleasures, he quickly falls victim to whichever politician has the most to promise and the fewest scruples about how his promises are to be fulfilled: in this way the rule of the people ends in tyranny.

This is exactly what happened in Siena. Towards the end of the fifteenth century the struggle between the various social orders and political parties reached its culmination. The People's Party, *il Monte del Popolo*, eventually united all the poorer inhabitants with all the formerly influential ranks of society, and rose against the rule of the rich merchants—the Council of Nine, *i Noveschi*—in a bloody insurrection, driving them out of the town. But the adherents of the 'Nine' withdrew only to wait until those opposing parties remaining in the city had become weakened by their mutual enmities, then returned and took possession of the town by sudden attack. This they succeeded in achieving in the year 1487, under the leadership of Pandolfo Petrucci, who however had no intention of returning the 'Nine' to power, but welded all classes and parties together into what was called the 'Sienese People's Party', and while flattering the populace ruled in fact alone as tyrant. Following the example of other contemporary tyrants, he used the services of hired murderers to remove those influential men who stood in his way, even being guilty of having his own father-in-law killed. The populace excused these things, for he spared their pockets by levying money for his projects and his ostentatious life from the rich citizens, as well as by confiscating Church property, and he bought peace for Siena by ceding to Florence Montepulciano and the Sienese strongholds in the valley of the Chiana. For all this the future was to demand a heavy penalty.

In the year 1499, the French King Louis XII conquered Milan, while further south, in the Romagna, the notorious Caesar Borgia, illegitimate son of Pope Alexander VI, had reached the peak of his power. First with one and then with the other side Petrucci made pacts, hoping thereby to steer cleverly between Scylla and Charybdis. In secret he supported the conspiracy of Caesar Borgia's *condottieri*

PANDOLFO
PETRUCCI

against their master. The latter, however, getting wind of the plot, invited all the conspirators to Sinigaglia, where he staged a mass-murder; Pandolfo Petrucci alone, realizing the trap, remained in safety in Siena.

To revenge himself, Caesar Borgia, allegedly to release the Sienese from their tyrant, fell upon the city with an army of 15,000 men, demanding the banishment of Petrucci, who found himself compelled to flee. Closely followed by Caesar Borgia's men, he galloped to Lucca, where he was given asylum. Hereupon the French King Louis XII intervened, claimed that Siena was under his protection, and demanded the reinstatement of Petrucci, to which request the Borgias—Alexander VI and his son Caesar—had no alternative but to agree. By way of thanks Petrucci allied himself only a few years later with the Spanish, who had defeated the French at Carigliano; yet again, when the Spanish party, in their endeavour to conquer Florence, found themselves in difficulties, Petrucci forsook them to return to his former alliance with France. In the meantime, Florence had not only Montepulciano but also Pisa in its power: the Florentines had now free access to the coast and also controlled the great highway to Rome. This spelt doom for Siena. In 1512 Pandolfo Petrucci died on his way homewards after taking the mineral waters at San Filippo. His funeral was celebrated with great pomp in the Church of the Osservanza near Siena.

It is said that the Pope once asked the learned Antonio da Venafro, Petrucci's permanent adviser, by what means his master managed to keep the fickle Sienese under control, to which Venafro answered: "With lies and deception, Holy Father."

In his favour it is usually said that under the rule of the tyrant Petrucci science and the arts flowered anew. But even this blossoming was degenerate and sickly, like most of the developments in Siena at that time: Pinturicchio, who painted the graceful but quite unspiritual frescos in the Piccolomini Library of the Cathedral, was also responsible for the decorations in Petrucci's palace; and Sodoma, said to have painted the portrait of Petrucci, has shown, with his lively but effeminate and perverted art, just what sort of spirit was in the air at that time. The most important of Siena's contemporary artists, the architect Baldassare Peruzzi, lived and worked chiefly in Rome.

After the death of Petrucci his son Borghese came to power but conducted himself so much in the style of a Nero that after four years he was forcibly deposed by the Sienese. Into his position stepped his cousin Raffaello Petrucci whom Leo X had raised to be Cardinal, and when, to the relief of the Sienese, he too died, his brother Fabio became governor of the city. As Fabio's rule was even more cruel and corrupt than that of Borghese, he was forced soon after his accession to the governorship to leave the city and go into exile.

Tax-return of the painter Giovanni Antonio Bazzi, named 'Il Sodoma':

"Citizens and Tax-office Officials, I, Master Giovanni Antonio Sodoma of Boccaturo, hereby declare as follows:—

"Firstly: I own a vegetable garden near Fontenuova, where I do all the work that others may reap the harvest.

"Secondly: I own a house in which I live in Vallerrozzi, and on the subject of which Niccolò de'Libri and I are in disagreement and have a law-suit.

"At present I have eight horses, sometimes called 'goats', and I think must I be a gelding to go on keeping them.

"I have a monkey, and a raven which can speak: the latter I keep so that he can teach the theological-looking ass in the cage how to talk; besides which there is an eagle-owl with which to frighten stupid folks, and also a grey owl. About the night-owl I will not go into detail, because of the above-mentioned ape.

"I possess two peacocks, two dogs, two cats and a falcon, a sparrow-hawk, six hens and eighteen chickens; besides these there are two moor-hens and so many birds that it would be bewildering if I described them all.

"I also have three bad-tempered creatures, namely three women; further there are about thirty growing children who keep me on the run. Your Excellencies will therefore realize that I am kept enormously busy.

"Finally: in the Statutes there is a clause to the effect that anyone possessing twelve children is not liable to taxation at all—for which reason I beg to sign myself yours respectfully, Bene valete, Sodoma, derivatum mihi Sodoma."

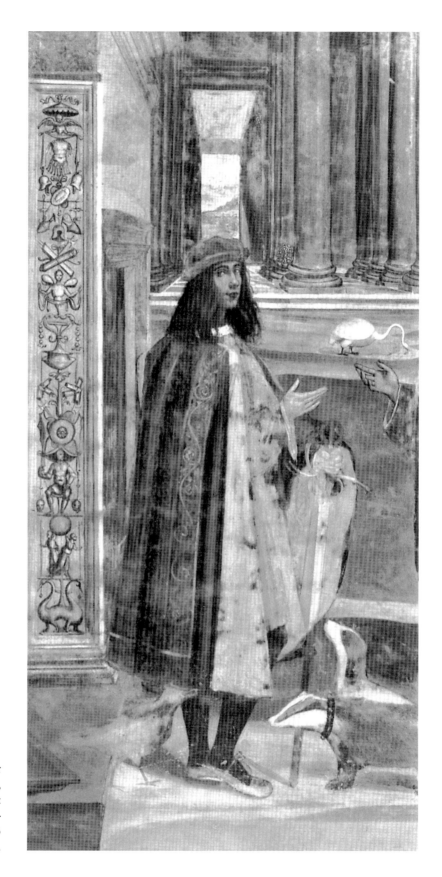

Self-portrait of the painter Giovanni Antonio Bazzi, named 'Il Sodoma': part of his fresco in the Monastery of Monte Oliveto Maggiore, near Siena.

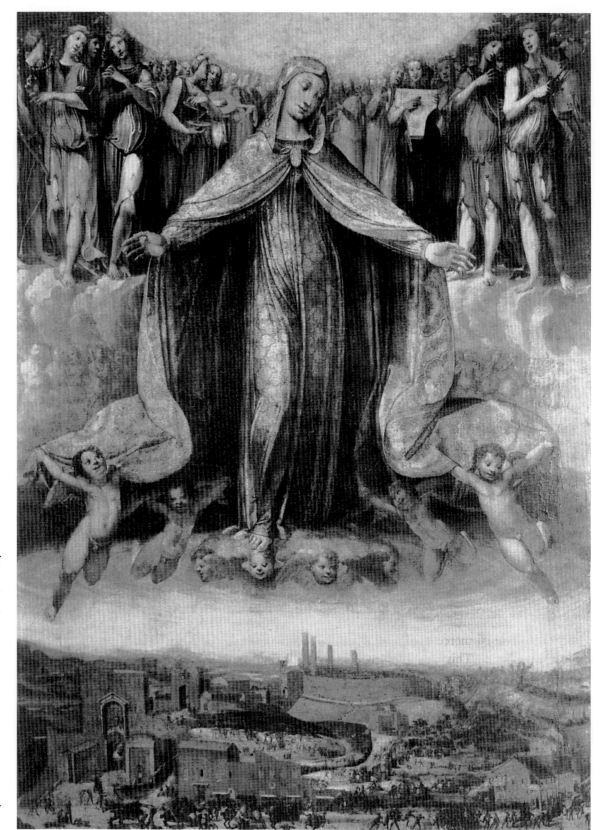

The Victory of
Ponte Camollia,
commissioned by
the Council from
the artist Giovanni
di Lorenzo Cini,
1528. This repre-
sentation of the
Holy Virgin spread-
ing Her cloak to
protect the city
probably takes its
origin from the pic-
ture on the great
white Sienese war-
banner.
*In the Church of
San Martino.*

THE SIEGE

After the overthrow of tyranny the inhabitants of Siena split up into innumerable political parties in their struggles for the reinstatement of the old free constitution. With the sixteenth century, however, an age had dawned when it was no longer possible for a free city to exist by its own strength and under its own laws.

In the Middle Ages society developed of its own accord, as a result of natural relationships, into a terraced tier-upon-tier structure culminating in a highest point. The various castes, the guilds, and the city councils were, to a great extent, their own law-givers within the framework of the traditional justice, and the Emperor, King, or Bishop had little else to do beyond guaranteeing, as the highest authority, the application of those laws in accordance with circumstances. The arbitrariness of monarchs was thereby curtailed, so that even the Emperor lacked the right to interfere in certain kinds of personal matters, or to alter the structure of the social order. He ruled by means of his control of the heads of the hierarchy; his power was therefore indirect. Consequently justice, as it was understood in those days, did not consist in the application of an identical rule for all men, but in having regard for all the laws which originated from the nature of men and things themselves.

It was now, when this flexible social structure had gone to pieces, that absolute monarchy came to the fore, no longer ruling on a basis of existing corporations, but downwards from above without regard for particular city conditions. Mercenaries came definitely to replace the knights at arms; and the supremacy of firearms had the effect of relegating the rules of knightly battle to an unnecessary, purely decorative and dangerous game.

<div style="float:right">ABSOLUTE
MONARCHY</div>

The people of Siena, for whom the old City State still remained as the highest ideal, struggled obstinately against absorption into this new world-order which was now imposing itself in Italy in triple form as the Empire of Charles v, "His Catholic Majesty" of Spain; as the Kingdom of Henri ii, "the Most Christian King" of France; and thirdly as the ecclesiastical and secular power of the Pope.

After the despotism of Petrucci, the Party of 'Nine', out of which that tyranny had developed, attempted to regain power in the city with the help of papal intervention. But a new free party which called itself the 'Libertini', and which had as its object the overthrow of despotism, rose up against the Party of Nine and against the papal garrison and drove them out of the city.

With the intention of punishing the Sienese and reinstating his faithful adherents, the 'Nine', at the head of political affairs in the city, Pope Clement vii, a member of the Medici family, sent an army of 7,600 papal mercenaries with 2,200 Florentine state troops under the command of Andrea Doria against Siena. This army encamped before the Gate of Camollia.

<div style="float:right">THE BATTLE OF
PORTA CAMOLLIA</div>

As they had done in the past before the battle of Montaperto, the Sienese resolved to entrust their city to the protection of the Holy Virgin. The keys of the Gates were thereupon brought by the city elders and laid on the altar of the Cathedral of the Mother of God, the Heavenly Queen being proclaimed Protectress of their *res publica*.

On 25 July the little troop of city militia, with a hundred horsemen and only a few cannon, made a sortie through the gates of Fontebranda and Camollia, defeating the enemy with one bold stroke. At the same moment the great voice of the bell in the Town Hall tower was heard calling the inhabitants to hasten to the support of their militia and to complete the victory; but the enemy army, already filled with terror, had fallen back in wild disorder.

Just as formerly after the victory at Montaperto, the victorious Sienese, laden with loot and crowned with olive-branches, went in procession through the streets to the Cathedral to lay a thank-offering before the Holy Virgin. Even strangers who had witnessed the event spoke of it as a miracle. To protect themselves against further encroachments by the Pope the new ruling party, the Free—the 'Libertini'—now allied themselves after accepted Ghibelline tradition with the Emperor Charles v, whose general, Don Ferdinando Gonzaga, immediately sent troops to reinforce the city militia.

THE EMPEROR
CHARLES V
In April 1536 the Emperor Charles v himself visited the city. From the Porta Romana there rode forth fifty Sienese noblemen to welcome him, crying "Imperium! Imperium!" and kissing the Emperor's hand, his feet, and even his horse. At the Gates of the city he was awaited by the Magistracy and the clergy, preceded by two hundred youths of noble blood clad in white and gold, bearing garlands of flowers and olive-branches. Brocades, Eastern carpets, and garlands hung from the houses in the streets through which the Emperor would pass. Women waved from the windows and the inhabitants rejoiced, crying: "Welcome to our Emperor, Charles the Fifth!"

The Emperor addressed the people, warning them to remain of one mind. But hardly had he left the town than the same old party dissensions broke out afresh, with which even the imperial garrison was unable to cope. The Emperor therefore resolved to erect a fortress in Siena. On hearing of this the Sienese, despairing of their freedom, sent an ambassador to the Emperor to beg him to reconsider his decision. A Sienese named Alessandro Sozzini writes of these events in his Diary as follows:—

Sozzini
"Meanwhile, Signor Girolamo Tolomei, chosen to be ambassador, set out on his errand with a secretary and a guide, to carry the message to His Catholic Majesty. He rode away to Spain, where the Emperor was residing at that time. On arriving there he wrote back almost at once to the Senate in Siena to say that His Catholic Majesty refused to grant him a hearing: that he had already waited three days to be received in audience and that in his opinion it would hardly be possible to achieve what the town of Siena was requesting.

"After a few more days of delay the ambassador again wrote that thanks to the help of some friends of his at court he had been admitted to the presence of His Catholic Majesty. The latter, on seeing whom he had before him, frowned, saying he should rise from his knee and leave the presence, refusing to listen to the message the ambassador had brought. Whereupon Signor Tolomei begged the Emperor, for the love of God, at least to let him deliver the message entrusted to him by the Republic of Siena, that he might be able to report that he had carried out his orders. The Emperor therefore gave him permission to speak, commanding him to be brief. The ambassador then explained in few words that the whole city hoped His Majesty might be moved to alter his decision and, instead of erecting a fortress near Siena, might make some other plan, to the greater honour of His Catholic Majesty and to the greater reassurance of the Sienese citizens. His Majesty might rest assured that no further riots would occur in the city; he could promise in the name of all his co-citizens that any other plan whatsoever, except the erection of a fortress, would find acceptance with the Sienese. His Catholic Majesty replied that such an alteration in his plans was impossible, that he—the Emperor—had already issued his orders from which there was no departing. Our ambassador answered asking His Majesty at least to give him some reason for such an inexorable command; whereupon His Majesty answered: *Sic volo, sic iubeo, stat pro ratione voluntas* (I wish it, I order it; the reason is my will). After this he dismissed the ambassador, exchanging no further word with him."

The Sienese, who would rather die than renounce the freedom of their own opinion, found the absolutism of the Emperor quite inconceivable. They were bewildered: their pride had sustained a great shock.

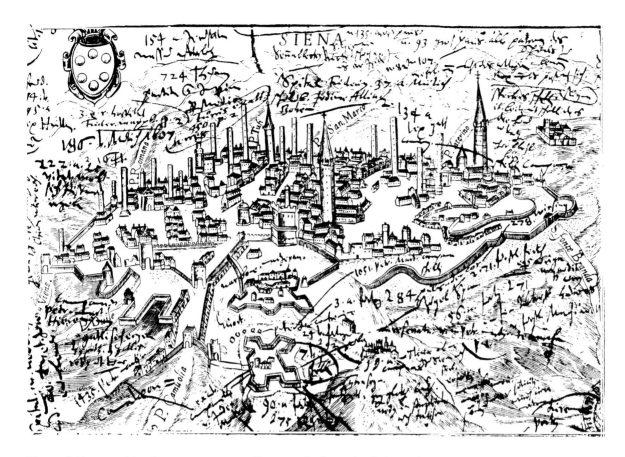

View of Siena. Etching by Francesco Bertelli, towards the end of the 16th century, with hand-written notes. *City Museum, Town Hall, Siena.*

Meanwhile, in Siena, under the imperial representative, Don Diego Hurtado de Mendoza, the building of the fortress began in what today is the Lizza Gardens, not far from the Church of San Domenico.

Once more the Sienese turned to their Protectress, the Holy Virgin, for help in their trouble. During the temporary absence of Don Diego in Rome, the City Fathers, who had lately received the title of 'priori', together with a great crowd of the inhabitants, gathered to walk in solemn procession to the Cathedral, where, after prayer and after receiving Holy Communion, they laid the keys of the city before the 'Madonna del Voto'.

Hearing of this event, Don Diego sent reinforcements to strengthen the garrison at Siena. Feeling in the town now reached fever-pitch. After consultation with the Magistracy the 'priori' resolved to send another ambassador to the Emperor Charles V. But when he too returned with a negative answer the people gathered in the churches entreating help from heaven and groups of flagellants were to be seen walking through the streets.

In the meantime, exiled citizens had assured the French King's ambassador in Rome, Cardinal de Tournon, that Siena would be happy to accept the protection of His Most Christian Majesty; and as in the town of Siena itself a number of influential personages had clandestinely declared their adherence to France, allied troops from the Sienese territories were called together in great haste and placed under the leadership of the young Sienese nobleman Enea Piccolomini. On 26 July 1552,

the little army gathered near the town, advancing towards the Porta Nuova. On that day Don Diego Hurtado de Mendoza was absent from Siena. His deputy, Don Franzese, did his best to suppress the insurrection, but could not bring himself to arrest the leading citizens and hold them as hostages. The further rapidly succeeding events of that day are related by Sozzini in his Diary:

Sozzini

"It so happened that in the house of the Cerini family, near the fountain of S. Giusto, seven or eight young men were holding some sort of celebration late at night. They were standing out in the street when three Spaniards belonging to Captain Paceco's company from the Servi quarter of the town came towards the lads and ordered them back into the house. Thereupon a scuffle ensued, whereby one of the Spaniards met his death at the hand of the notary Francesco Cosimi. The other two Spaniards fled; the dead man's body was removed.

"The Sienese, who were waiting to be released by those brave conspirators, when they heard of what had happened that night rose in rebellion, arming themselves with the few weapons that had been hidden and had escaped discovery. Heaps of stones were collected and piled everywhere before the windows and at one o'clock in the morning the armed citizens moved off to cries of 'France! France! Victory and Freedom!' These cries struck terror into the hearts of the Spaniards: simultaneously in every window lights sprang up out of the darkness until the whole city was lighted as bright as by day.

"Those in the French camp outside Porta Nuova, hearing the noise from the city which seemed to be in their favour, approached as far as the monastery of the brothers of Angioli, and when they heard cries of 'France! France!' they advanced as far as the Convent of the Nuns of Ognissanti, where they were held up for a while by an attack of a few Spaniards who had gathered on the bulwarks above the Porta Nuova. This delay prevented the men from the French camp from getting near enough to set fire to the city gate. But Signor Enea delle Papesse Piccolomini, brave and daring as he was, discovered in a room in the Convent a great deal of dry brushwood and snatching up a bundle he shouted: 'Let him who is a man, who loves his fatherland and loves me and will free his city from the Spaniards, each take his bundle and follow me!' Many noblemen who had joined the French camp from their estates outside the town, and also a number of youths from the district of Fontebranda, followed Signor Enea's example, who meanwhile, regardless of danger, had laid his firewood bundle up against the gates. Each man brought his bundle and stacked it before the gate and then the whole was set alight. The Spaniards above the gate did all they could by throwing down stones and shooting with their arquebuses. But thanks be to God, they could not do much damage except for inflicting a severe head-wound on Annibale de' Martini which nearly caused his death, but from which he eventually recovered. When the main guard of the Spaniards saw the gate of Porta Nuova in flames and realised that outside it there stood eight or ten thousand men ready to hew them in pieces, they began to take alarm and banded themselves together, gathering into a strong formation on the square. When the troops under Captain Paceco, who were waiting in the Servi quarter of the town, moved towards the Campo by order of the Field-marshal to join the rest of the Spaniards, they were met with a rain of stones in every street through which they had to pass, stones which wounded many soldiers and caused them to quicken their pace to a run rather than a trot..."

With this hail of stones the Sienese women revenged themselves for all the insults they had received from the Spanish mercenaries. Although the Spanish were reinforced by four hundred Florentine militia from Duke Cosimo dei Medici's company, they could not deal with the situation. Meanwhile a strong French relief-army under the command of Cardinal Farnese entered Siena. Duke Cosimo, fearing the outbreak of a general war between France and Spain in Tuscany, offered to act as inter-

mediary, which resulted in an agreement that the Florentines and Spaniards should retire with all the honours of war and that Siena should continue to enjoy the protection of Charles v. On 5 August 1552 the Spaniards and Florentines withdrew from the newly-erected fortress on the Lizza. Sozzini's description reads as follows:

Sozzini

"...The last to leave was Field-marshal Don Franzese. As he passed, he saw many Sienese youths who had been very friendly with him on account of his good qualities (for he was as gentle as a maiden). And as he saluted them there was one among them, a good friend of his, Signor Ottavio Sozzini, who addressed Don Franzese with the following words: 'Don Franzese, whether friend or foe, I at any rate, as a true nobleman, would like to say that, apart from the interests of the Republic, Ottavio Sozzini is, and will always remain, your friend and servant.' To this Don Franzese responded, with tears in his eyes: 'I thank you for your good opinion which I will never requite with evil.' Then, turning to the others who had saluted him he made the following significant remark: 'You brave Sienese carried out a splendid surprise attack; but in future take care, for you have insulted too powerful a personage...'

DESTRUCTION OF THE SPANISH FORT

"As soon as the Spanish and Florentines had left the Citadel, M. de Lansach, representing Monsignor de Termes, entered it with his company and took up his quarters there. He sent messengers to the heads of government and their commanding officer to assemble in the Citadel, as he intended, according to contract, to hand it over to them to do with it as they thought best. The bells rang in the city to call the assembly together, the Councillors, the commanding officer, and all the city officials and the Magistracy formed into procession. Before the city elders the banner of Our Blessed Lady was carried. Each man was crowned with fresh olive-leaves and the procession was brought up by a huge crowd of the inhabitants who were followed by the clergy. Many people brought with them pickaxes, hoes, hammers, iron bars, and other tools, with which to demolish the Citadel, all looking as pleased as if they were off to a wedding. As soon as the procession reached the Citadel the aforementioned M. de Lansach, in the name of the Christian King of France, and as his deputy, drew up a deed presenting the Citadel to the Republic..."

The chief Councillor of the city ordered that the fort be demolished, whereupon the entire population, weeping tears of joy, began to take it to pieces stone by stone with such eagerness that within one hour the walls were razed to the ground.

After this the city gave itself up for days on end to celebrating the event. The Madonna del Voto was carried in procession through the streets, old party quarrels were forgotten and every man resolved in future to live at peace with his neighbour.

But Charles v had resolved to make Siena pay the penalty for its behaviour and to this end he

The Holy Virgin spreads Her protecting cloak over Siena. Woodcut of the 16th century. *City Museum, Town Hall, Siena.*

gathered a great army in the territory around Naples. The Sienese left off celebrating festivals and set to work with great energy to fortify their town.

The support which Siena received from the French came under the command of Piero Strozzi, a personal enemy of Cosimo dei Medici. The latter now intervened in the war and sent his general, Giovanni Iacopo dei Medici, the Marquis Marignano, with troops against Siena, and Charles v put four thousand Spanish soldiers and a company of German mercenaries at his disposal. The Marquis Marignano hoped to carry out a surprise attack. On 26 January 1554 he crossed the frontier suddenly with his army and approached the town by forced marches. Sozzini reports as follows:

"At seven o'clock in the evening the enemy arrived before the defences of Camollia and finding no resistance they succeeded in forcing an entrance and taking possession of the fort. It is said that the army consisted of about six thousand Italian infantry, five hundred Spaniards, and two hundred horsemen. But fifteen Neapolitan soldiers had taken up their position on the bulwark of the 'Madonna dipinta', with provisions for six days of bread, wine, and ammunitions. They were armed with muskets and as the enemy emerged they killed off as many as possible. In spite of this the enemy troops forced the first and the second bulwark, entered S. Croce and the cemetery and took possession of the Sun Tavern, and broke in the iron gates with battering-rams. A Spanish non-commissioned officer stood before the gate, stuck his sword through a chink, and shouted in Spanish: 'Open the gate! Don Diego Hurtado de Mendoza wishes to enter here!'"

The Marquis, finding it impossible to surprise Siena by sudden assault, laid siege to the city, devastating the countryside and cutting off supplies of foodstuffs. Any peasant who was caught attempting to bring food into the town was hanged by the enemy from the trees outside.

Piero Strozzi meanwhile planned to attack Florence with the support of his allies and to rid the city of the Medici, who had enemies even in their own town. Henri ii, King of France, had promised to send an army of Gascons and Germans to his assistance, which would join Strozzi's troops at Lucca; meanwhile the Florentine exiles under Bindo Altoviti would attack Florentine territory from the south. In June 1554 Strozzi succeeded in putting his plans into action and broke through the enemy lines by way of Casole, Volterra, and Pontedera, reaching the Arno, where he crossed the river and joined the French auxiliaries as arranged at Lucca. The Marquis Marignano, at first surprised by the attack on Florence, took up the pursuit, himself crossed the Arno, and gathered his troops together in Pistoia. Strozzi now waited in vain for the army of exiled Florentines which was to have approached to the attack from the south through the Chiana valley after reaching Viareggio with the Algerian fleet. But the arrival of this army was delayed through personal intrigues and Strozzi was compelled to retire in order to avoid being surrounded by Marquis Marignano's troops, which had meanwhile increased in numbers. By making another surprise-crossing of the Arno he successfully reached the Maremma unobserved. Here, at Buonconvento, he joined the Florentine army of exiles which had meanwhile landed at last in Port'Ercole. Marshalling both armies together he returned and encamped outside Siena before the Porta Romana.

Piero Strozzi had requested the French King to put at his disposal an experienced officer who could command the defence of Siena while he himself was absent outside the town fighting against the imperial army. Henri ii sent Blaise de Montluc, a Gascon, who henceforth, as representative of the French King, took part in the government of the city, winning the respect and devotion of the Sienese. He reached the city simultaneously with the return of Strozzi's armies.

Instead of immediately launching an attack on the imperial army, whose morale was shaken by the sudden arrival of the French and Sienese armies, Strozzi hesitated and finally retired once more to the Chiana valley, pursued by Marquis Marignano's troops. The main advantage over the enemy

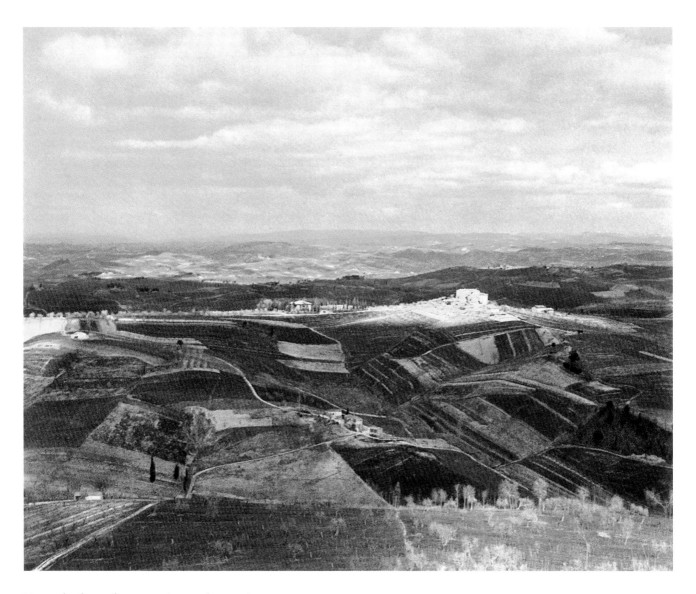

Tuscan landscape between Siena and San Gimignano.

which the Franco-Sienese army possessed was its cavalry. As the country was unsuitable for horse-men Strozzi resolved to withdraw still further, as far as Lucignano. Although Blaise de Montluc begged him emphatically to carry out the retreat by night, Strozzi, acting from a false sense of chival-rous pride, broke camp in daylight on 2 August. The enemy attacked him in country unfavourable to his horsemen near Marciano, where he suffered a terrible defeat, of which Sozzini reports as follows in his Diary:

"...In the overthrow of Signor Piero's army he lost ninety standard-bearers of the infantry and fifty of the cavalry. The remainder were saved, for they fled from the battle. Those who fought were nearly all killed. Among the fallen were Signor Giovannino Bentivogli, Captain of the Cavalry, and Captain Antonio Galeazzo of the Infantry, both of whom were natural brothers of Signor Cor-nelio. Many Gascons and Swiss troops, some from the Grisons, were captured, stripped of their pos-

sessions and then set free. When the trumpet sounded calling all troops together, about twelve thousand men were missing from the French camp, either fallen in battle or captured and carried off to Florence.

"No one who saw all these soldiers of different nationalities returning to Siena robbed, wounded, maltreated, falling in the streets weeping, or lying on benches and low walls—for the hospital was crowded with four in each bed, every seat and table held the wounded, and even the church was full, so that others had no alternative but to lie down in the open streets—no one, I say, who witnessed all this could keep back the tears even were his heart made of stone. It was a horrible scene: the streets crammed with the wounded, the heartbreaking laments, particularly the cries of the Germans and French, men begging for a sip of water or a little salt for their wounds: all beholders were moved to pity. Men and women brought salt, bread, and wine to relieve the wounded as best they could. But I myself can testify to having seen more than a hundred men turn their heads to the wall weeping at the sight of the misery of these poor wretched soldiers who had endured such a day of slaughter...

"On the 6th of the same month the erection of a fort to the left, beside the Porta Nuova, was begun. The Convent of the Nuns of Ognissanti, near the gate on the right, was demolished. On the same day, the soldiers who had guarded the two small forts outside the Gate of S. Marco were withdrawn, as there was now a shortage of guards. And also on the same day the remainder of the imperial army arrived at Badia al Piano, where previously the cavalry had camped, spreading out over the territory up to San Lazzaro. On the roads they confiscated many packhorses laden with flour and corn, so that on that day little food reached the city intact, and the road to Rome had become impassable..."

THE BLOCKADE From now onwards Siena entered into a state of siege with all the attendant horrors of starvation and bombardment. Montluc promised the Sienese the assistance of the French King and the city elders swore they "would as soon eat their own sons as see themselves surrender to the enemy". It was therefore decided to send out of the town all those persons who were not actually engaged in the defence of the city, in order to have fewer mouths to feed. In October 1554 two hundred and fifty children between the ages of six and ten, from the Orphanage of the Hospice Santa Maria della Scala, escorted by four companies of soldiers and accompanied by many men and women, left the town. But the Spaniards defeated the escort and fell upon the cavalcade of children, confiscating the pack- and saddle-horses. Sozzini writes:

Sozzini "... [The Spaniards] began by cutting the saddle-girths through, so that all the children fell off the horses on to the ground, some being killed and some injured. Many of the women accompanying them were killed. As all the pack-horses had been seized there was nothing left for the escort to do but to return home to the city. In the morning the surviving children were found outside the Gate of Fontebranda (where formerly once a year a pig-market used to be held) lying on the bare ground, sobbing and crying desperately..."

In November the French troops were forced to commandeer the city's store of wheat. Sozzini writes:

Sozzini "... On that day the four city officials who administered the distribution of corn, accompanied by the King's agents, took possession of the Hospital Warehouse keys, after promising the Hospital administrator to allocate him ten measures of corn each month for the maintenance of the orphans, girls and young women in his charge. But after the first month no further allocation was made, and the inmates of the Hospice began to suffer severely. A proposal was made to distribute the orphan girls in the city, one each to any family where there was still a store of food; but the boys were to be sent out of town. Every day crowds of orphans left the city to collect firewood in the surroundings, which they exchanged for bread to keep from starving outright. This state of affairs called forth the

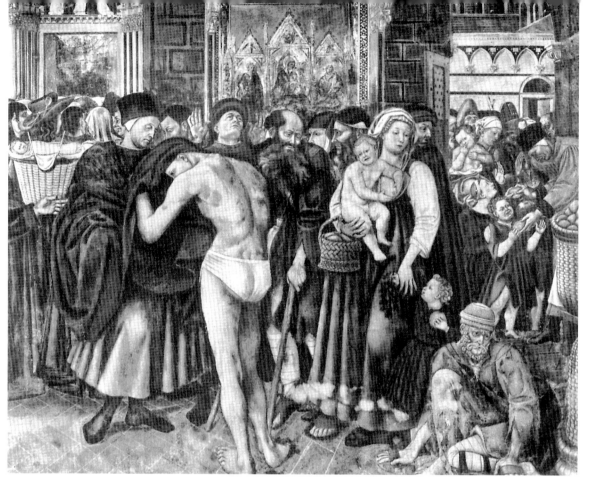

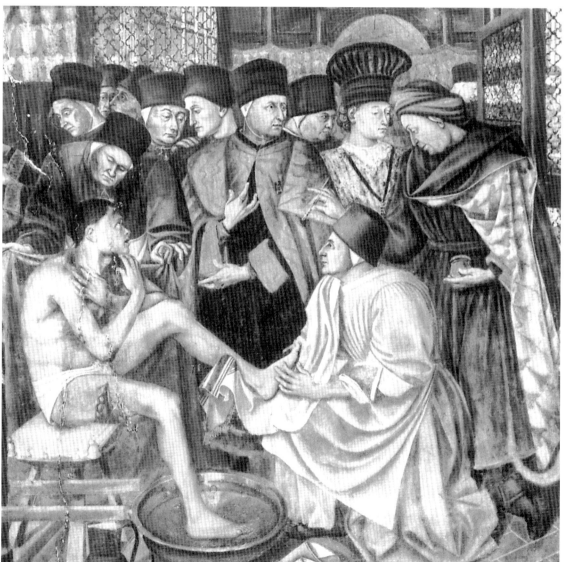

Care of the sick and
distribution of alms.
From the fresco by
Domenico di Bar-
tolo in the Inferme-
ria del Pellegri-
naggio in the Hos-
pice of Santa Maria
della Scala.
1441–1444.

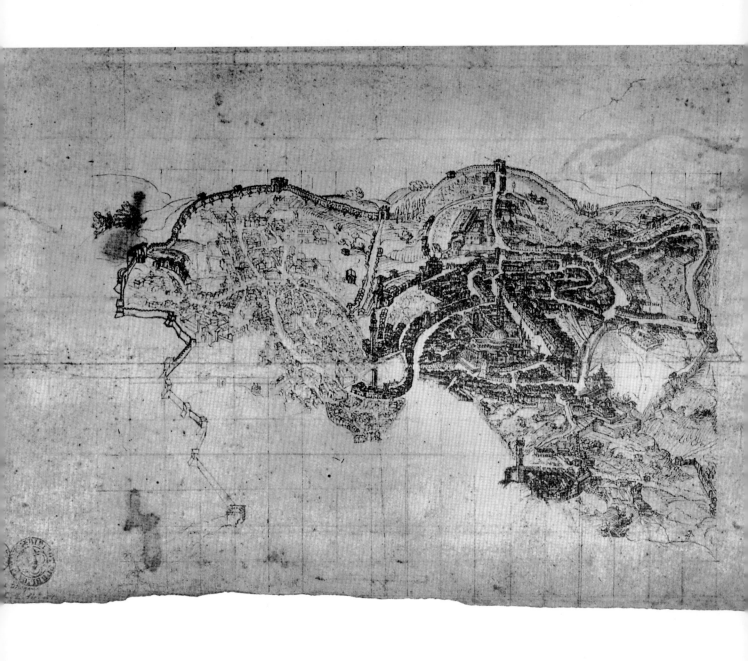

Bird's-eye view of Siena. Pen and ink drawing of the 17th century. *City Museum, Town Hall, Siena.*

anger of many citizens. Their opinion was that the benevolent work of such a holy house as the Hospice of Santa Maria della Scala gave Siena reason to expect the glorious Mother of God to plead with Her only-begotten Son to release the city from the dangers encompassing her. But now the Holy Mother would see bread taken from Her children and given to strangers, while Her protégées suffered at the hand of the enemy. It was to be feared that Her anger was aroused and that She would be deaf to our prayers and would ask the Lord to mete out to us just punishment for such a sin…"

Four months' hunger, and the news that Marquis Marignano was bringing up strong reinforcements of artillery against Siena, discouraged many of the leading citizens. In his 'Comments' Montluc writes:

"Towards 20 January news reached us that the artillery was approaching from Florence, with 26 or 28 cannon or large culverins. Spies were sent out from Siena to discover what was true in this rumour. They found that the artillery had reached Lucignano. I was somewhat uneasy on hearing this news. The next day a meeting of the nobility and citizens was called in the Town Hall to discuss whether the attack should be resisted or whether negotiations should be entered into with the Marquis. For me to have shown anger would have been useless, for I was outnumbered; and one must seek to win these people over with sensible argument and quiet persuasion, without threat or anger. Believe me, I had difficulty in restraining myself… Among Germans or Swiss one must be brazen; among Spaniards, sinister and haughty, pretending to be more pious than one really is; among Italians be tactful and cautious, not insulting them or making love to their women; with the French one can do whatever one likes…" Montluc

One of the elders in the Sienese government gave Montluc to understand that the meeting was more likely to vote for negotiation than for armed resistance. Montluc goes on to write as follows:

"I was still so exhausted after my illness that I went about the town muffled up in the bitter cold, wrapped up in furs. Nobody seeing me in such shape would have any confidence in my health, they must all have thought I was in a slow decline. Women and timid persons (of whom there are many in every city) said: 'Whatever shall we do if our Governor dies? We should be lost, for except for God we trust only in him…' So I got out a pair of boots made of scarlet velvet that I had brought from Alba, with gold bordering, cut low and well made, which I had specially made for myself at a time when I was courting… I also put on a doublet and, to go with it, a shirt richly ornamented with scarlet silk and gold thread (it was the fashion then to wear the shirt-collar slightly turned down) and over that a collar of buffalo-leather; to complete it all I had my coat of arms in gold relief put on my breast-plate. The colours I had been wearing were grey and white in honour of a lady whose humble servant I was whenever I was at leisure. I also possessed a hat made of grey silk in the German fashion with a heavy silver cord and heron's feathers… Over my shoulders I threw a loose coat of grey velvet encrusted all over with rows of little silver braids each about two fingers' breadth apart, lined with silver cloth and cut away between each braiding. In Piedmont I used to wear it over the cuirass. I still had two little bottles of the Greek wine which the Marquis d'Armagnac had sent to me: some of this wine I rubbed into my hands and then washed my face with it until a little colour came into my cheeks. I then drank three thimblefuls of it and ate a scrap of bread and finally inspected myself in the mirror. I swear I could hardly recognize myself: I could almost believe I was still in Piedmont and in love, as I was then: indeed, I could scarcely keep from laughing for it looked as though God had suddenly given me quite a new face.

"The first to arrive at my house with his chief officers was Signor Cornelio, together with Count de Gayas, Commissioner de Bassompierre, and Count de Bisque, for all of whom I had sent, who, Montluc

on seeing me so dressed up, began to laugh. I stalked about the room as bold as fourteen men all rolled into one, though actually I had not the strength to kill a chicken…"

As soon as the chief officers of the Italian, the French, and the German troops had all arrived, Montluc proceeded with them to the Town Hall:

"As we ascended the steps leading to the Great Hall we found it filled with nobles and citizens belonging to the city government. Now, at the left, there is a small hall which is kept for the meetings of the Captain of Militia, the twelve Councillors, and the Eight of War: these men form the Magistracy… At first I entered the Great Hall, removing my hat in greeting. No one recognized me: they all took me for some nobleman or other whom Signor Strozzi had detailed to direct the defence of the city. Feeling weak I went on into the smaller hall, followed by all the chief officers and the captains, who remained standing at attention in the doorway. I went and sat down next to the Captain of Militia, on the chair reserved for the King's representative. As I did so I smiled first at one and then at another, my hat in my hand. Everyone showed astonishment as they watched me seating myself and two of them had just begun to speak their minds on the subject when I plunged into a speech in Italian, as follows:

MONTLUC'S SPEECH

'Gentlemen, I have been told that when the news came that the enemy had actually brought their artillery into position, certain disagreements broke out amongst you, witnessing rather to anxiety and fear than to stern determination to defend your city and your liberty at the point of the sword. This seemed strange to me, and it astonished me so much that I could hardly believe it. However, at last I resolved to come with the chief officers of the troops of three nations whom the King has stationed in this town, to meet you personally and to learn from you the truth of the rumours which are going about. Now, gentlemen, I beg you to think over and most carefully weigh the advice of this meeting to which you have been called, for upon the resolution which this Council will formulate depends the honour, the greatness, the power and the security of your State, your lives, and the preservation of your ancient liberty, or on the contrary it can bring shame, dishonour, censure, and lasting disgrace on your children and ignominy on your ancestors who left you such a grand inheritance, which was always defended with the sword against despoilers. You are now given the opportunity, at the price of half your possession, to show the whole of Christendom that you are worthy to be the sons of your ancestors who fought so often to uphold your freedom. Is it really possible that Sienese hearts, these stalwart Sienese hearts, should be terror-stricken on hearing tell of artillery? Are you really capable of being intimidated? I cannot believe such a thing of you who have shown such courage. It cannot be the outcome of a lack of friendship or of confidence towards the Christian King; nor can it be that you mutually distrust each other on account of any special political parties in your town, for I have never heard that you were at variance: on the contrary, I always found you united at all such times when it was a question of maintaining your liberty and high position. I always saw you resolved rather to die under arms than to be robbed of your freedom… You are not lacking in courage, for never was there a sudden foray without one of your young men distinguishing himself even amongst older and more experienced soldiers. I cannot imagine that a people capable of such things could lose courage at the sound of cannon—which are more noisy than dangerous—nor that such people should be ready to sell themselves into slavery either to the insufferable Spanish nation or to old enemies among their neighbours. Therefore, as this cannot reflect your real character, it must be my fault, who have the honour to be the representative of your friend and protector the King of France. Perhaps you have thought I have not the health and stamina to take upon me the task of enduring the attacks of the enemy, that my serious illness has weakened me too much; but rest assured on that point: brute strength is not everything. The great Captain

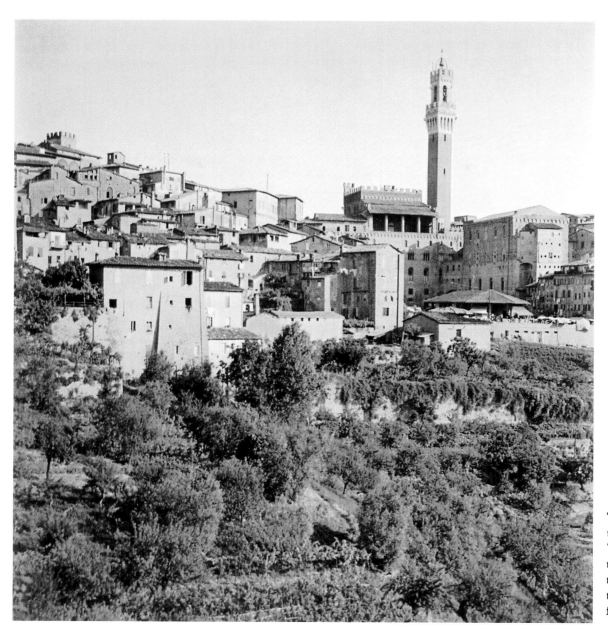

The ward of the town known as the 'City' ward, with the Town Hall and the Market, seen in the early morning from Sant'Agostino.

de Lève, gouty and weak as he was, won more battles from his chair than did any other living man who was on horseback...

'... Now, gentlemen, I am convinced that you realize your own power and you know that you would be bringing on yourselves lasting shame if your decision were any other than a resolve to defend yourselves without counting the losses which may be involved...

'... I now ask you unanimously to draw up a resolution such as only brave men of your calibre can do: to die sword in hand rather than be deprived of your position and liberty. We all, myself and all the leaders and officers whom you see here, swear by the Lord God that we are all ready to die with you, as we will show you when the hour comes—not seeking our own advancement or monetary advantage nor considering our own comfort—for you can see we are enduring hunger

107

and thirst at this moment—but only because it is our duty, and in order to keep the oath we swore, so that it can be said—and you yourselves will witness to it—that we were those who defended the liberty of this city and that posterity will know us as the protectors of the Sienese.'

"Hereupon I rose and told the German interpreter to keep my speech well in mind, to be able to repeat it to Captain Reincroc and his chief officers. Then I addressed the officers present saying: 'Signori miei e fratelli, giuriamo tutti e promettiamo innanzi Iddio che noi moriremo tutti l'arme in mano con essi loro per aiutarli a diffendere lor sicurezza e libertà, e ogni uno di noi s'obblighi per gli suoi soldati; e alzate tutti le vostre mani!' Each man concerned raised his hand. The interpreter repeated it to the Captain who at once also raised his hand and all his officers followed suit, crying: 'Io, io, huerlic' (Alemannic: 'Jo, jo, herrlig!') and the others cried: 'Oui, oui, nous promettons!' each in his own language..."

About the bombardment of Siena Sozzini writes:

"... During that same night all the guards near Porta d'Ovile heard the rumble of wheels, heavy cannon-waggons advancing towards Poggio di Ravacciano. Sentries making the rounds of the walls asked the guards what these sounds might be. The guards replied that they thought about twenty heavy guns had been brought to Poggio and placed in position in the entrenchment, which already held twenty such other cannon. The next day was therefore expected to bring a still more intense bombardment than the previous one, and each man mounted guard with his weapon in his hand. At midnight the moon rose and many young men now went to the bulwark of San Lorenzo to see if new entrenchments were being thrown up, but they could distinguish nothing. At last the red dawn came and everyone was wide awake expecting at any moment to hear the sound of guns, but all was still silent. When, from the East, the sun rose high one could see that the openings in the entrenchment for the mouth of each cannon were empty, for the imperial army had moved the artillery to Croce dell'Osservanza; seeing this a sigh of pleasurable relief went round.

"When the sun had risen somewhat higher the French sent men to the entrenchments to reconnoitre: there they found neither soldiers nor artillery. The sounds the sentries had heard which they believed to be the bringing up of reserve cannon turned out, on the contrary, to be the noise of the guns being removed... Thereupon the officers gave all the Sienese companies permission to leave their posts and to take a rest, for they were all very tired after being on duty day and night. This order pleased the men, and not least myself."

Sozzini goes on to report:

Sozzini

"That day, about mid-day, many young Sienese met on the great Square (the Campo), took off their heavy clothing, and performed, in their doublets, an elaborate round dance which took up more than half of the Square. They then chose two leaders, divided into two sides, and played a wonderful ball-game for two hours or more. All the French officers stood around to watch, surprised at our follies; for yesterday the town was under bombardment and today we played ball-games.

"The sentries' cook, Bernino, a brave young fellow, had three days earlier taken prisoner a young Spanish nobleman who wore a very beautiful jerkin. A sudden idea occurred to Bernino: he went to fetch the prisoner, had his uniform removed leaving him clothed in his doublet with its red sash, and then let him take part in the ball-game. He was more admired than all the others, for he was very agile and beat everyone else in jumping and running. At the finish of the game the trumpet-call sounded and each man returned to his particular ward of the city, and then a great boxing-match took place. M. de Montluc, the Governor, was so enthusiastic that he nearly wept and told the players they were the bravest lads he had ever seen. Whereupon some of them answered: 'Just imagine how

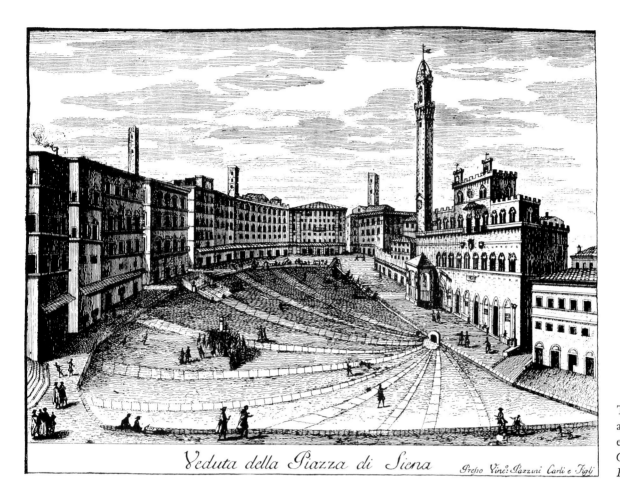

Veduta della Piazza di Siena

Presso Vinc: Pazzini Carli e Figl.

we could beat the enemy, we who are capable of fighting each other like this and yet, in the evening, we are all friends again.' As the boxing came to an end the call sounded: 'Mount guard, Mount guard!' At once they all left the Square to take up arms again and returned each man to his post…"

The Sienese had enlarged the belt of the city walls to an extent that precluded the direct bombardment of the town by gun-fire. From time to time the idea had occurred to Montluc to take advantage of this fact to lure the enemy into an ambush, his idea being to allow them to enter one of the gates—which would afterwards be barred to their retreat by gun-fire—and then to attack them from all sides with pikes, halberds, and swords in the space between the wall and the inside entrenchment. In this connection he writes:

"… In the evening the Marquis posted his artillery on a small hill between Porta Ovile and the Osservanza Monastery. This particular position put me and my secret plan in rather a predicament, for the Porta Ovile is built with a large projecting front-structure: the houses of that part of the city almost touch and are only separated by the street, leaving no room to construct an entrenchment without demolishing at least a hundred houses. This I was reluctant to do, as it might produce hostility in our midst, for the poor citizen who must look on while his house is being razed to the ground is likely to lose patience… But just see the exemplary behaviour of the people! I will describe it so that it shall serve as a model to posterity and to all who value their liberty. Instead of showing anger or sorrow at the loss of their homes the unfortunate inhabitants themselves were the first to begin on the work, each one lending a hand. There were never less than four thousand souls on that site, all

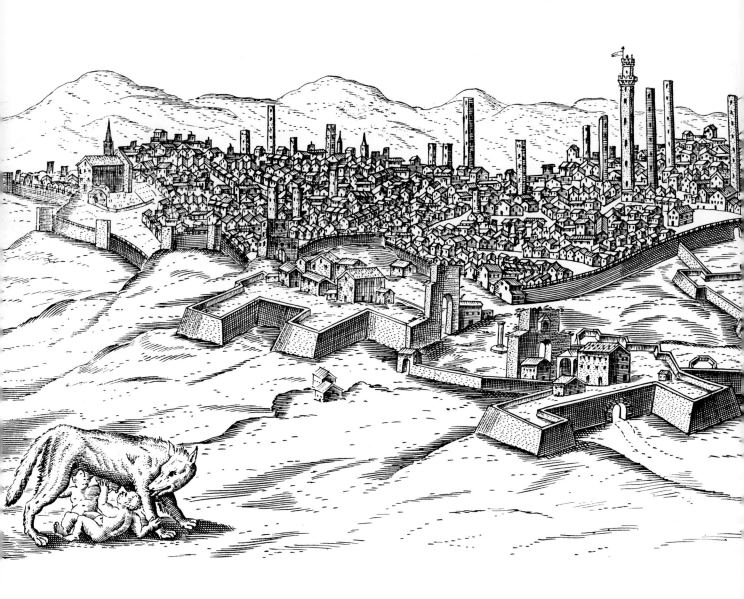

View of Siena from the north showing the fortifications built at the time of the siege.

THE WOMEN
OF SIENA
busy helping in the demolition. And certain Sienese aristocrats pointed out to me a number of noble ladies each carrying earth in a basket on her head. You noble Sienese ladies, as long as Montluc's book exists, it will continue to sing your praise: for verily, if ever women were worthy of lasting fame, it is the women of Siena!"

"At once, after the people of Siena had taken their splendid decision to defend their liberty, the womenfolk of the town divided themselves into three groups. The first was led by Signora Forteguerra. She was clad in violet, as were also all her followers, in short garments like nymphs, showing up to the knee the crossed ribands around the leg. The second group was headed by Signora Piccolomini, in bright pink, her troop of women similarly attired. The third division was under Signora

110

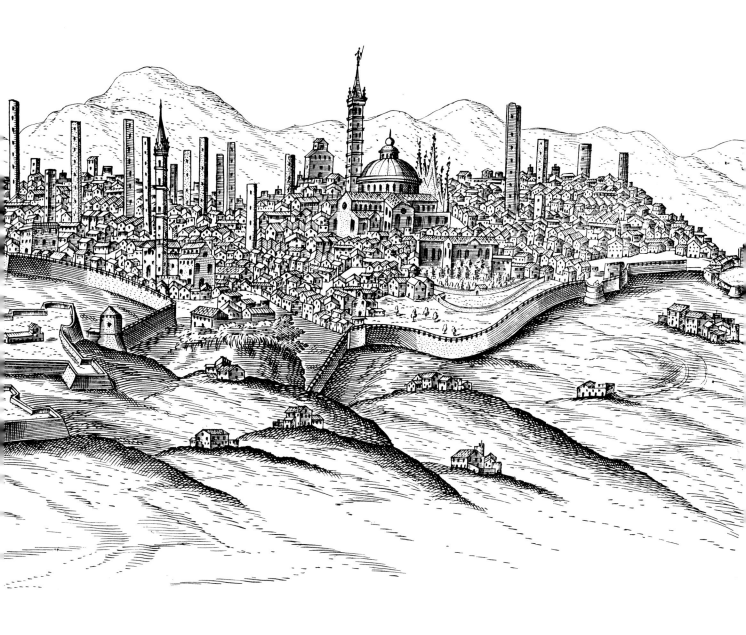

From a 16th century engraving. *City Museum, Town Hall, Siena.*

Livia Fausta, dressed, with all her women, in white, carrying a white banner. Upon each banner was inscribed a beautiful motto and I would give a great deal to be able to remember the words today.

"These three troops, counting three thousand women in all, were composed of aristocrats as well as of townsfolk. Their weapons were pickaxes, shovels, back-baskets [*gerle*], and bundles of faggots. Armed in this manner they set out to build the fortifications. Monsignor de Termes, who has often retold the tale (for at that time I was not yet stationed in Siena), has assured me he had never seen a more beautiful sight. At a later date I saw their banners. They used to sing a song which they had composed in honour of France; I would gladly sacrifice the best horse in my possession to be able here to quote the words of that song.

"And while I am writing in praise of these women, let me tell you of one who, although she was the daughter of humble people, should be in the forefront of honour, that all who come after may admire the courage and virtue of this young Sienese girl. During the time when I was given supreme authority in Siena, I ordered that any man who failed to take his turn on sentry-duty should be punished. Now it so happened that the above-mentioned girl realized that one of her brothers, whose turn it was, could not go on guard and would be penalized, so she put on his helmet, slipped into his boots and the buffalo-leather collar, and shouldered his halberd, and in this get-up she took his place on sentry-duty. At the roll-call she answered in his name and then made his rounds all night, not being recognized until the dawn broke. The other guards accompanied her home with great honour and after a meal Signor Cornelio presented her to me."

THE FAMINE

Montluc

As the stores of food were running short it was again decided that the town should be relieved of all those who could not take part in the defence of the city. About this Montluc writes:

"...They could not agree which people were to be considered as 'superfluous mouths', for one person wanted this man and the other wanted that one to be spared. Accordingly they voted for me as Governor to have supreme authority for a month. During that time neither the Commanding Officer nor the Magistracy issued any orders: I alone had the rank and dignity which belonged in ancient times to the Roman dictators. So I chose six commissioners who should make a list of the superfluous persons' names, and a Knight of St. John of Malta, together with twenty-five or thirty soldiers, was commanded to lead these people out of the town. This all took place three days after I had issued the order. Had I not the Sienese themselves and the King's officers who were stationed along with me in the town as witnesses of what I say, I would not write this report for fear I should be called a liar; but what I write is an absolute fact: I assure you the number of the 'superfluous mouths' on that list counted over 4,400 souls. Of all the misery and the piteous sights I have ever witnessed, this was the worst, and I shall never see anything to compare with it. Master was forced to abandon his faithful old servant, mistress her lady's-maid, not even to mention the numberless poor souls who lived by the work of their hands. The weeping and misery of the exodus lasted three whole days: all these wretched people had to pass through the ranks of the enemy, who forced them back again towards the city walls, to do which their camp remained day and night under arms, for they threw the exiled people back to the foot of the wall, trying to compel us to take them in again, so that our remaining small store of food might the sooner be exhausted. Thus the enemy hoped to excite the town to pity for their erstwhile menservants and waiting-women; but in vain. For eight days this went on. The people had no other food but herbs and more than half of them succumbed or were killed outright by the enemy, only very few succeeding in escaping. There were among them a great number of young girls and lovely women: these the enemy allowed to pass through their lines, for at night some of them were fetched by Spanish soldiers for their own ends, though this was done without the knowledge of the Marquis, for had he known, their lives would have been forfeited. A few specially dogged and brave men managed to slip through during the darkness, but these did not represent even a quarter of the total number and all the rest found their death. Such are the laws of war: if one will outwit the enemy one must be cruel. Indeed God must be very merciful to us, who do so much wrong."

In March of the same year, Sozzini writes:

Sozzini

"Courage was at its lowest ebb for it was plain to anyone who cared to face the obvious facts that the town was heading for a terrible catastrophe. As far as one could see in the whole city there was only bread enough to last until the twentieth of the month. In all the monasteries the monks and nuns were already starving, for the Monastery of the Osservanza could no longer supply them with

APREXENTATIONE DELECHIAVI QVANDO TVT
EQVATRO EMONTI SADVSSENO ADVNO

QVESTE LENTRATE E LVSCITA DELLA GENERALE CABELLA DEL MAGNIFI
COMVNO DISIENA P TEMPO DVNO AÑO INCOMICIATO ADI P DI DIGENAIO M
CCCC LXXXII & FINITO ADI VETIMO DI DICEJBRE MCCCC LXXXIII ALTEJPP
DELI SPECTABILI HOMINI PAVOLO DILANDO FSBERGHIERI K E MIS ANGNIO
DORBANO DEL TESTA GIOVANI DANTII DINERI MARTINI ANTONIO DIMARIA
PACINELLI GIOVANI DI FRACESCHO GHABRIELLI EXECVTORI
PELPMI SEI MESI & MISS SAVINO DIMEO DANT DIGHVIDO AN
TONI DIBARTA SPINELI BART CRISTOFANO BERT BART DANTI
DIGHVELF EXECVTORI P LSECODI SEI MESI ANGNIOLO DIM
DILOREZO SCPTORE S'ANGNIOLO DIMEO DANGNIOLO DIGH
NO PLLP SEI MESI & GIOVANI DINICHOLO CECHINI P L SECOSEIMESI

The Magistracy presents the keys of the City to the Madonna del Voto in the Cathedral. In the background the High Altar with the picture by Duccio di Buoninsegna. Miniature on the cover of a city account book *(biccherna)* of the year 1483. *State Archives*, Siena.

food and they were all at the point of death. People still cherished in their hearts a glimmer of hope and faith in the goodness of God Almighty, believing in the intercession of His most glorious Mother, the ever-virgin Mary, Our Lady, intercessor and protectress. Accordingly, as so often in the past, the Magistracy resolved to place the keys of the city in the keeping of Our Blessed Lady, with every

ceremonial which the elders of the town considered fitting. The citizens were bidden to forgive one another past insults and in the face of the extremity into which party quarrels had brought the city to lay aside all thoughts of revenge and commit their souls to God, entreating Him in His unfailing mercy—not because of any merit of their own—to rescue the town from the destruction and annihilation which threatened it...

"On Sunday, 24 March, the day before the Feast of the Annunciation, the clergy, the Captain of Militia, the ensigns and all the city officials proceeded to the Cathedral, without any fanfare of trumpets. They were clad in violet capes, bearing the Standard of Our Blessed Lady, carrying a silver dish wherein lay the keys of the city. Arrived at the Cathedral they humbly renounced their usual seats on the tribunes, taking lower places in the chancel below the music-chapel. Neither choir nor organ-music was heard: the Mass of the Holy Virgin was read—chanted by the venerable Prebendary Bernardino di Girolamo Maccabruni. After the Mass the Chief Councillor, Signor Girolamo Tantucci, offered up the silver dish containing the keys of the city to the glorious Virgin Mary, Protectress of the City of Siena, with reverent words, which, for the sake of brevity, I will not repeat here..."

In the face of Siena's hopeless plight the Council resolved to parley with the enemy. Sozzini writes in this connection:

Sozzini "On 29 March, at four o'clock in the afternoon, Signor Alessandro Guglielmi came out of Siena bearing a letter and having full powers to negotiate with the enemy in accordance with the decision of the Senate. On the same day a few peasants and country-people whose names were on the list of the unwanted persons also left the city. Not far outside the town the Imperialist forces seized them, cut off their noses and ears, and sent them back into the city, warning them that if they came out again they would be hanged...

"On 3 April the Imperial army renewed the bombardment with many guns, showing that the artillery had not been withdrawn at all. Up till then no one had entered the town: no news came in and nothing was known of the whereabouts of the Florentine envoy. Meanwhile there was no more bread: even for money there was none to be found. The inhabitants were in despair; many of my friends, when I asked them how they were getting on, replied: 'I am finished with life.'

"There being practically no bread left in the Hospice of Santa Maria della Scala, the orphans could no longer exist: every day a few of them died of starvation. It was therefore decided to let them go round knocking at the doors of nobility, begging, for the love of God, for a scrap of bread. One may be sure that before they resolved to do such a thing all stores of food had been used up and they had even sold the clothes off their backs. The Magistracy did nothing to relieve this situation, so that the God-fearing people predicted such an injustice would bring about the certain fall of Siena...

"On the 15th of the same month, as bread was lacking in all the parishes (and no longer even obtainable for money), poor shopkeepers were unwilling to take their turn at guarding the wall. They gathered together before the Town Hall shouting that they were dying of hunger and that no one should be surprised if they were to do something desperate. As the distributors of food-stores feared a riot, they called the shopkeepers together and authorized them in every parish to enter the houses of those citizens who were suspected of hoarding corn and meal; should they find any hidden food which had not been notified they were to confiscate it; but for food not hidden which had only missed being notified, they should pay at the rate of 20 lire the bushel. To obviate any possible opposition they were accompanied in each parish by two constables. So they all set out on their errand and found hidden food, which they confiscated, and also food which had not been notified to the Council which they also commandeered, paying the arranged price. After this they were somewhat

pacified. Dough was now mixed in each parish and loaves made of it weighing about 6 to 8 ozs., for which 14 pence were paid.

"On the 16th of that same month the fort at Montalcino sent out fire-signals in several different ways all the night through, and the Town Hall Tower gave answer: but no one ever heard what the signals meant.

"On the 17th of that same month the soldiers had no more bread, since many of those who had promised to supply each day a certain amount thereof did not keep their promise. Therefore Messire Montluc slaughtered his big horse which was worth a hundred ducats and distributed its meat to the soldiers in order to quiet them..."

On 17 April 1555 the negotiations between the Sienese ambassador and Charles v's delegate were completed. It was agreed that Siena should put herself under the protection and the sovereignty of the Emperor: he on his side gave his word not to erect a fortress in Siena. The French army was to leave the town with all military honours. THE SURRENDER

The French marched away through the Porta Romana on 21 April, accompanied by a large crowd of those citizens who had determined not to relinquish their liberty but to move out to Montalcino and there to found an independent Sienese republic. Montluc writes about the sight of the starving crowds of departing men and women with their children:

"Never in my life have I seen a more pitiful exodus. I could not keep back my tears at such a woeful sight and wept bitterly for the fate of these people risking everything with such devotion and fidelity for the preservation of their liberty." Montluc

The effect of the siege had been to reduce the population from forty thousand to eight thousand souls. But undaunted as they were by nature, nothing could dissuade them from welcoming their conqueror, the Marquis Marignano, with festive splendour. Women dressed themselves in their best and hung brocades from their windows. Over the outer gate of Camollia they carved the words: *Cor magis tibi Sena pandit* ('Siena opens her heart still wider to you').

Sozzini writes:

"Even before the French troops had left the town, three battalions of imperial soldiers marched in, a Spanish, a German, and an Italian, each with seven standards. They moved into the city, orderly and disciplined. Assembled on the Great Square [the Campo] they raised with one accord a great shout of exultation. At that same moment the bells from all the churches and from the Town Hall tower sounded a festive answering chime. The Marquis Marignano now appeared with many of the chief officers and war-chiefs and a splendid bodyguard of German halberdiers. They all moved into the Cathedral to attend Mass, after which the Marquis rode to the Papeschi Palace on the Largo Chiasso. As the flag of the French King by some oversight still hung in the Cathedral, the Spanish began to show signs of anger, threatening to tear it down, but the Master Mason, seeing this, immediately had it removed and hidden away. Sozzini

"After the imperial troops had taken up their quarters in Siena, there appeared on the Campo a great number of pack-horses laden with foodstuffs, so that one could only stare, astonished: loads of corn, wine and bread, fresh and salted meat, and eggs. And although it all cost a great deal of money it almost seemed, by comparison with the last four months, as if the stuff were really cheap, almost given away for nothing... Quicker than any whirlwind can blow a street clean of rubbish did those poor starved Sienese clean up the Campo of all those provisions; at the same time they also lightened their purses and their spirits rose..." Sozzini

"On 1 May all the fountains on the Campo, which had been turned off for months, were set going again, and this put the inhabitants in festive mood."

Right up to the last the Sienese had counted on the intervention of the Pope.

"On the third of the month the great flag of Marcellus II, the new Pope, was hung in the Cathedral. And now something very strange happened: the flag had just been hung up with a strong new cord and the sacristan and I were on the point of leaving the church, when a noise behind us made us turn back: the cord was broken, the flag lay on the ground... Soon afterwards the news reached us that the Pope had been called to a better life. On comparing the day and the hour of his death it was found to be exactly at that moment when the flag, breaking its cord, had fallen to the ground."

COSIMO
DEI MEDICI

Cosimo dei Medici aspired to the possession of Siena. So in the year 1557 he demanded from Philip II the sum of two million ducats owing to him by Spain for his services in the war against the French: he added that were the money not forthcoming he would be obliged to accept certain proposals which had been made to him by enemies of Spain. There remained no other course for Philip II to take than to yield up to the Medici Siena and all its territories. On 15 July 1557 Cosimo took possession of Siena. He erected a fortress to the west of the Lizza, where it stands to this day. Those Sienese, fighters for their independence, who had left the city to found a new republic in Montalcino, subjected themselves perforce to Cosimo, who was crowned by Pius V as Grand Duke of Tuscany in 1570. Thus the independence of Siena was lost for ever.

Coat of arms of the
Medici, Grand
Dukes of Tuscany.

THE PALIO

The incorporation of Siena in a grand-duchy, then in a national kingdom, and finally in the ever more widely generalized and abstract conception of a modern state was bound to leave permanently unsatisfied the inborn political passion of the Sienese people, who, taking the word 'political' in its truest sense, possessed a creative and ardent love for their own 'Polis'. This passion, deeply implanted in the very flesh and blood of the Sienese, could only be given an outlet by making a return, to some extent at least, to what amounted to their original 'cell', to the *contrada*, the city quarter. Strictly speaking these so-called quarters of the city covered a much smaller area than a quarter, being scarcely more than a seventeenth part of the town. Each *contrada* is something like a political unit, although their communal activities concern all manner of things which have nothing to do with politics as understood today.

The division of the city into *contrade*, at one time twenty-two in number, probably goes back to a constitution adapted for the needs of warfare. Certain it is that in the Middle Ages the whole population belonged to one or other of two groups, the *milites* or the *populus*, the knights or the people, and that the people as well as the knights-at-arms were included in military corporations, of which the most important represented the three divisions of the city. It is thus very possible that the *contrade* still existing today correspond more or less to those regions of the town which always formed a military unit, although these associations were first clearly recognizable historically from Renaissance times, in the annals of public festivals.

On the other hand Siena, from the very nature of the ground whereon it stands, falls into separate regions: one can easily imagine it growing together out of a series of isolated settlements. In the early Middle Ages there was apparently no city wall encircling the scattered parts of the town, so that each group of buildings represented a kind of fortress in itself. Later it became customary for the various types of crafts to settle in particular sections of the town, as can be seen from an examination of the coats of arms of the respective *contrade*. For instance, the silk-worm *(bruco)* on the coat of arms of the *contrada* of that name indicates the silk-workers' craft, which was practised in that part of the city. As is plainly recognisable in the Festival of the Palio (the Banner Horse-races), the arch-enemy and rival of each *contrada* is its nearest neighbour, while all other more distant *contrade* are considered as allies. That is the natural law of politics.

The rivalry between the different *contrade*, or wards, finds its expression mainly in the annual horse-races known as the Palio, which at the same time provide an occasion for a contest in display: for that is the other side of the Sienese passion, namely, their ardent love of public exhibition, of fine gesture, of *magnificenza*, which is all of a piece with the half aristocratic, half bourgeois habits of old Siena. Picturesque festivals crop up throughout the history of Siena with the regularity of milestones along a roadway.

The Palio horse-race is not racing in the ordinary sense of the word, for its aim is not the triumph of the best horse and the best rider. The *contrade* cast lots for their horses, and the riders, who are not Sienese but just young men from the horse-pastures in the Romagna, are engaged by the *contrada* only a few days before the Palio takes place. The race is really more like a trial by ordeal, but one in which every sort of trick and cunning likely to favour one's chances is quite in order, so much so that the result depends almost more on secret intrigue than on the quality of the horses.

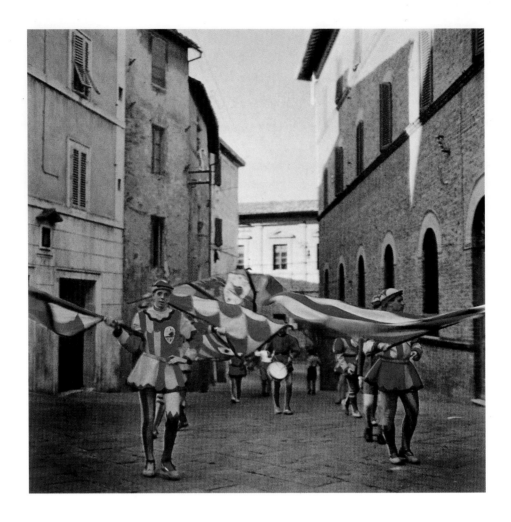

Visit of a *comparsa* to a friendly *contrada* on the feast of its patron saint.

The coats of arms of the three city wards, *San Martino, Città* (city), and *Camollia;* and of two *contrade, Montone* (ram) and *Aquila* (eagle).

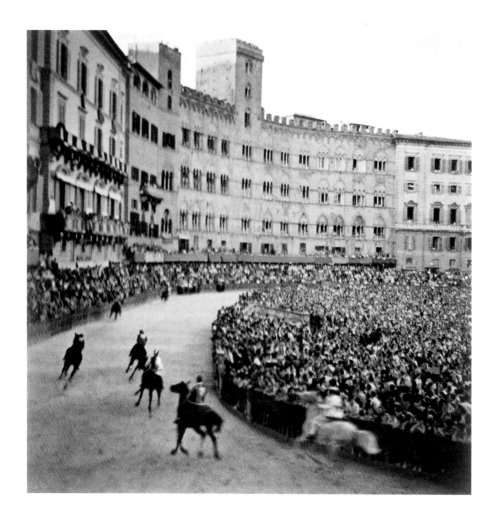

The Palio Race on the Campo at sunset.

The emblems of the *contrade*, *Chiocciola* (snail), *Civetta* (screech-owl), *Giraffa* (giraffe), *Pantera* (panther), and *Bruco* (silkworm).

Onda (wave)

Leocorno (unicorn)

Drago (dragon)

Selva (forest)

Oca (goose)

The Palio races were held in the first place—and certainly since the beginning of the fourteenth century—on the Feast of the Assumption in honour of the Holy Mother of God of Provenzano; this was a picture formerly in the possession of Provenzano Salvani, political leader of Siena at the time of the Montaperto war, which hangs now in the church of that same name. Later, approximately from 1650 onwards, the race was held on 2 July, the Feast of the Visitation, and still later a second race was added which took place on 16 August. In early days the race was run right across the whole town; for the last four centuries, however, it has been held on the Campo and is now so bound up with the social character of the square that the whole Palio seems to represent the Campo at its culmination of artistic significance.

At the Palio each *contrada* appears not only with its horse and rider but also in the decorative figures of its *comparsa*, a dramatic representation of armour-bearers and arms, consisting of a Captain *(capitano)*, two ensigns *(alfieri)*, standard-bearer *(figurino)*, drummer *(tamburino)*, rider *(fantino)*, the equerry *(barbaresco)*, and a page. In the procession before the race, which should never fail to include a reproduction of the *carroccio*, the war-waggon of Siena, the rider or jockey goes ahead on a parade horse, while the equerry leads the actual race-horse by the reins. Meanwhile the ensigns show their acrobatic skill in the swinging of the flags to the sound of rolling drums.

The race itself takes place at sunset around the Campo on a course strewn with earth; the sharpest corners to the right and left of the Town Hall are edged with mattresses, as on taking the bend it is quite possible for a rider to be flung off his horse in a sweeping curve.

The apparel of the *comparse* is renewed from time to time, with the result that it is not the dress of the fourteenth century that is chosen as a model, as one might expect, but that of the Renaissance. But reminiscent of the height of old Siena's glory is the grandeur of the heraldry on banner, standard and hanging draperies.

Besides the City coat of arms one sees the horizontally divided white and black *Balzana*, the banner of the three main sections of the town; and then the seventeen crests of the contending *contrade*, each with its own particular animal. These latter were raised to the rank of aristocratic emblems by King Umberto I, an enthusiastic spectator at the races, since when they have been further adorned by the badge of the House of Savoy. Every *comparsa* wears the colours of its special coat of arms.

In each *contrada* there is a kind of Guild-house in which traditional customs are fostered and preparations made for the Palio: here the members meet and here the trophies of former victories, the costumes, the drums and the banners, are exhibited. Nearly always one can find pictures there of famous races and sometimes, exhibited with proud irony, the dented helmet of some *fantino* whom rivals had mishandled on account of some wily victory. Once a year the feast of the *contrada*'s patron saint is celebrated: the little church near by is decorated, friendly *contrade* are visited with waving of flags and beating of drums, and the day ends with a banquet on a festively lighted street.

Every Sienese remains faithful to that *contrada* where he has passed his childhood and at the approach of the Palio races he takes part eagerly in all the intrigues aiming at bribing the *fantini* of the enemy *contrade* to hold back their horses, or to throw a rider by a well-aimed slash of the whip. At the same time big candles are burnt in the churches; and even in the horse-box, where the allotted horse is kept and jealously watched and tended till the day of the race, a picture of the patron saint is hung, surrounded by burning lights.

The race begins with a consecrated offering to the Holy Virgin, for, in spite of all the trickery which is carried on with wry humour and dogged intensity, the whole affair is a kind of solemn game of consecration, possibly distantly related to the horse-racing of antiquity in honour of some god.

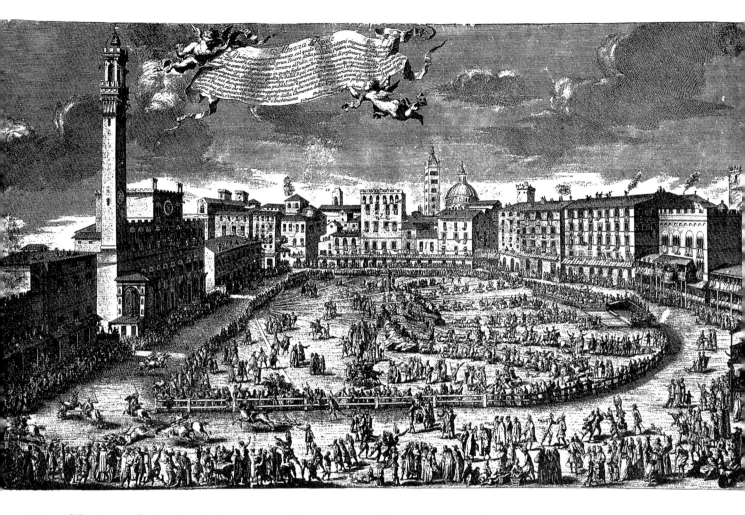

View of the Campo during the Palio horse-race and the procession of the *comparse* on 2 July 1717. From a contemporary engraving printed by Domenico Rossi in Rome. *City Museum, Town Hall, Siena.*

The Sienese know full well that in this way they can harmlessly dispel a passion which might otherwise weigh upon them, and at the same time satisfy their yearning for the great imaginative fulfilment of their community in the only manner that still remains possible.

The Palio may be described as the last popular manifestation in the proud history of a free city.

Emblems of the *contrade*, *Istrice* (hedgehog), *Torre* (tower), *Lupa* (she-wolf), *Nicchio* (mussel-shell), and *Tartuca* (tortoise).

EPILOGUE

The narrow streets of old Siena are not made for modern traffic. Concessions given stage by stage in face of its encroaching demands would soon end in the complete destruction of the old scene, and thus an irreplaceable example of city architecture, the only 14th-century European city remaining to us in its original perfection, would be lost irretrievably. The Municipal Council of Siena has therefore worked out a plan that will very largely protect the ancient quarters of the town and prevent building on the site of the gardens which lie inside the walls and so greatly enhance the beauty of the city. This plan provides for a business and industrial development in the direction of the Lizza; the main stream of traffic will be carried in the curve around the inner city, and under the market-place an underground parking station will be constructed to accomodate the cars which at present disfigure the beauty of the ancient squares. To carry out such a plan, however, requires a larger sum of money than lies at the disposal of a municipality such as Siena. It is therefore to be hoped that widespread interest will be aroused in Europe so that help may be forthcoming to preserve one of the most beautiful monuments of Western culture from destruction before it is too late.

Publisher's Note: In 1995, Burckhardt's wish to see the beauty of Siena preserved from destruction by modern development became a reality when the historical center of the city was designated a World Heritage Site by The United Nations Educational, Scientific, and Cultural Organization (UNESCO).

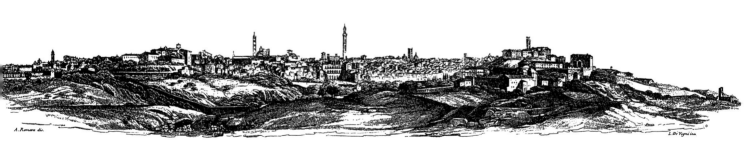

View of Siena. Engraving of a drawing by Alessandro Romani, 19th century, printed by L. de Vegni.

SOURCES

Titles of works from which documents have been taken, giving abbreviations of their titles used in the margin of this book

S. Bernardino da Siena: LE PREDICHE VOLGARI; ed. by P. G. Cannarozzi. Firenze 1934. *(Cannarozzi)*

S. Bernardino da Siena: LE PREDICHE VOLGARI INEDITE; a cura del P. Dionisio Pacetti, OFM. Siena 1935. *(Pacetti)*

S. Caterina: EPISTOLARIO; a cura di Piero Misciatelli. Siena 1922. *(Epistolario)*

Lorenzo Ghiberti: DENKWÜRDIGKEITEN; German edition by J. von Schlosser. 1920. *(Ghiberti)*

Milanesi: DOCUMENTI PER LA STORIA DELL'ARTE SENESE; Tomi I–IV. Siena 1854 e 1873. *(Milanesi)*

Blaise de Montluc: COMMENTAIRES. Bordeaux 1592. *(Montluc)*

Muratori: RERUM ITALICORUM SCRIPTORES; Tomo XV, Parte VI: CRONACHE SENESI; a cura di All. Lisini e F. Iacometti, Bologna. *(Muratori)*

Gentile Sermini: NOVELLE; in SCRITTORI NOSTRI. Lanciano 1911. *(Sermini)*

Sozzini: DIARIO DELLE COSE AVVENUTE IN SIENA DAL 20 LUGLIO 1550 AL 28 GIUGNO 1555. Firenze 1842. *(Sozzini)*

Tozzi, Federico: ANTOLOGIA DI ANTICHI SCRITTORI SENESI. Siena 1913. *(Tozzi)*

Archives of the Bianchi-Bandinelli Family, Siena. *(Bandinelli)*

N.B. Excerpts from the original Italian and French, which have been used in this book, were all translated by the author, except for the following, for which grateful acknowledgement is made to the publishers concerned:
extracts from *St. Catherine of Siena as seen in her Letters* by Vida D. Scudder, on pages 57 and 61 of this book, by permission of Messrs. J. M. Dent & Sons;
extract from Dante's *Inferno*, translated by Dorothy L. Sayers, on page 19, by permission of Penguin Books Ltd.

LIST OF ILLUSTRATIONS

INDEX

For a glossary of all key foreign words used in books published by World Wisdom, including metaphysical terms in English, consult:
www.DictionaryofSpiritualTerms.org.
This on-line Dictionary of Spiritual Terms provides extensive definitions, examples and related terms in other languages.

BIOGRAPHICAL NOTES

TITUS BURCKHARDT, a German Swiss, was born in Florence in 1908 and died in Lausanne in 1984. Burckhardt was an eminent member of the "Traditionalist" or "Perennialist" school of twentieth century thought, devoting his life to the study and exposition of the different manifestations of the timeless wisdom—the *philosophia perennis* or *sophia perennis*—underlying the world's great religions.

Although Burckhardt was born in Florence, he was the scion of a patrician family of Basle, Switzerland. He was the great-nephew of the famous art historian Jacob Burckhardt and the son of the sculptor Carl Burckhardt.

Burckhardt was fluent in German, French, Arabic, and English and wrote seventeen books in German, eight books in French, translated three books from Arabic into French, and wrote numerous articles in various languages. Twelve of these books have been translated into English. A more extensive biography and a complete bibliography are available on www.worldwisdom.com.

WILLIAM STODDART was born in Carstairs, Scotland, lived most of his life in London, England, and now lives in Windsor, Ontario. He studied modern languages, and later medicine, at the universities of Glasgow, Edinburgh, and Dublin. He was a close associate of both Titus Burckhardt and Frithjof Schuon during the lives of these leading Traditionalists/Perennialists. He was assistant editor of the influential English journal, *Studies in Comparative Religion*. His books include *Outline of Hinduism* (1993), *Outline of Buddhism* (1998), and *Sufism: The Mystical Doctrines and Methods of Islam* (1986). A collection of Dr. Stoddart's writings has been published by World Wisdom, entitled *Remembering in a World of Forgetting: Thoughts on Tradition and Postmodernism* (2007).

Other Books by Titus Burckhardt

Introduction to Sufi Doctrine

Famous Illuminated Manuscripts

Sacred Art in East and West

Alchemy: Science of the Cosmos, Science of the Soul

Moorish Culture in Spain

Art of Islam: Language and Meaning

Mystical Astrology according to Ibn 'Arabi

Fez: City of Islam

Chartres and the Birth of the Cathedral

Edited Writings of Titus Burckhardt

The Essential Titus Burckhardt: Reflections on Sacred Art, Faiths, and Civilizations, ed. William Stoddart

Mirror of the Intellect: Essays on Traditional Science and Sacred Art, ed. William Stoddart

The Foundations of Christian Art: Illustrated, ed. Michael Oren Fitzgerald

Foundations of Oriental Art and Symbolism: Illustrated, ed. Michael Oren Fitzgerald

Other Books in the Sacred Art in Tradition Series

The Feathered Sun: Plains Indians in Art and Philosophy, by Frithjof Schuon

Art from the Sacred to the Profane: East and West, by Frithjof Schuon, ed. Catherine Schuon

Images of Primordial and Mystic Beauty, by Frithjof Schuon

Sacred Art in East and West, by Titus Burckhardt

Other Titles on Christianity by World Wisdom